Modigliani

Grange BOOKS

Author : Jane Rogoyska and Frances Alexander

Designed by: Baseline Co Ltd
19-25 Nguyen Hue
Bitexco Building, Floor 11
District 1, Ho Chi Minh City
Vietnam

Published in 2005 by Grange Books
an imprint of Grange Book Plc
The Grange Kingsnorth Industrial Estate
Hoo, nr Rochester, Kent ME3 9ND
www.Grangebooks.co.uk

ISBN 1-84013-779-7

Printed in Singapore

Contents

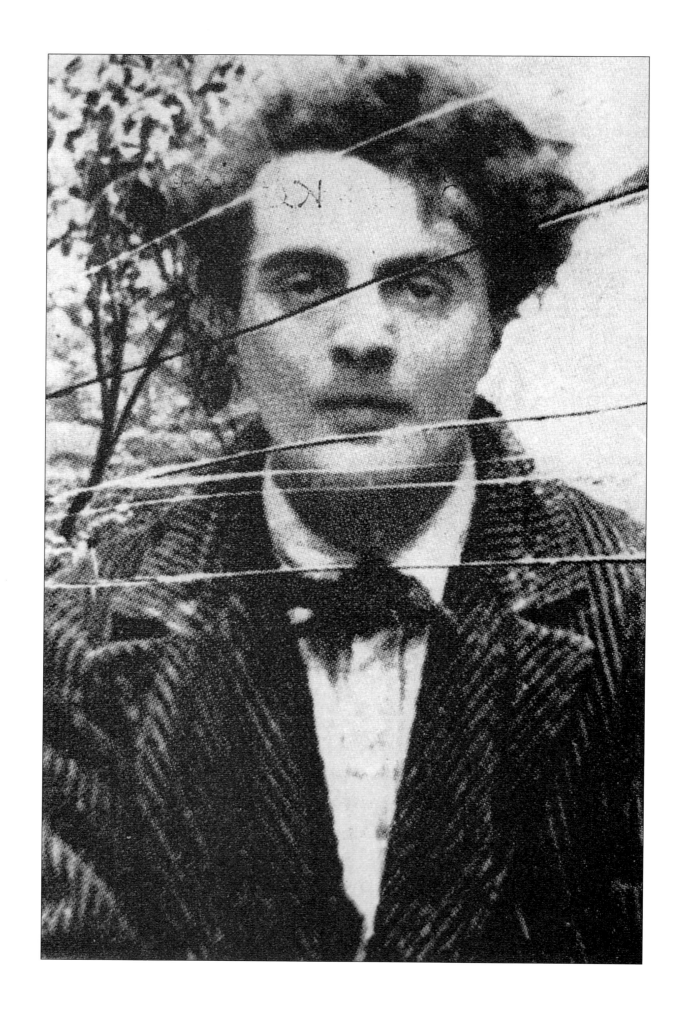

His Life

Amedeo Modigliani was born in Italy in 1884 and died in Paris at the age of thirty-five. He was Jewish, with a French mother and Italian father, and so grew up with three cultures. A passionate and charming man who had numerous lovers, his unique vision was nurtured by his appreciation of his Italian and classical artistic heritage, his understanding of French style and sensibility, in particular the rich artistic atmosphere of Paris at the turn of the 20th century, and his intellectual awareness inspired by Jewish tradition.

Unlike other avant-garde artists, Modigliani painted mainly portraits – typically unrealistically elongated with a melancholic air – and nudes, which exhibit a graceful beauty and strange eroticism.

In 1906, Modigliani moved to Paris, the centre of artistic innovation and the international art market. He frequented the cafés and galleries of Montmartre and Montparnasse, where many different groups of artists congregated. He soon became friends with the post-impressionist painter (and alcoholic) Maurice Utrillo (1883-1955) and the German painter Ludwig Meidner (1844-1966), who described Modigliani as the "last, true bohemian" (Doris Krystof, *Modigliani*).

Modigliani's mother sent him what money she could afford, but he was desperately poor and had to change lodgings frequently, sometimes abandoning his work when he had to run away without paying the rent. Fernande Olivier, the first girlfriend in Paris of Pablo Picasso (1881-1973), describes one of Modigliani's rooms in her book *Picasso and his Friends* (1933): "A stand on four feet in one corner of the room. A small and rusty stove on top of which was a yellow terracotta bowl that was used for washing in; close by lay a towel and a piece of soap on a white wooden table. In another corner, a small and dingy box-chest painted black was used as an uncomfortable sofa. A straw-seated chair, easels, canvases of all sizes, tubes of colour spilt on the floor, brushes, containers for turpentine, a bowl for nitric acid (used for etchings), and no curtains."

Modigliani was a well-known figure at the Bateau-Lavoir, the celebrated building where many artists, including Picasso, had their studios. It was probably given its name by the bohemian writer and friend of both Modigliani and Picasso, Max Jacob (1876-1944).
While at the Bateau-Lavoir, Picasso painted *Les Demoiselles d'Avignon* (1907), the radical depiction of a group of prostitutes that heralded the start of Cubism.

Other Bateau-Lavoir painters, such as Georges Braque (1882-1963), Jean Metzinger (1883-1956), Marie Laurencin (1885-1956), Louis Marcoussis (1883-1941), and the sculptors Juan Gris (1887-1927), Jacques Lipchitz (1891-1973) and Henri Laurens (1885-1954) were also at the forefront of Cubism.

The vivid colours and free style of Fauvism had just become popular and Modigliani knew the Bateau-Lavoir Fauves, including André Derain (1880-1954) and Maurice de Vlaminck (1876-1958), as well as the Expressionist sculptor Manolo (Manuel Martinez Hugué, 1876-1945), and Chaim Soutine (1893-1943), Moïse Kisling (1891-1953), and Marc Chagall (1887-1985). Modigliani painted portraits of many of these artists.

1. Modigliani at his arrival
 in Paris in 1906. Photograph,
 archives Billy Klüver.

2. *The Jewess,* 1908.
 Oil on canvas, 55 x 46 cm.
 Private collection, Paris.

3. *Head of a Young Woman,* 1908.
 Oil on canvas.
 Private collection, Paris.

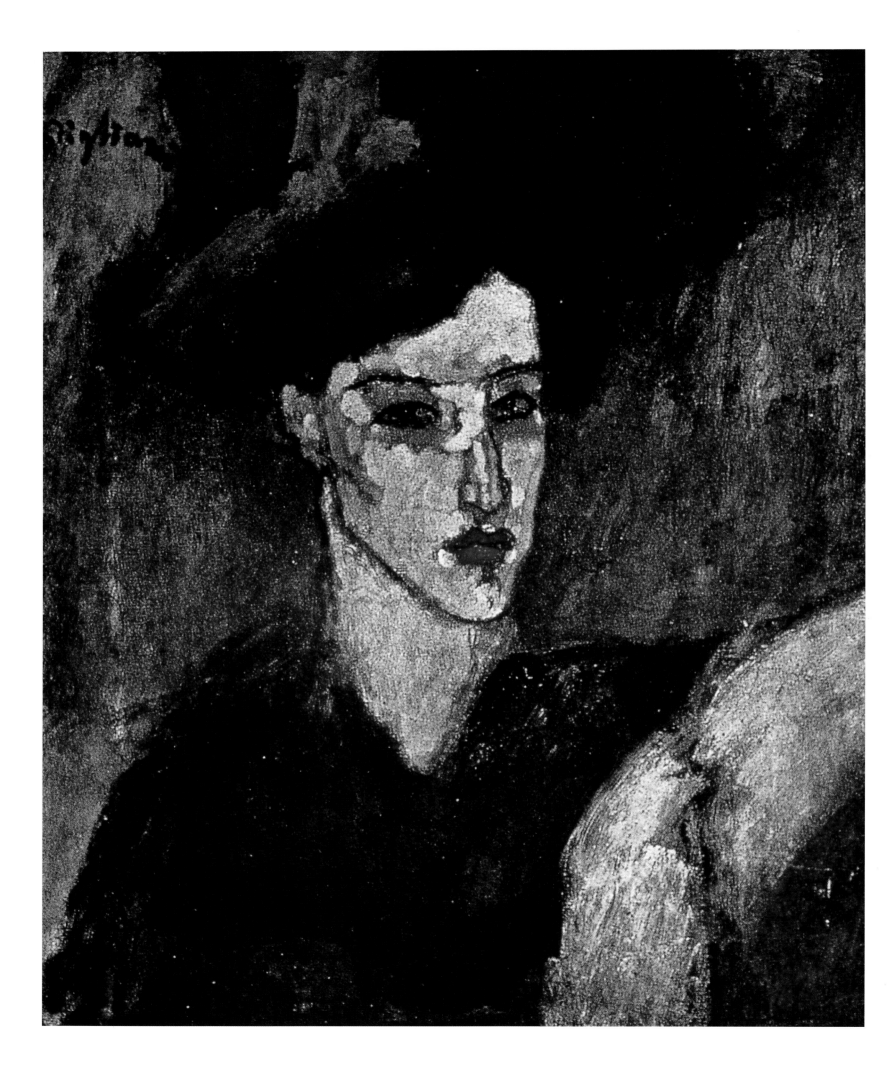

6.

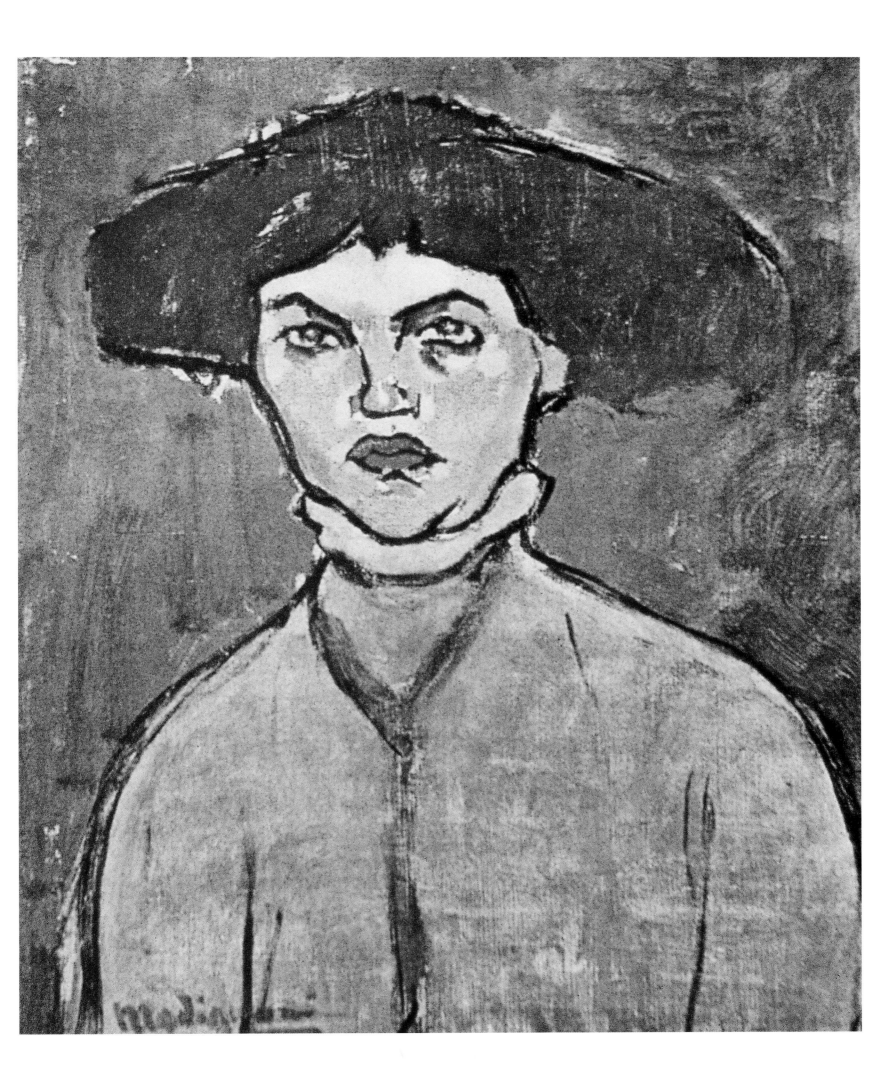

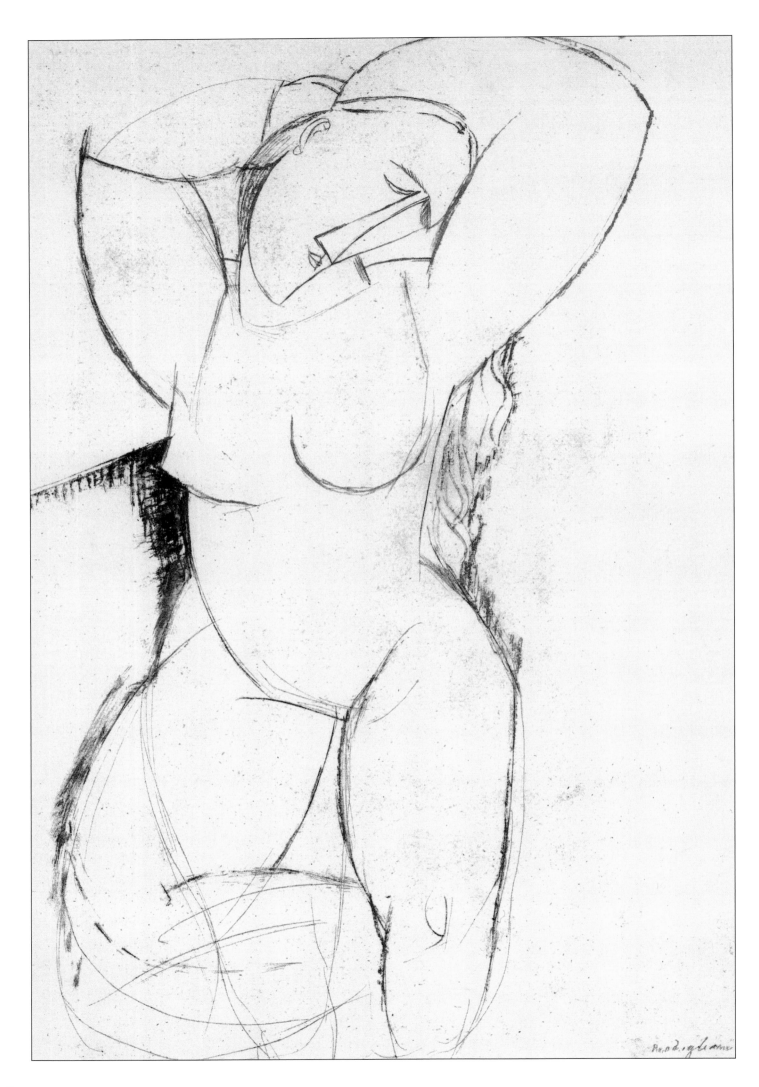

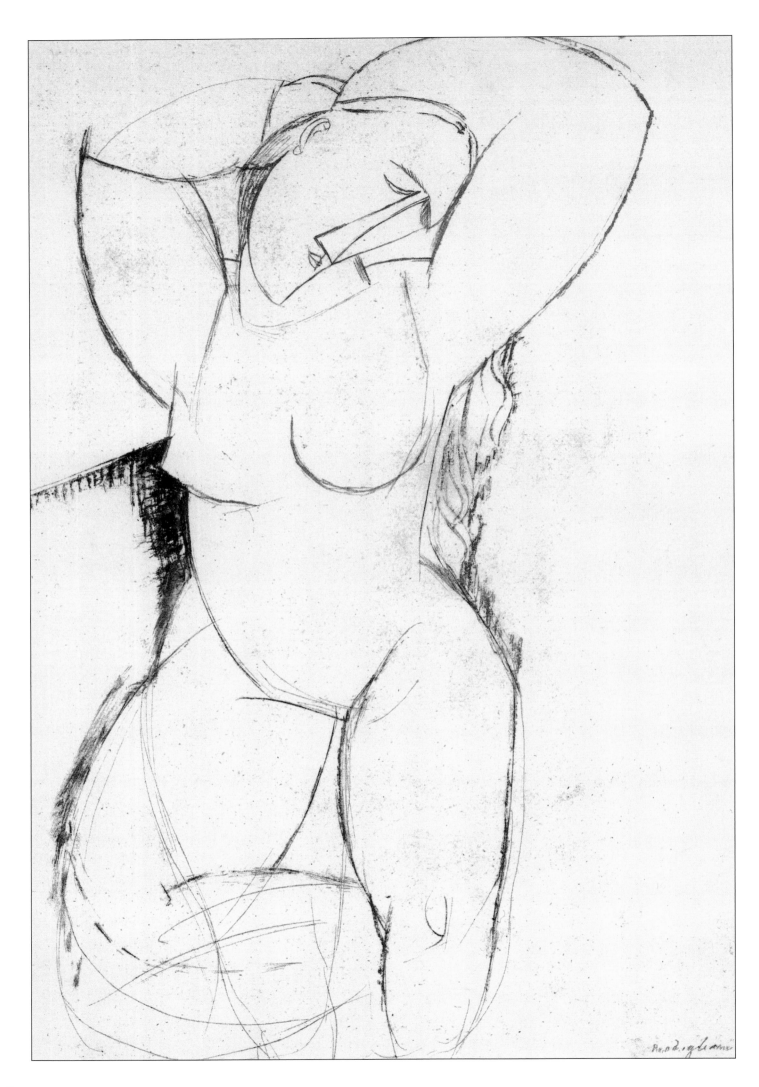

8.

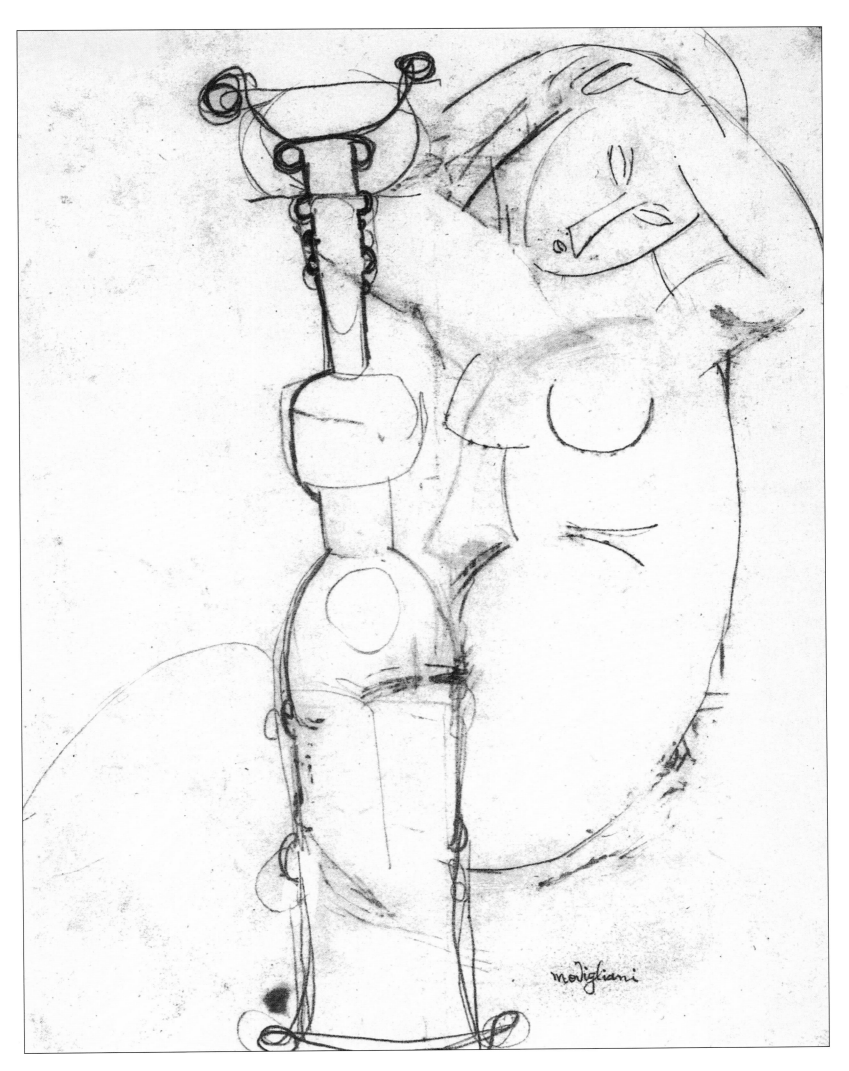

Max Jacob and other writers were drawn to this community which already included the poet and art critic (and lover of Marie Laurencin) Guillaume Apollinaire (1880-1918), the Surrealist Alfred Jarry (1873-1907), the writer, philosopher and photographer Jean Cocteau (1889-1963), with whom Modigliani had a mixed relationship, and André Salmon (1881-1969), who went on to write a dramatized novel based on Modigliani's unconventional life. The American writer and art collector Gertrude Stein (1874-1946) and her brother Leo were also regular visitors.

Modigliani was known as "Modi" to his friends, no doubt a pun on *peintre maudit* (accursed painter). He himself believed that the artist had different needs and desires, and should be judged differently from other, ordinary, people – a theory he came upon by reading such authors as Friedrich Nietzsche (1844-1900), Charles Baudelaire (1821-1867), and Gabriele D'Annunzio (1863-1938). Modigliani had countless lovers, drank copiously, and took drugs. From time to time, however, he also returned to Italy to visit his family and to rest and recuperate.

In childhood, Modigliani had suffered from pleurisy and typhoid, leaving him with damaged lungs. His precarious state of health was exacerbated by his lack of money and unsettled, self-indulgent lifestyle. He died of tuberculosis; his young fiancée, Jeanne Hébuterne, pregnant with their second child, was unable to bear life without him and killed herself the following morning.

From Tradition to Modernism
A Reinterpretation of Classical Works

Modigliani's first teacher, Guglielmo Micheli (died 1926), was a follower of the Macchiaioli school of Italian Impressionists. Modigliani learned both to observe nature and to understand observation as pure sensation. He took traditional life-drawing classes and immersed himself in Italian art history. From an early age he was interested in nude studies and in the classical notion of ideal beauty.

In 1900-1901 he visited Naples, Capri, Amalfi, and Rome, returning by way of Florence and Venice, and studied firsthand many Renaissance masterpieces. He was impressed by *trecento* (13th-century) artists, including Simone Martini (c.1284-1344), whose elongated and serpentine figures, rendered with a delicacy of composition and colour and suffused with tender sadness, were a precursor to the sinuous line and luminosity evident in the work of Sandro Botticelli (c.1445-1510). Both artists clearly influenced Modigliani, who used the pose of Botticelli's Venus in *The Birth of Venus* (1482) in his *Standing Nude (Venus)* (1918) and *Red-Haired Young Woman with Chemise* (1918, p.123), and a reversal of this pose in *Seated Nude with Necklace* (1917, p.98).

The sculptures of Tino di Camaino (c.1285-1337) with their mixture of weightiness and spirituality, characteristic oblique positioning of the head and blank almond eyes also fired Modigliani's imagination. His distorted composition and overly lengthened figures have been compared to those of the Renaissance Mannerists, especially Parmigianino (1503-1540) and El Greco (1541-1614). Modigliani's non-naturalistic use of colour and space are similar to the work of Jacopo da Pontormo (1494-1557).

For his series of nudes, Modigliani took compositions from many well-known nudes of High Art, including those by Giorgione (c.1477-1510), Titian (c.1488-1576), Jean-Auguste-

4. *Caryatid Study*, c.1913. Ink and pencil. Private collection.

5. *Sheet of Studies with African Sculpture and Caryatid*, c.1912-13. Pencil, 26.5 x 20.5 cm. Private collection, Chicago.

6. *Madame Pompadour*, 1905. Detail. Oil on canvas, 61.1 x 50.2 cm. Art Institute of Chicago.

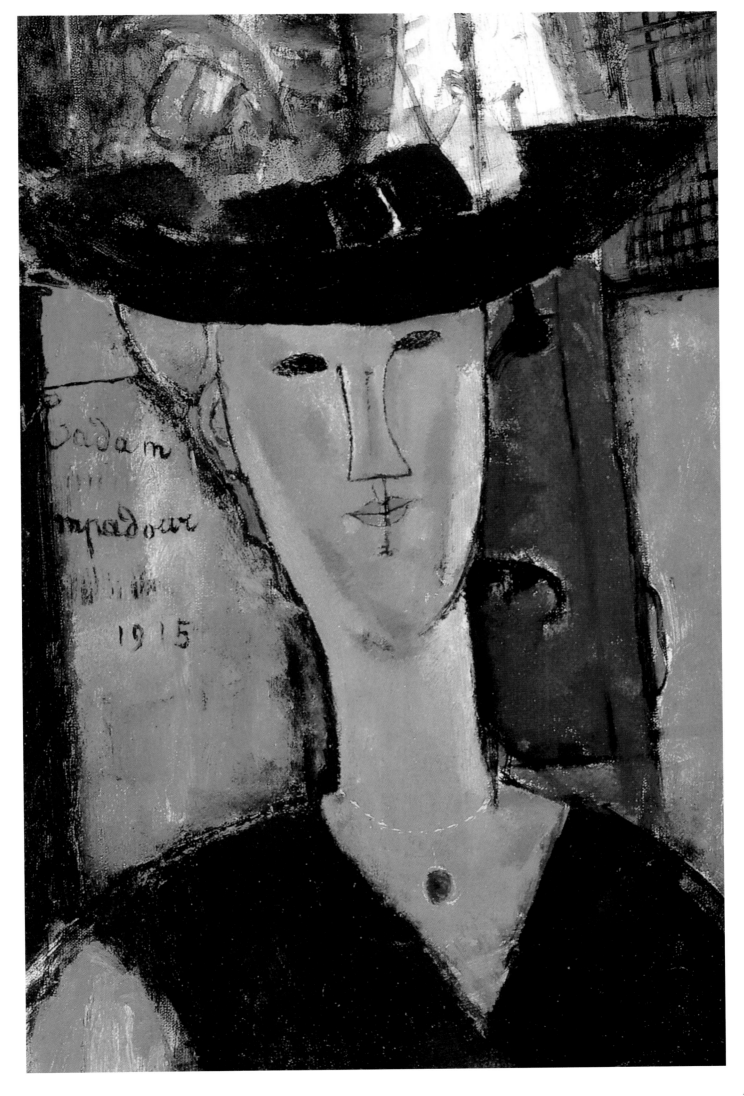

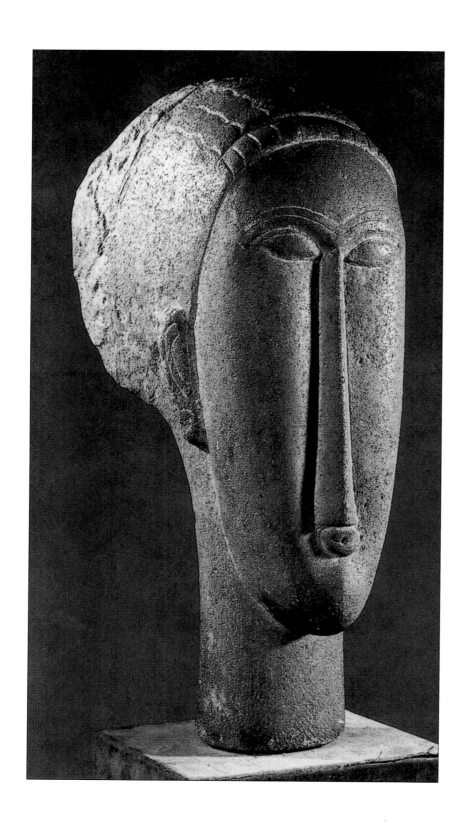

7. *Head,* 1911-12.
Limestone, 50 x 19 x 19 cm.
Private collection.

8. *Head,* 1911-12.
Limestone, 71.1 x 16.5 x 23.5
cm. Philadelphia Museum of
Art, Philadelphia.

9. *Head,* 1912.
Stone, 58 x 12 x 16 cm,
Musée National d'Art Moderne,
Centre Georges Pompidou, Paris.

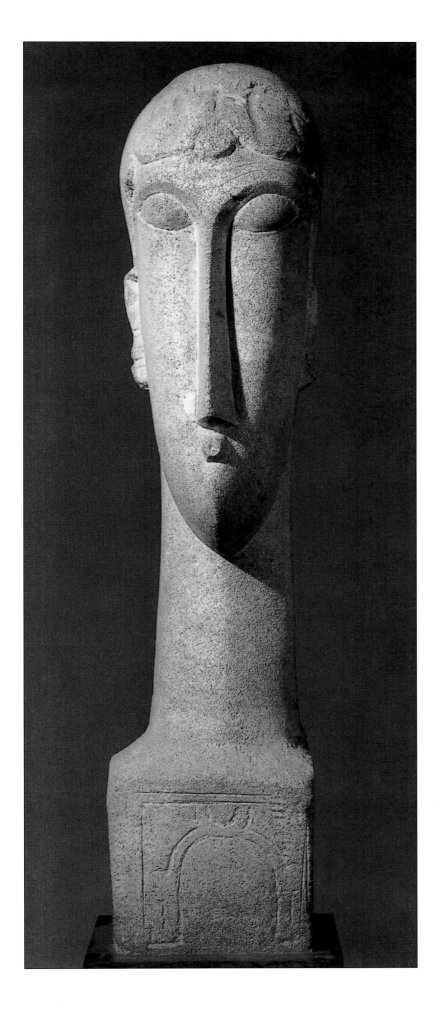

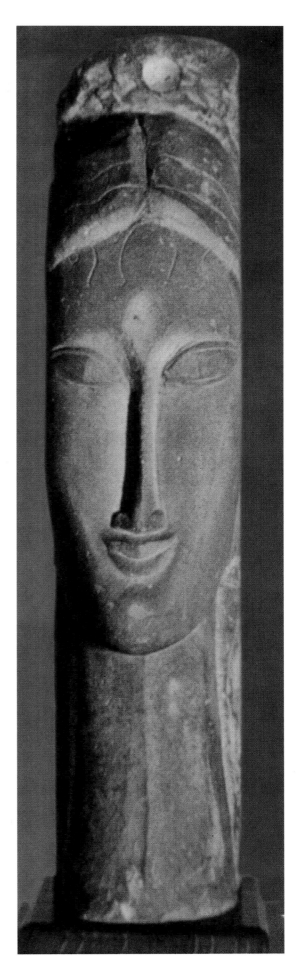

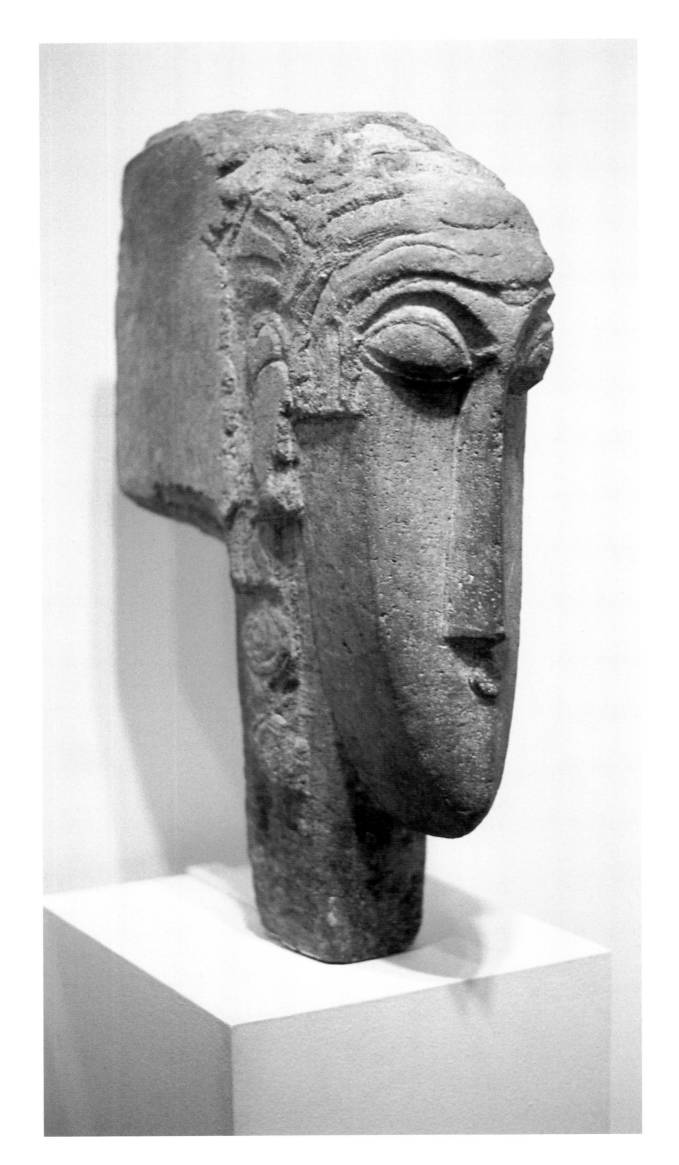

Dominique Ingres (1780-1867), and Velázquez (1599-1660), but avoided their romanticization and elaborate decorativeness. Modigliani was also familiar with the work of Francisco de Goya y Lucientes (1746-1828) and Edouard Manet (1832-1883), who had caused controversy by painting real, individual women as nudes, breaking the artistic conventions of setting nudes in mythological, allegorical, or historical scenes.

Discovery of New Art Forms

Modigliani's debt to the art of the past was transformed by the influence of ancient art, the art of other cultures, and Cubism. African sculptures and early ancient Greek Cycladic figures had become very fashionable in the Parisian art world at the turn of the century. Picasso imported numerous African masks and sculptures, and the combination of their simplified abstract approach and use of multiple viewpoints were the direct inspiration for Cubism. Modigliani was impressed by the way the African sculptors unified solid masses to produce abstract but pleasing forms that were decorative but had no extraneous detailing. His interest in such work is illustrated by his *Sheet of Studies with African Sculpture and Caryatid* (c.1912-13, p.9). He sculpted a series of African-inspired stone heads (c.1911-1914), which he called "columns of tenderness," and envisaged them as part of a "temple of beauty."

His friend, the Romanian sculptor Constantin Brancusi (1876-1957), introduced Modigliani to early ancient Greek Cycladic figures. These, along with Brancusi's own work, inspired Modigliani's caryatids. Modigliani was interested in the depiction of solidity, yet caryatids as weight-bearing structures must be powerful as well as graceful. The details in Modigliani's caryatids, however, show a modern awareness of sexuality and a desire to render a sense of the fleshy femininity of the figures. *Caryatid* (c.1914, p.82) has her arms behind her head in a pose more often associated with sleep and foreshadows, the pose of *Sleeping Nude with Arms Open (Red Nude)* (1917, p.100). The caryatid narrows at the waist, but her belly and full thighs are massive and reflect her full, round arms and head. Her pose echoes Renaissance use of *contrapposto* and shows Modigliani's awareness of the pliability of her flesh and the sensuousness of her fully curved figure. The *Pink Caryatids* (1913-14, p.76) have even fuller curves and display a lush use of luminous colour. They are essentially patterns of circles and are highly geometric. It was the Cubist approach, developing the ideas of Cézanne, that led Modigliani to stylize the caryatids into such geometric shapes. Their balanced circles and curves, despite having a voluptuousness, are carefully patterned rather than naturalistic. Their curves are precursors of the swinging lines and geometric approach that Modigliani later used in such nudes as *Reclining Nude* (p.109). Modigliani's drawings of caryatids allowed him to explore the decorative potential of poses that may not have been possible to create in sculpture.

The raised arms of *Caryatid* (1911-12, p.66) give her a stylized, ballet posture. She is more angular and lean than most of Modigliani's caryatids, apart from her fully rounded breasts and the curving outline to her hip and thigh. *Caryatid* (1910-11; charcoal sketch) has a similar angled head and uplifted leg. In *Caryatid* (c.1912-13) Modigliani has emphasized the raised thigh and pointed breast, showing his intention to present the figure as a sexual female.

Caryatid (c.1912, p.70) faces the viewer and can be seen as a predecessor of Modigliani's standing nudes. The geometrizing of the figure is apparent, as is the reduction to simple forms. *Caryatid* (1913, p.78) is a more highly worked version with fine detailing on the nipples and navel.

10. *Head*, c.1915. Limestone,
 56.5 x 12.7 x 37.4 cm.
 The Museum of Modern Art,
 New York.

11. *Portrait of Béatrice Hastings*,
 c.1915.
 Oil on cardboard, 69 x 49 cm.
 Fondazione Antonio Mazzotta,
 Milan.

12. *Antonia*, c.1915.
 Oil on canvas, 82 x 46 cm.
 Musée de l'Orangerie, Paris.

13. *Portrait of Max Jacob*, c.1916.
 Oil on canvas, 91 x 58 cm.
 Private collection, Paris.

14. *Paul Guillaume, Novo Pilota*,
 1915. Oil on cardboard,
 on plywood, 105 x 75 cm.
 Musée de l'Orangerie, Paris.

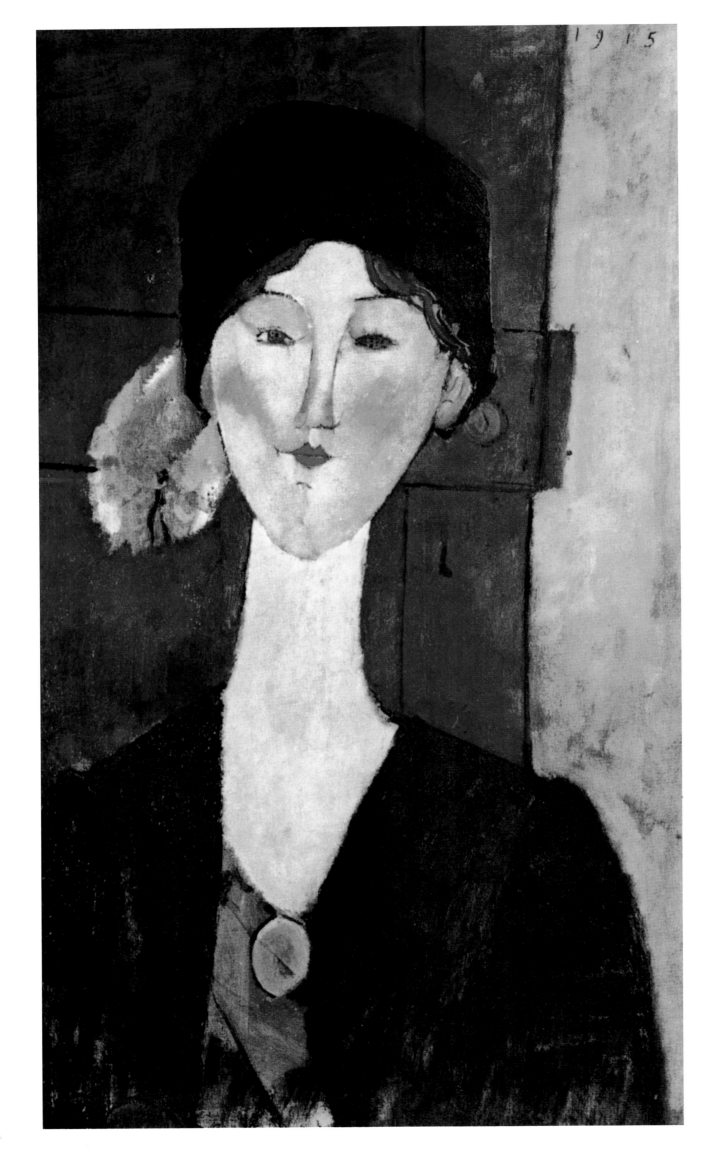

1915

16.

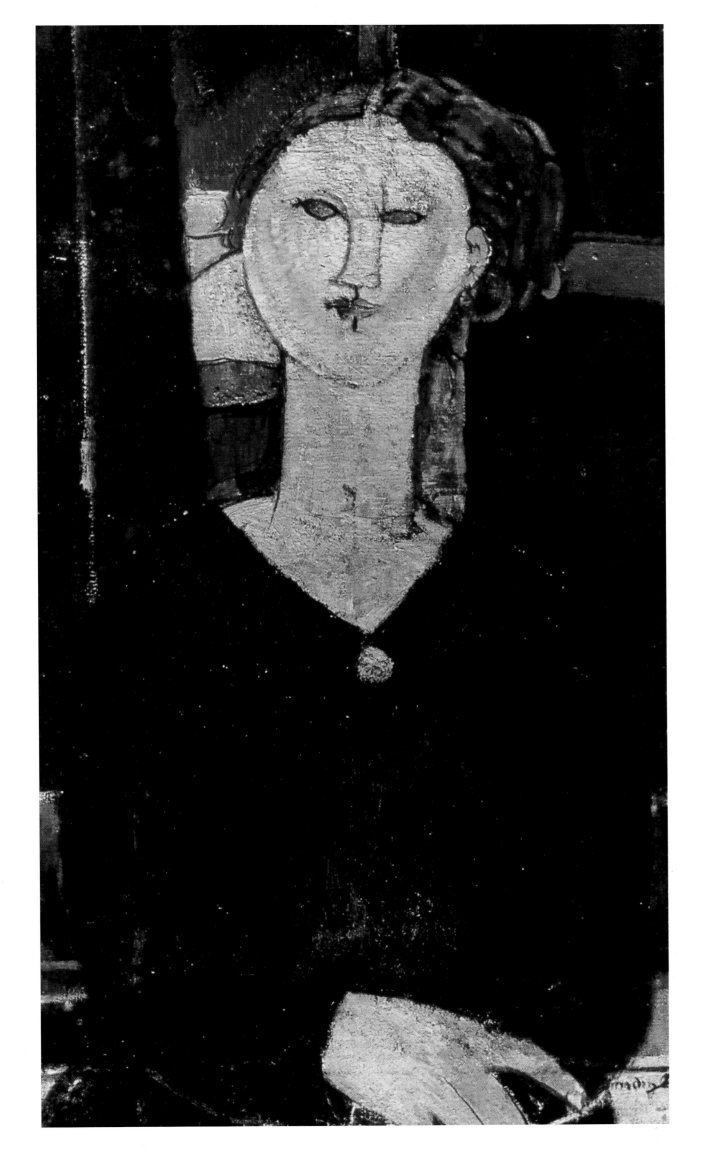

17.

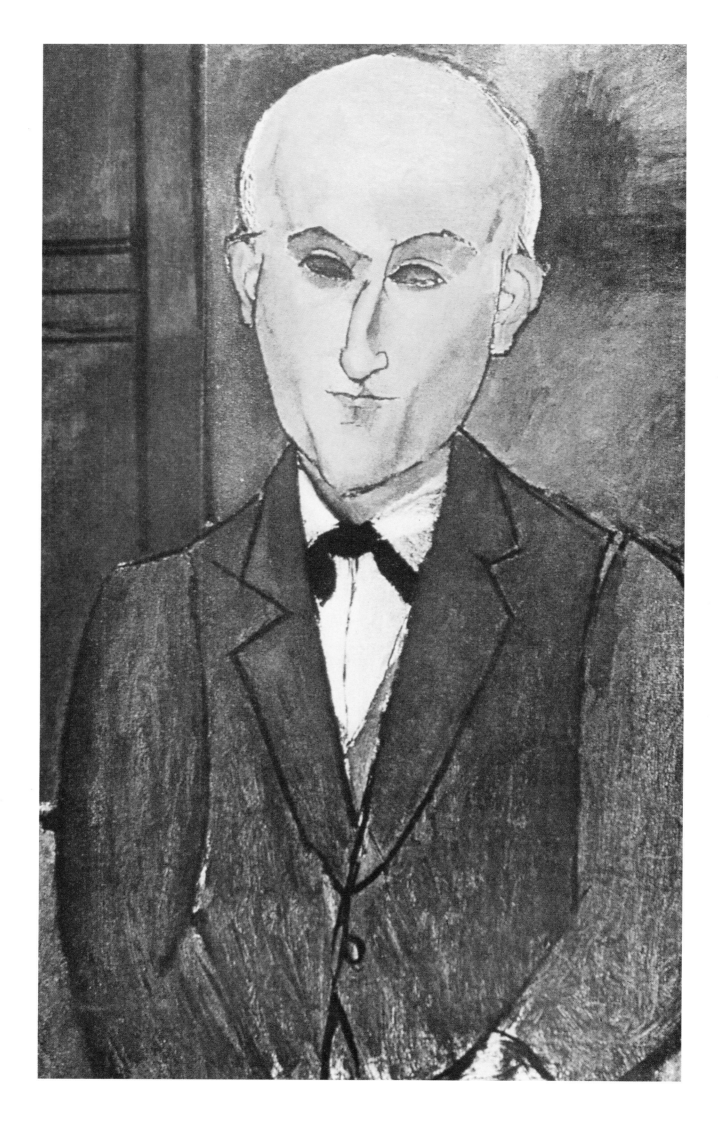

18.

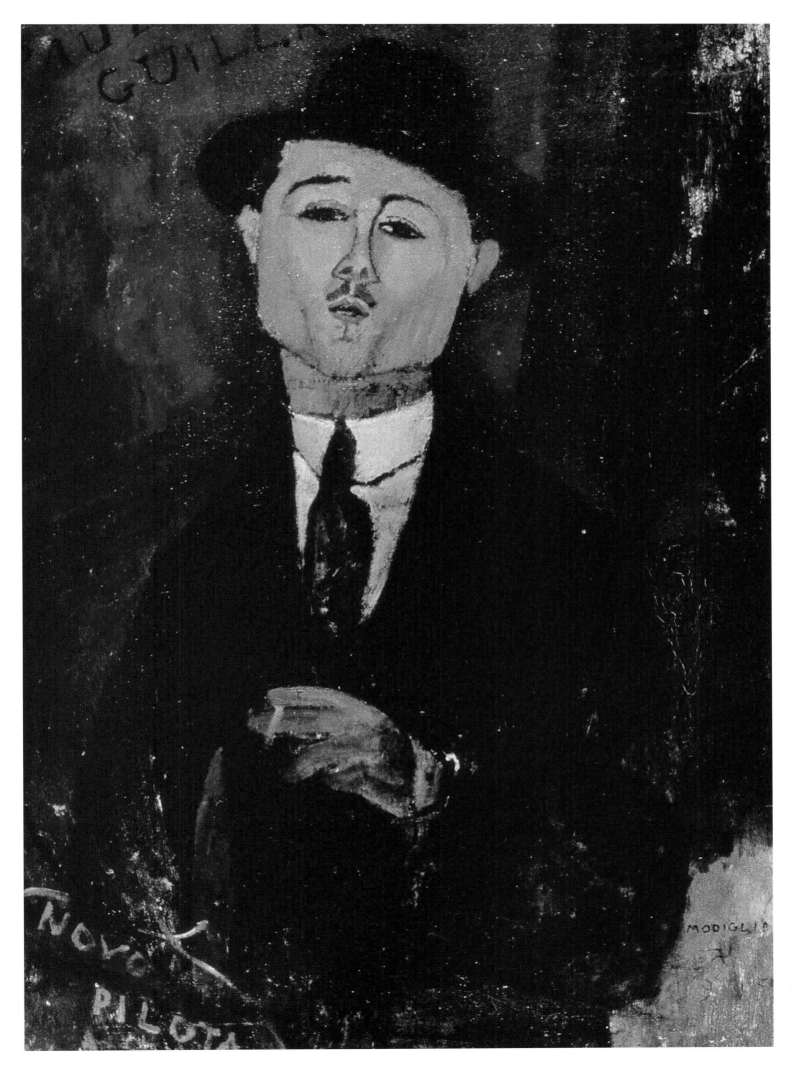

19.

The slight curve of the right leg where it bends at the knee is an enlivening and humanizing detail. The curious patterned lines across her belly suggest necklaces and emphasize the cone shape of her abdomen and the sexual triangle at the top of her thighs.

The *Standing Nude* (1911-12, p.69) no longer functions as a caryatid and is a true nude study, showing an architectural approach to the body. Her folded arms frame her heavily outlined breasts, while her face remains abstract and Africanized. The sketch of the *Seated Nude* (c.1910-11) is a fully realized nude drawing and shows the completion of Modigliani's transition from the caryatids to the true nudes. He allows the lines of the figure's body to swing in a more expressive approach to her eroticism.

Only one caryatid sculpture, *Crouching Caryatid* (1914, p.85), in limestone has survived. It is rough-hewn unlike the stone heads, so Modigliani may have abandoned it without finishing it, or possibly left it unrefined to give it a powerful appearance. Although her pose is similar to the caryatid drawings, the forms are massive and bulky, and less geometrical and more naturalistic in detailing. The treatment of the breasts and stomach show Modigliani's understanding of the underlying musculature and his interest in resolving solid forms at awkward points, such as the area between the breast, neck and arm.

The influences of Cézanne and Expressionism are clear in the harshness of the *Nudo Dolente* (1908, p.59), one of Modigliani's early nudes, which lacks the luxuriant sexuality of his later nudes. It is a disturbing rather than attractive image although the figure's upturned face with full, slightly parted lips and half-closed eyes hint at a state of frenzy, perhaps agony, perhaps pleasure. The painting illustrates Modigliani's willingness to experiment stylistically and express his intensity and passion.

In 1909 Modigliani, like many other artists at that time, moved to Montparnasse, where his friend Brancusi lived. The Café du Dôme on the south side of Montparnasse Boulevard was especially popular with German artists, while the Café de La Rotonde on the north side of the boulevard was a favourite haunt of the Japanese painter Tsuguharu Fujita (1886-1968) and his friends.

The influence of the innovative painters of the late 19th century, such as Paul Gauguin (1848-1903) and "Le Douanier" Henri Rousseau (1844-1910), could still be felt, while younger artists, such as André Derain and the Fauves, Pablo Picasso, Ossip Zadkine (1890-1967) and the Cubists, were creating their own styles.

The exchange of ideas must have been phenomenal, and art dealers and collectors, such as Paul Guillaume (1891-1934), whom Modigliani met in 1914, and Leopold Zborowski (1889-1932), who became friends with Modigliani in 1916, also frequented the area. Amidst this hotbed of ideas, Modigliani came to understand many styles before finding his own path. So fast was the pace of innovation that by the time Modigliani was developing his African-influenced Cubist style, the original Cubists were pursuing new ideas.

In his sketch *Caryatid Study* (p.8) a clear similarity to Picasso's *Les Demoiselles d'Avignon* can be seen in the angular pose, weighty raised arms, and use of differing viewpoints.

15. *L'Enfant gras*, 1915.
 Oil on canvas, 45.5 x 37.5 cm.
 Pinacoteca di Brera, Milan,
 legacy of Lamberto Vitali.

16. *Girl with Braids (The Pink Blouse)*,
 1917.
 Oil on canvas, 60 x 44.4 cm.
 Private collection.

17. *Renée the Blonde*, 1916.
 Oil on canvas, 61 x 38 cm.
 Museu de Arte, São Paulo.

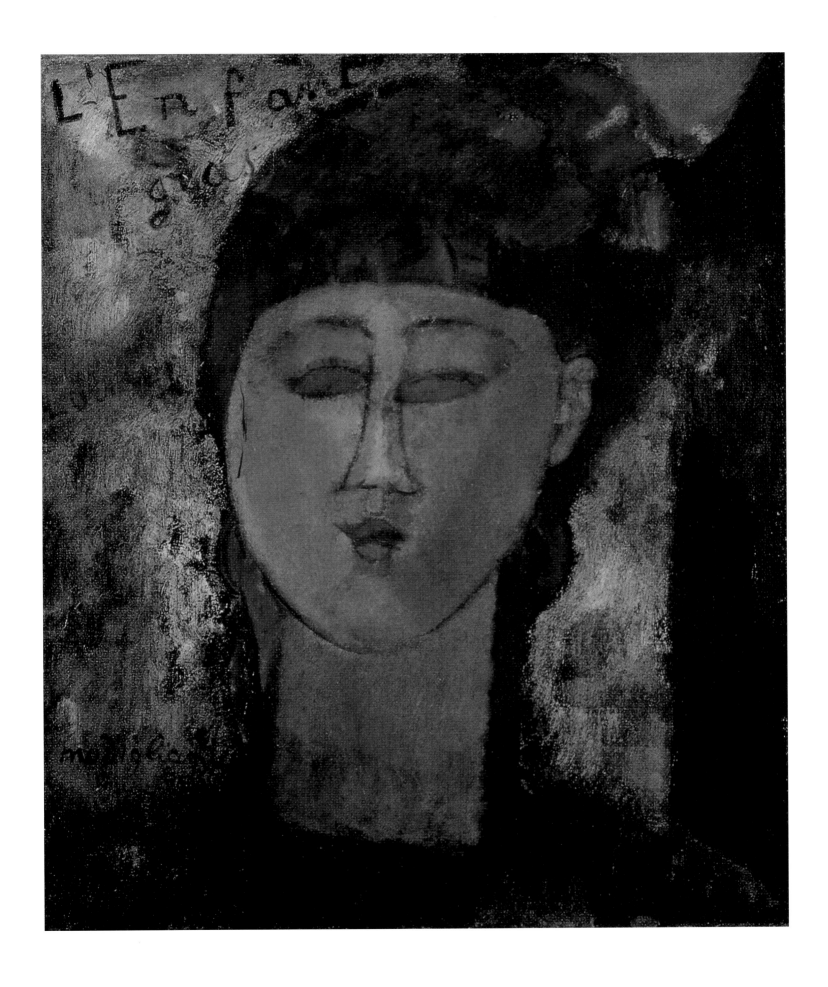

21.

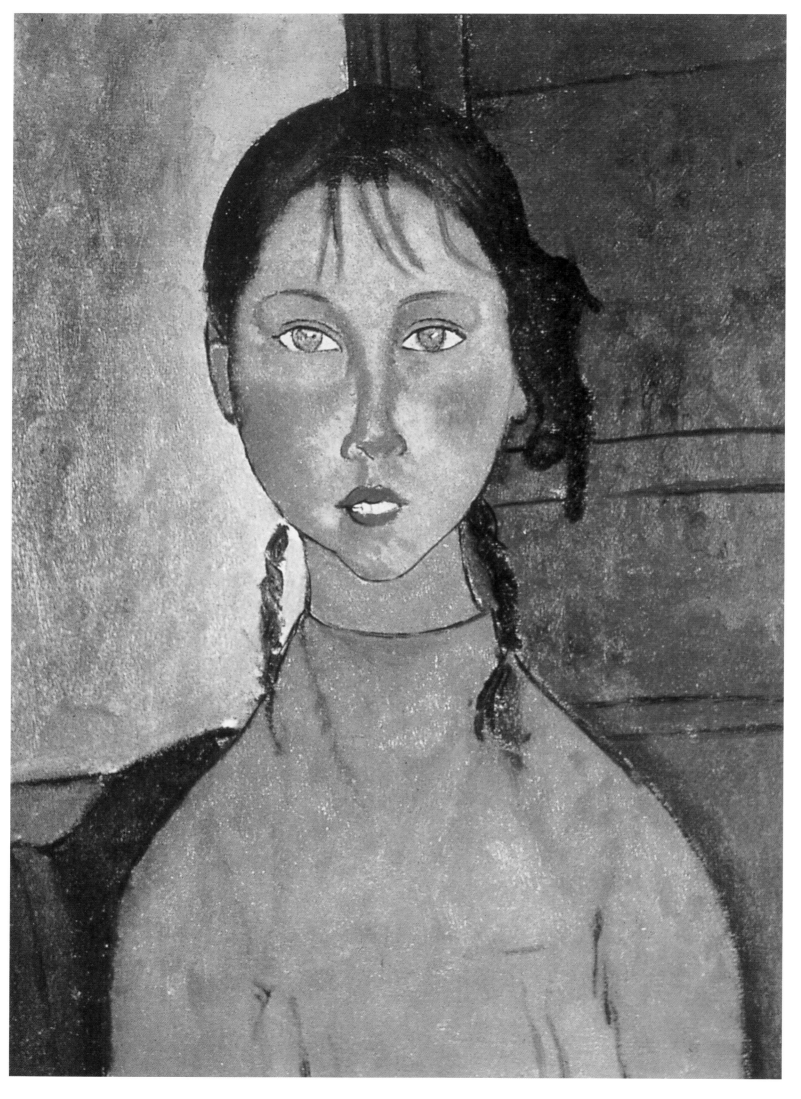

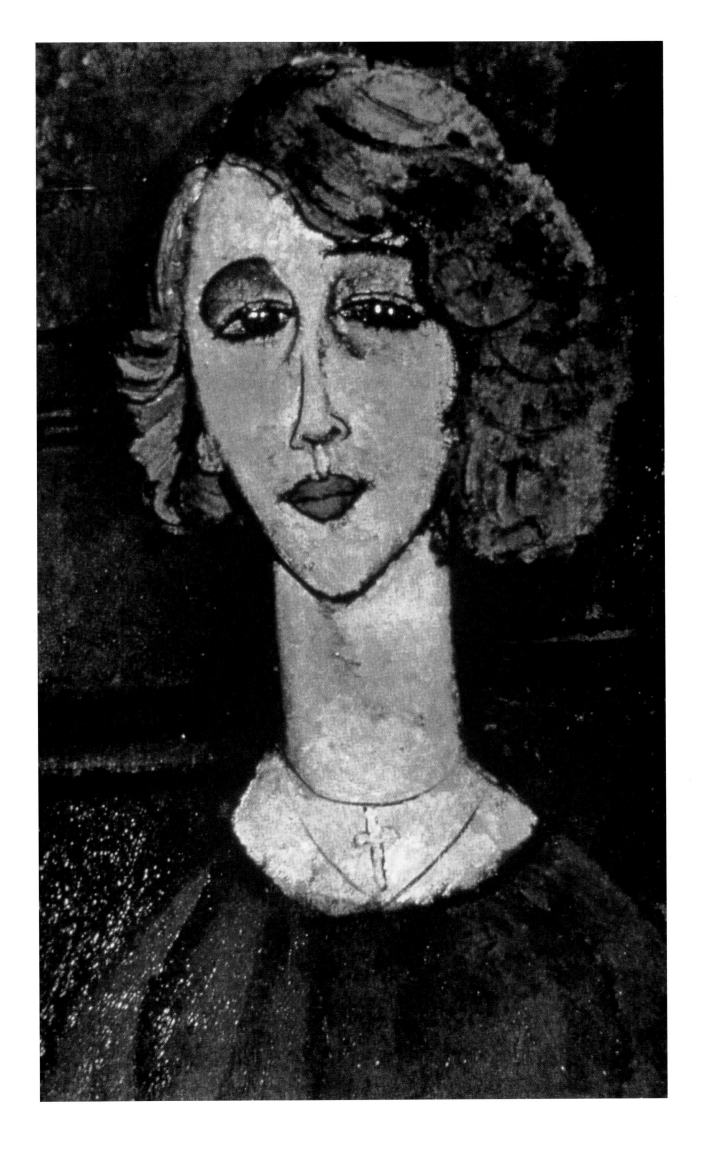

23.

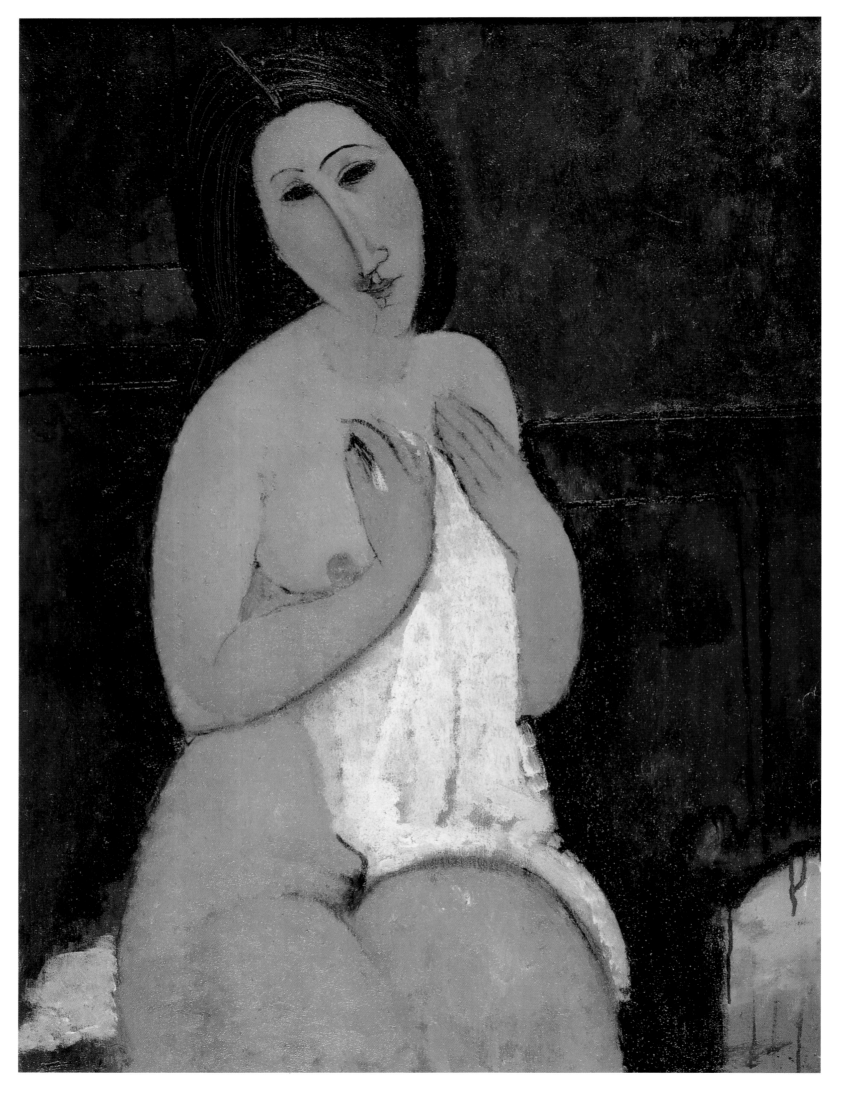

24.

The Nudes and Moral Values

Modigliani was fascinated by the way that outline can be used to represent volume. He wanted to translate the solidity of sculpture onto flat canvas while capturing the essence of classical elegance. This unwillingness to abandon the past led to criticism of his work by his avant-garde contemporaries, the Futurists, whose manifesto he had refused to sign.

The Futurists believed that art should concern itself only with modern styles and themes, such as machinery and motor cars. They thought Modigliani's paintings were too old-fashioned and they rejected the female nude because it was one of the standard subjects of traditional art. However, Modigliani's approach to the nude was so individual and innovative that traditionalists were shocked by his work.

An Unconscious Liberation

Goya's *Maja Desnuda* (1798-1805) had caused consternation because it depicted a real and well-known lady of the court. Modigliani adapted the composition for many of his nudes, for example *Nude with Necklace* (1917, p.102), *Nude* (1919, p.144), and *Sleeping Nude with Arms Open (Red Nude)* (1917, p.100) but Goya's painting has an aloof air and is deliberately posed, and so has a formality that is familiar from High Art. Modigliani avoids formal compositions, settings, and technique, so his nudes have a wildness and freedom that make them modern and striking.

Manet's *Olympia* (1863) was criticized when first shown, mainly because the model was an ordinary Paris prostitute, not considered a worthy subject for art, but also because she is gazing directly and openly at the viewer. This forces viewers to admit that they are admiring a prostitute, rather than allowing them to pretend that seeing a nude was an almost unintentional consequence of following a literary narrative or deciphering an allegorical scene. There is no ornate landscape or richly-drawn fabric to put Modigliani's *Nude* (1919) in a mythological or pastoral setting, even though she lies obliquely across the canvas with her right arm behind her head in a pose like that of Giorgione's *Sleeping Venus* (c.1508).

Nude on a Blue Cushion (1917, p.112) also borrows the pose of *Sleeping Venus*, but she is not demurely sleeping, unaware that she is being watched. Her full red sensual lips highlight both her attractiveness and her desire. This makes her more vivid and tangible than *Sleeping Venus* despite being less realistic in style. Manet's *Olympia* challenged the observer to enter into a visual transaction with the prostitute gazing back out of the picture. But the blue eyes of Modigliani's figure add to this challenge a disconcerting surrealism. Her blank eyes stare, but stare blindly, so she is both confronting the viewer and remaining oblivious.

Eyes were a potent image in Symbolism as the "mirrors of the soul," representing introspection as well as observation. Modigliani was a keen reader of Symbolist poetry, often reciting verses from memory, and would have seen symbolist works by such artists as Odilon Redon (1840-1916), Edward Munch (1863-1944), and Gustave Moreau (1826-1898) at the Venice Biennial Exhibition in 1903.

The gaze of Modigliani's empty-eyed nudes is perhaps their most unnerving feature, in contrast with both the passive and comforting averted or closed eyes of most classical nudes and Olympia's bold but recognizable stare.

18. *Seated Nude,* 1917.
 Oil on canvas.
 Private collection.

19. *Reclining Nude with Clasped Hands,* 1918. Oil on canvas, 64.7 x 100 cm.
 Private collection.

20. *Venus,* 1918.
 Oil on canvas, 99 x 64.7 cm.
 Private collection, Paris.

21. *Seated Young Woman,* 1918.
 Oil on canvas, 92 x 60 cm.
 Musée Picasso, Paris.

22. *Girl from Montmartre,* c.1918.
 Oil on canvas.
 Private collection.

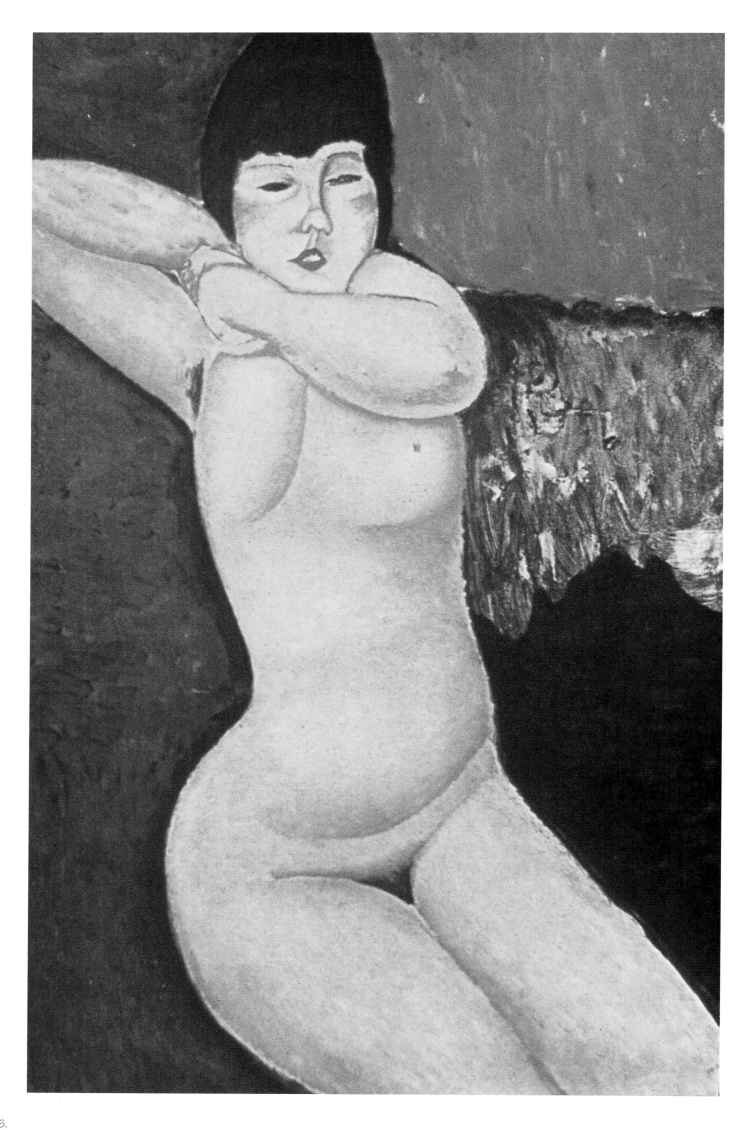

26.

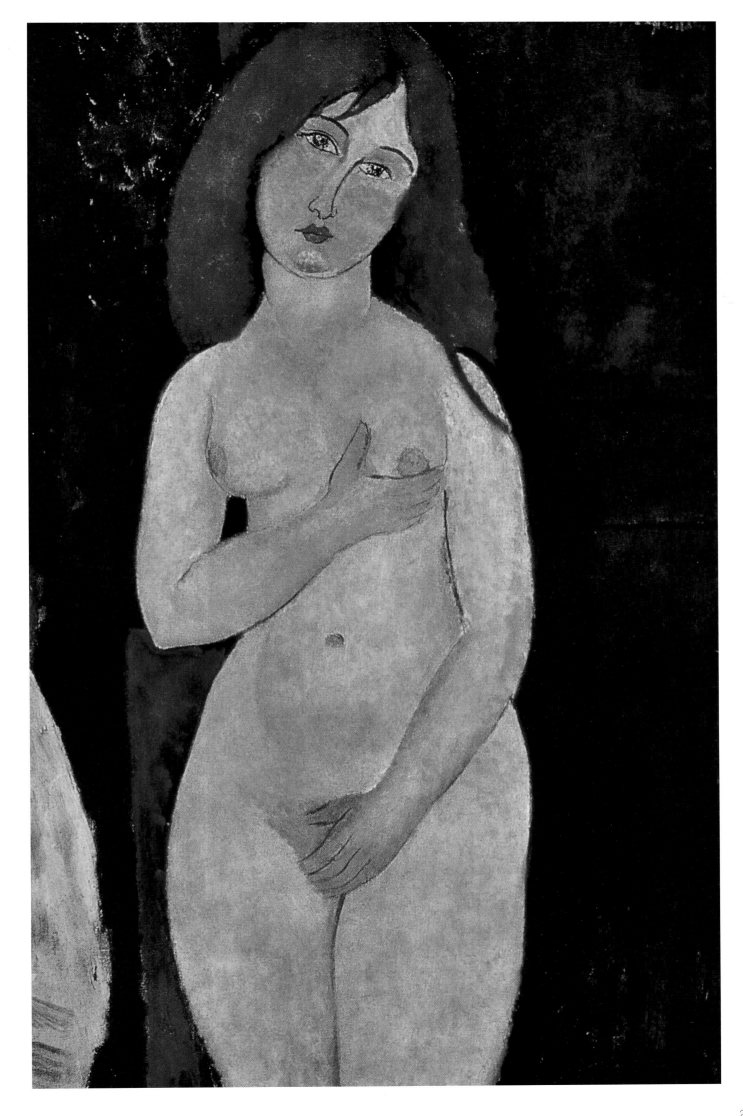

27.

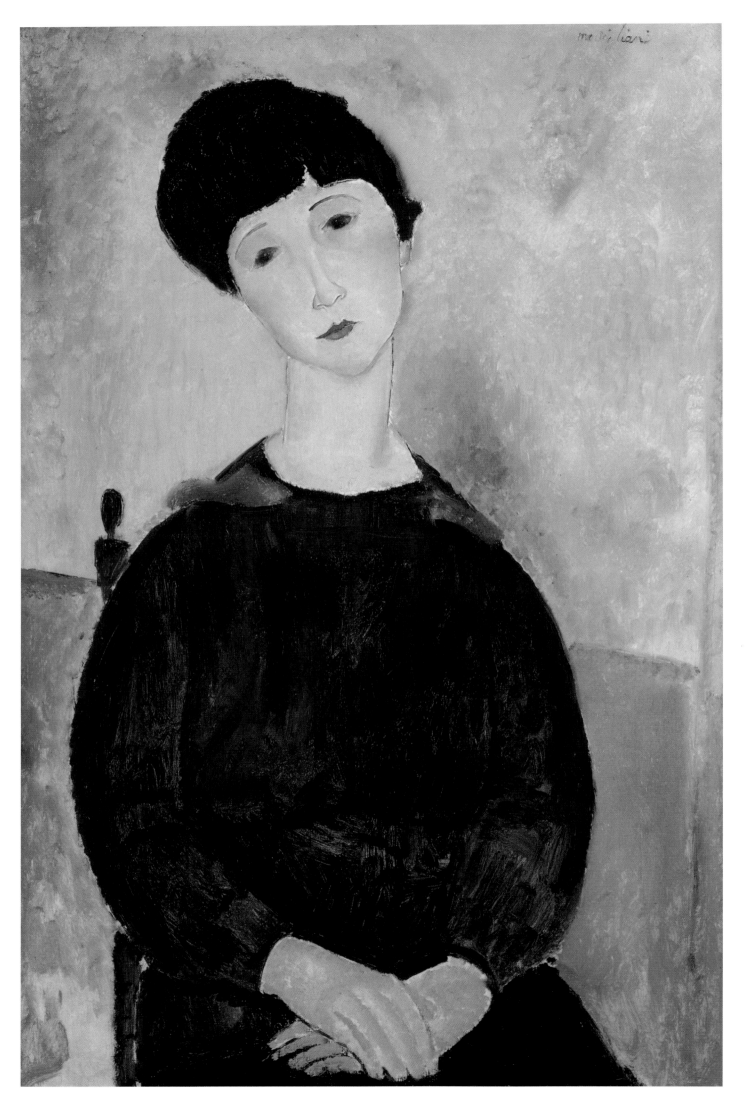

28.

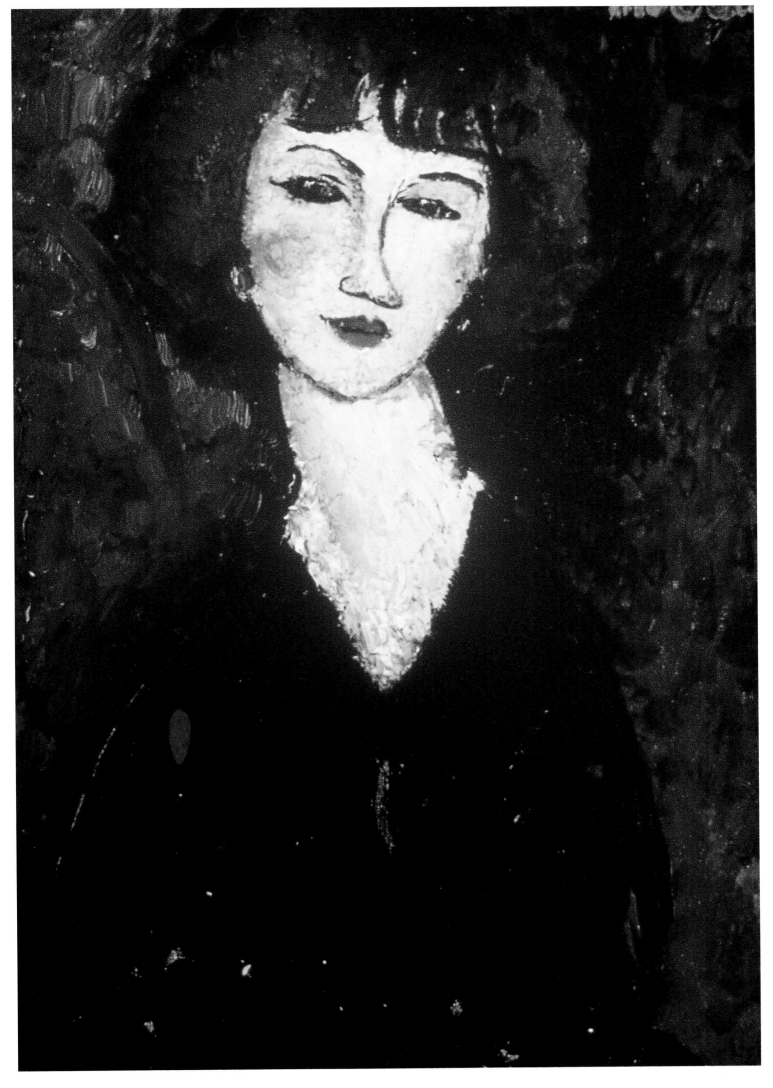

The cold, disinterested expression of *Nude Looking Over Her Right Shoulder* (1917) makes her seem annoyed that she is being watched. It is like the look of someone who has turned round to discover her photograph is being taken. She shares, in reverse, the pose of Venus in *The Toilet of Venus* (c.1645-1648) by Velázquez, but unlike Venus, who stares only at her own reflection, she is looking out of the picture, at the viewer. Meanwhile Modigliani draws the gaze of the viewer to her full hips and buttocks at the focus of the composition. The story goes that Modigliani met the ageing Impressionist Pierre Auguste Renoir (1841-1919), who described painting one of his pictures as repeatedly caressing the buttocks of the nude; Modigliani retorted rudely that he did not like buttocks. Indeed, most of his nudes are viewed from the front, and perhaps this explains some of the untypical tension of his painting.

Modigliani does not identify his models, so they may represent goddesses or prostitutes. The images therefore have to be considered purely in their own terms for they make no obvious social or political comment. This decontextualizing, however, was highly political in a society that was still largely governed by 19th-century prudery and strict social hierarchies.

Representations of nudity were considered morally acceptable only if they were presented according to the traditional artistic formulae which distanced the images from everyday life. This enabled people to enjoy looking at nudes while maintaining repressive attitudes towards sexuality in general. Modigliani was not a social élitist and considered the beauty and sexuality of ordinary women to be neither shameful nor an unworthy subject for great art. He does not add details or backgrounds to his nudes that would show them to belong to a particular social class or role.

This discourages the observer from making moral judgments about the status or lifestyle of the figures and so promotes a purely aesthetic approach. Such disregard for the old systems was threatening to those who feared female sexuality and bohemian liberality.

Manet's *Olympia* caused outrage because it celebrated a confident and unashamed prostitute. Most of Modigliani's nudes are not coy and demure like Giorgione's Venus or Titian's nudes. Their attitude, along with the reduction of narrative and subject matter to nothing but the erotic body, presented for its own sake, was considered scandalous. It is ironic that these works by Modigliani, who deeply respected and wanted to belong to classical tradition, were seen not as High Art but as outrageous depictions of naked women. The police, who closed down his first and only solo show, held at the Berthe Weill Gallery in 1917, expressed horror that Modigliani had painted the models' pubic hair, a tiny detail that nonetheless flouted artistic conventions. Earlier artists, such as Gustave Courbet (1819-1877), had taken delight in painting with such realism, but had not been allowed to show such work in public.

Modigliani did not see his nudes as the indulgence of private fantasies, and so did not see why they should not be put on public display. Clearly a great many people agreed. It was the crowd that came to see his show that drew the attention of the police. Modigliani's exhibition was closed down not simply because his paintings were deemed immoral but because they were popular. One of the first in his series of nudes, *Seated Nude* (1916, p.46), may be a portrait of Béatrice Hastings, an eccentric English writer with whom Modigliani had an affair from 1914 to 1916. She was very supportive of him, especially when he returned to painting having finally given up sculpture because of the expense of the materials and the irritation that the stone dust caused his lungs.

23. *Portrait of Pablo Picasso*, 1915.
Oil on canvas, 35 x 26.6 cm.
Private collection, Geneva.

24. *Portrait of Blaise Cendras*, 1917.
Oil on cardboard, 60 x 50 cm.
Private collection, Rome.

25. *Juan Gris*, c.1915.
Oil on canvas, 54 x 38.1 cm.
The Metropolitan Museum of Art, New York.

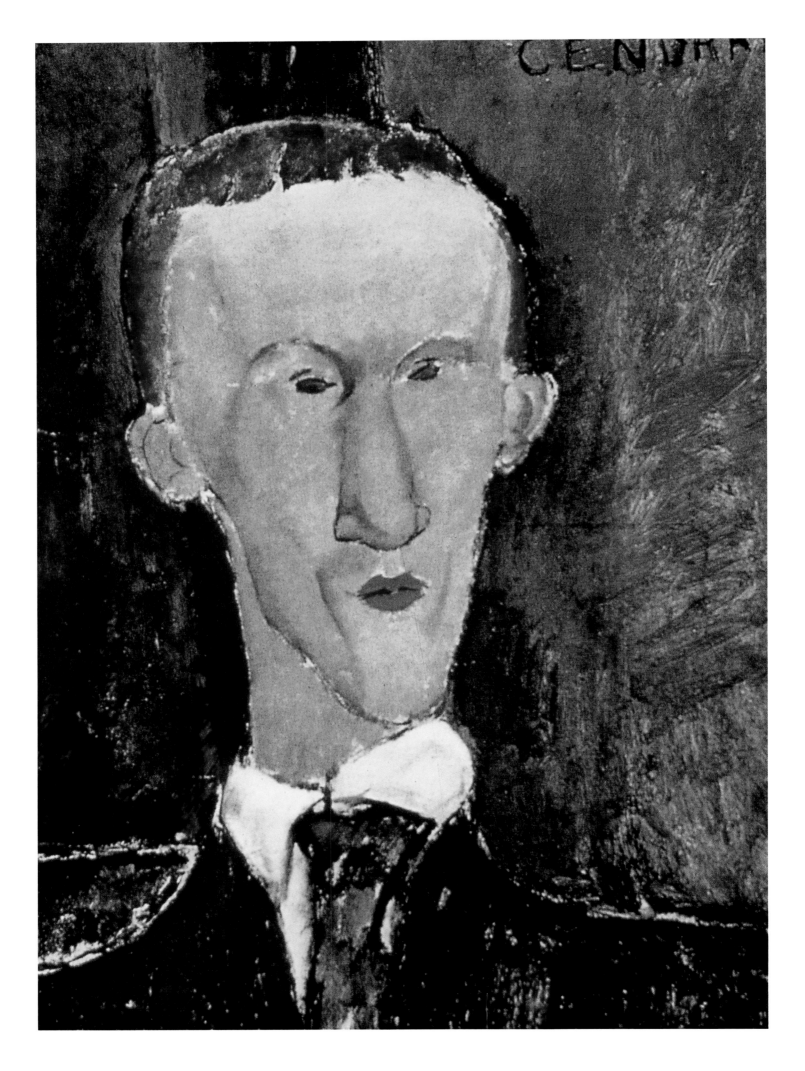

32.

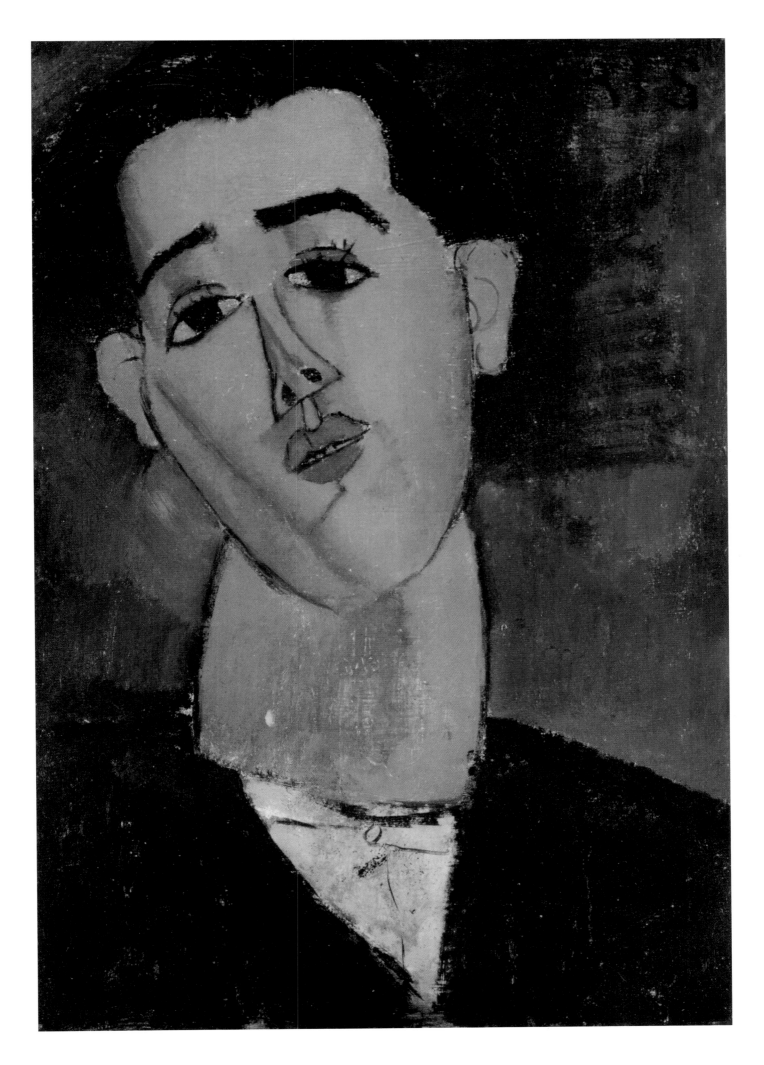

33.

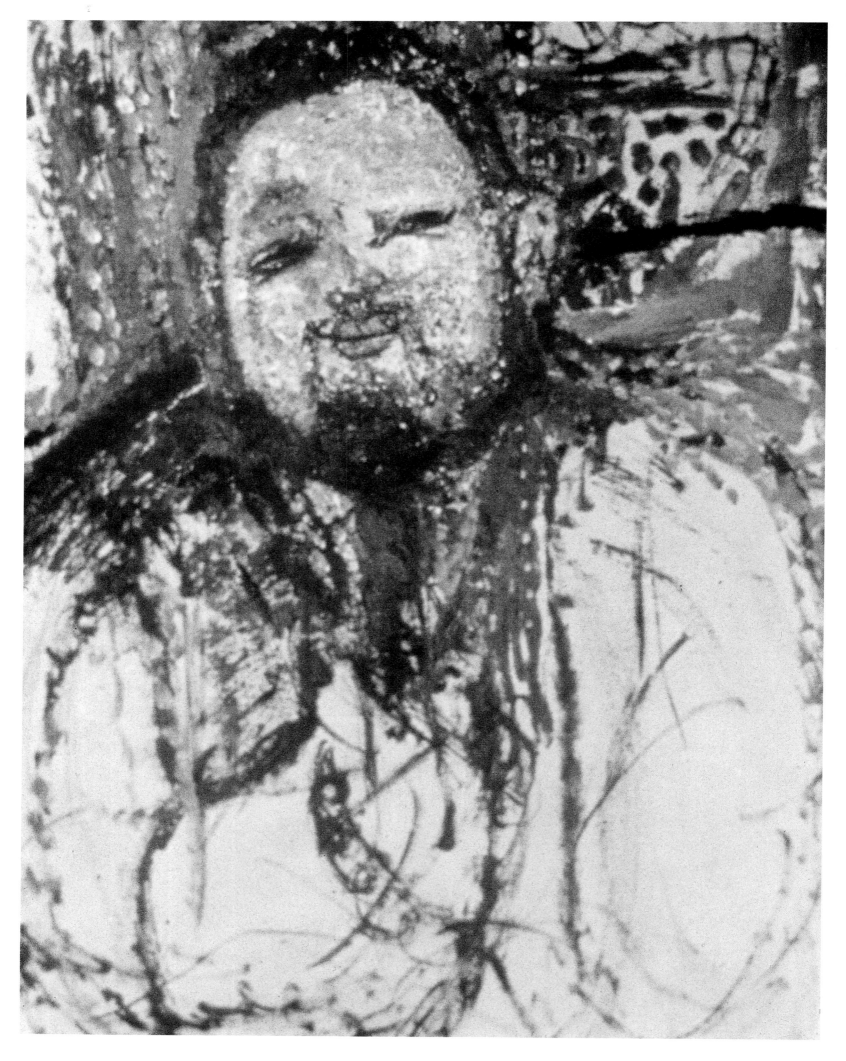

34.

The *Seated Nude* was certainly created with her encouragement. The outline is less sure than in later works: it is uneven and broken, and the head with its sharp chin sits rather awkwardly. The down-turned face functions to direct the viewer's gaze to the centre of the canvas and the centre of her body.

The fall of hair emphasizes the shape of the breast, and the delicate gradations of colour mark out the full roundness of the curves of her belly. She forms an elegant oblique across the canvas, the light to the left and the dark to the right, with just enough attention to the background to frame the figure without defining the space. Modigliani's attention to detail is only apparent in a few places, notably the pubic hair. The glowing use of colour gives the body vibrancy while the model herself sleeps.

The sketch *Seated Nude* (1918) also has a somewhat uncomfortable pose, with a dramatic twist to the stomach, an exaggerated *contrapposto*, and unresolved lower thigh. However, the feeling of motion and a youthful softness created by the delicacy of the curves give the figure a warmth and charm. The detailing in the upturned face is just enough to give her a sensuous, blissful air.

The *Seated Nude* (c.1918, p.111) is distorted and mannered, showing a Cubist influence. The shoulders, legs, and buttocks are not fully drawn, and the asymmetrical eyes make the image strange and less instantly appealing than *Seated Nude* (1918). However, there is a languid charm to the tilted head and the slackness of the body exudes relaxation. This conveys a dream-like eroticism that is all the more potent for its subtle portrayal.

A similarly odd atmosphere pervades *Nude on a Blue Cushion* (1917, p.112). Modigliani again does not complete the modelling of her legs but shows careful observation of the form of her breasts. Her quizzical and enchanting expression makes her seem awake and lively but her eyes are nonetheless unreal, so her seductive gaze is timeless and undirected. The heavy plasticity of her body owes much to Modigliani's experience of depicting the caryatids: her form is majestic and sculptural, while the composition is photographic – her legs and the top of her head cut-off and "out of shot."

The Art of "Close-Up"

Modigliani often takes a very close viewpoint for his pictures – far closer than most earlier painters of nudes. This was no doubt due to the influence of the new medium of photography, especially the erotic photography that was coming in to vogue. His use of this technique heightens the sense of physical presence of the figure and the artist's proximity to the model.

Modigliani cuts short the legs of almost all his nudes and many also have part of the head or arms cropped to create a snapshot effect. This device is particularly striking in *Sleeping Nude with Arms Open (Red Nude)* (1917, p.100).

By placing the model's body in the centre of the picture as if it is bursting out of the frame, Modigliani accentuates only the sexual aspects of the figure. Absolutely nothing else is of interest. The snapshot style makes the figure accessible as well as utterly dispensing with traditional rules of completeness in composition. Despite the careful brushwork and skilled use of delicate tonal variation, the overall effect is of effortless spontaneity – the complete opposite of the traditional notion that quality is the same as scholarly studiousness.

26. *Portrait of Diego Rivera,* 1914.
 Oil on cardboard, 100 x 79 cm.
 Museu de Arte, São Paulo.

27. *Jacques Lipchitz and his Wife,*
 1916-17.
 Oil on canvas, 78.7 x 53.3 cm.
 Art Institute of Chicago.

28. *Jean Cocteau,* 1916.
 Oil on canvas, 100.3 x 81.3 cm.
 Private collection, New York.

29. *Man with Pipe*
 (The Notary of Nice), 1918.
 Oil on canvas, 92 x 60 cm.
 Private collection, Paris.

30. *Portrait of Franck Burty Haviland,*
 1914. Oil on canvas, 61 x 50 cm.
 Private collection.

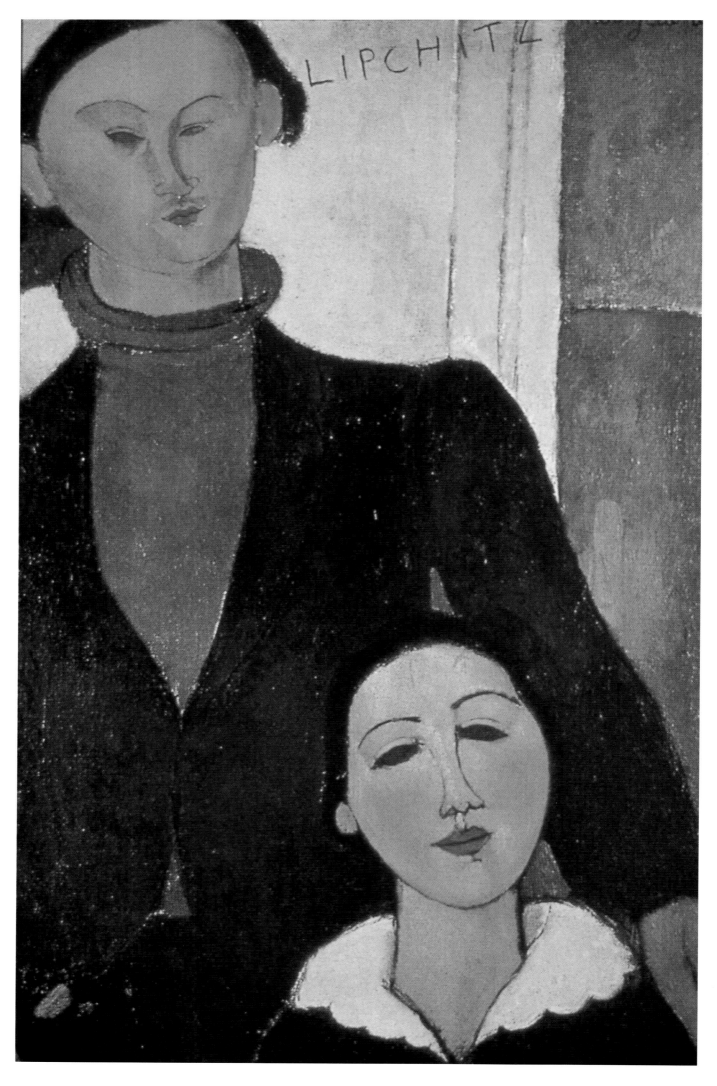

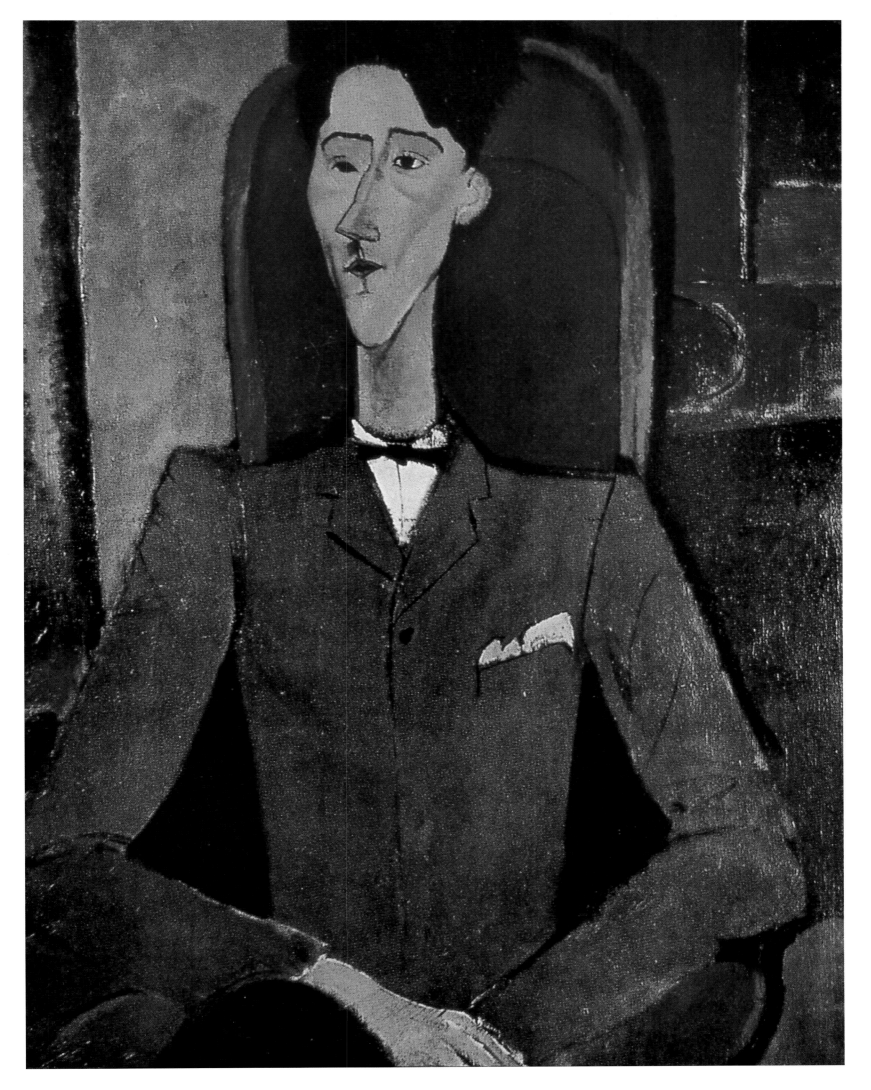

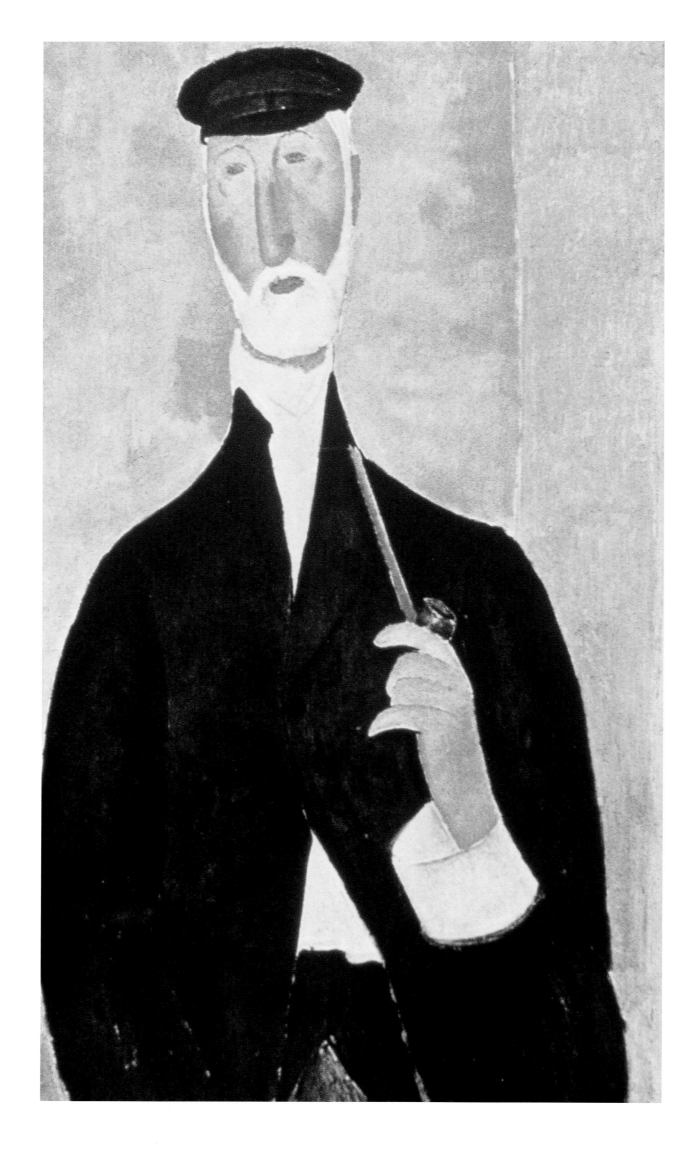

38.

39.

The spontaneous flamboyance of Modigliani's nudes made them appear all the more brazen and shameless to conservative eyes. The open enjoyment of the erotic that appears in his paintings was reflected in the sexual liberty of Modigliani's own life.

Even as a teenager he had a reputation as a seducer: when he was an art student in Venice he apparently spent more time in cafés and brothels than attending courses and in Paris he had numerous lovers, although there is little evidence and much speculation about his liaisons. He was said to have slept with all of his models, some of whom were well-known in the artistic community: Kiki, the Queen of Montparnasse, Lily, Massaouda la négresse, Elvira, the wild young runaway daughter of a Spanish prostitute, and Simone Thirioux, who bore him a son.

However, there are no nude paintings definitely identifiable as Elvira or Simone, and only one sketch that is definitely Béatrice Hastings. It is likely that he paid some professional models without having sexual relationships with them, and that he painted some of his lovers who were not professional models.

By the end of his series of nudes, Modigliani had reached the zenith of his style. He suggested volume with elegant arching arabesques and had achieved the utmost in simplification and abstraction. For example, *Reclining Nude* (p.105) shows Modigliani's full command of line. The outline is even and precise. The distortion of the hips is non-naturalistic but not jarring and hints at, rather than proclaims, the figure's sexuality. He has used a restrained palette, which gives the picture an air of tranquillity, and the artist's hand is masked by an ease of execution and delicacy of brushwork that adds to the transcendent atmosphere. She is bathed in a gentle light, and subtle tonal changes mark out her form so lightly that she appears to float against the dark background. The *Standing Nude (Elvira)* (1918, p.136) is called Elvira although Modigliani's affair with her had ended several years earlier. The model holds a folded cloth just low enough to suggest that she is completely naked, but this echoes, and perhaps even parodies, the suggested modesty of the great classical nudes.

She has a rigidly geometric pose and her full breasts are almost perfect hemispheres. Her blank gaze has a sense of boldness and is totally still. This gives her a monumental sculptural quality. The eroticism appears suspended and her personality is frozen. She is like a stone statue: not a real woman but merely a physical form, reified and depersonalized. Again, the absence of background detail adds to the timelessness of the image.

Emotional Involvement
A Depersonalizing Process

Despite depicting his models as particular individuals, Modigliani makes surprisingly little attempt to engage with them emotionally or to portray them psychologically. He maintains an objectivity and a distance as artist, especially in his later nudes, and does not overtly attempt to solicit any specific emotional reaction from the viewer. This allows the viewer a freedom of response, but also distances the artist from any direct involvement in that response.

Censors even as late as the 1940s and 1950s saw the paintings as obscene and pornographic, but Modigliani was not deliberately setting out to provoke such a response. Modigliani's unrepressed sexuality enabled him to express his desires with a carefree joy that borders on innocence.

31. *Gypsy Woman and Girl,* 1919.
Oil on canvas, 130 x 81 cm.
The National Gallery,
Washington.

32. *Le Zouave,* 1918.
Oil on canvas, 63 x 48.3 cm.
Private collection, Paris.

33. *Yellow Sweater
(Portrait of Mme. Hébuterne),*
c.1919.
Oil on canvas, 99 x 66 cm.
The Solomon R. Guggenheim
Museum, New York.

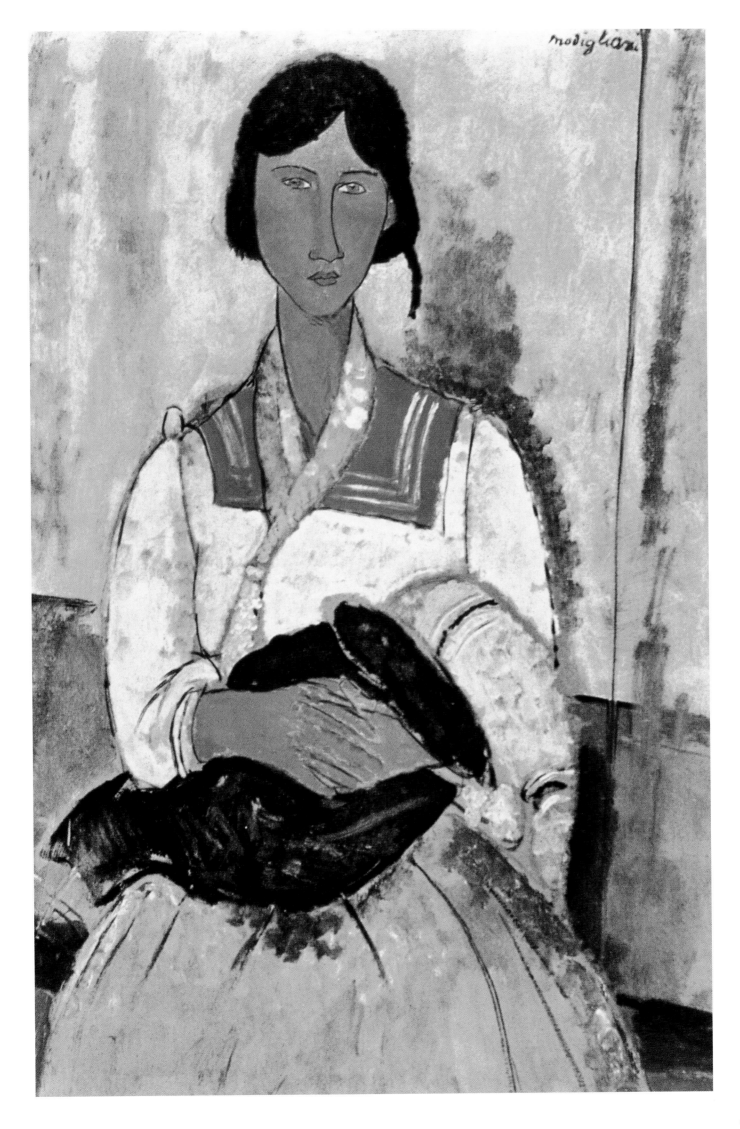

41.

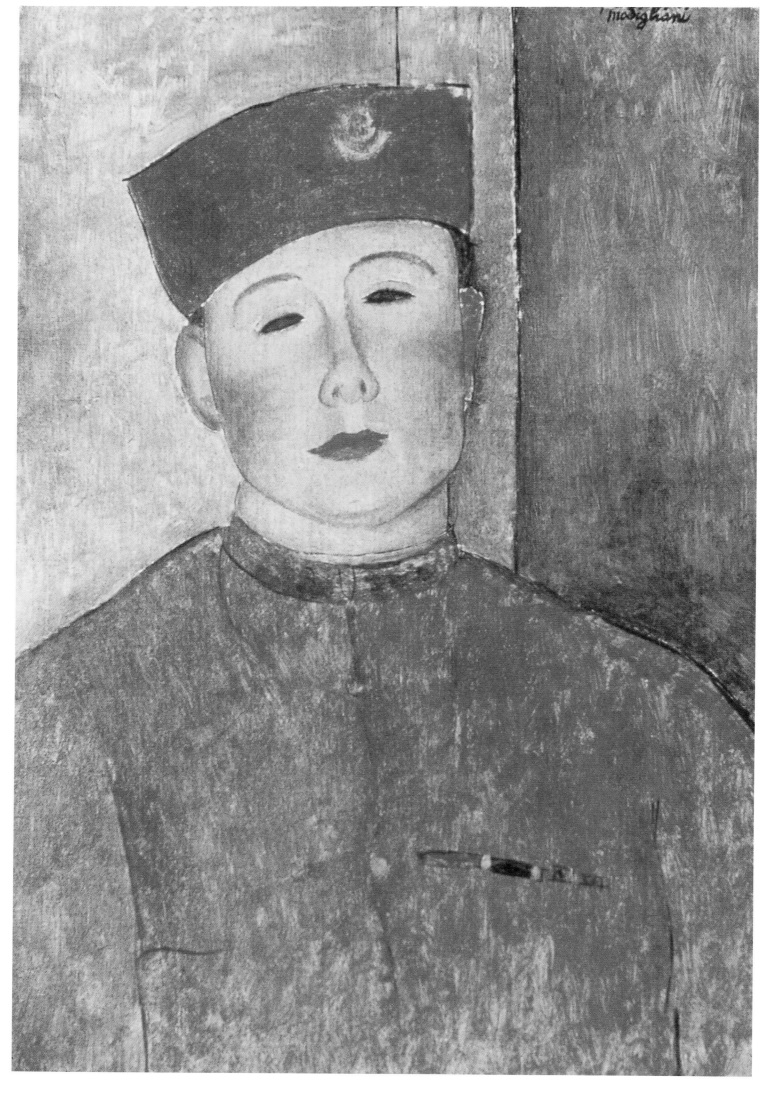

42.

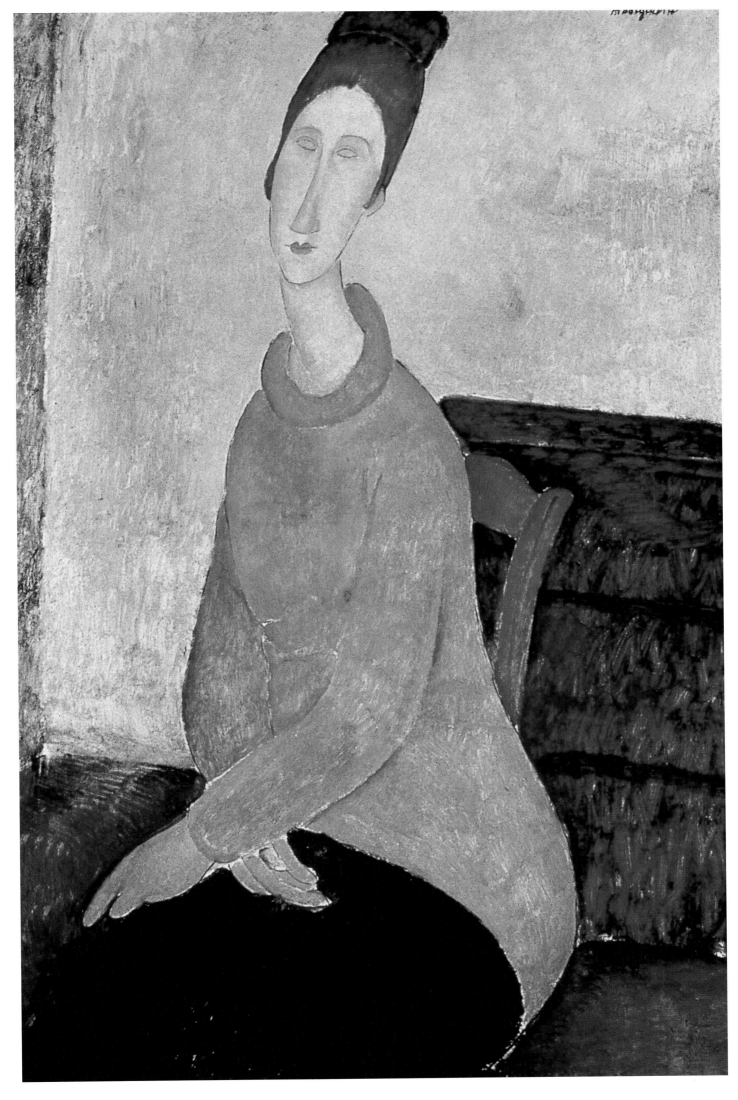

43.

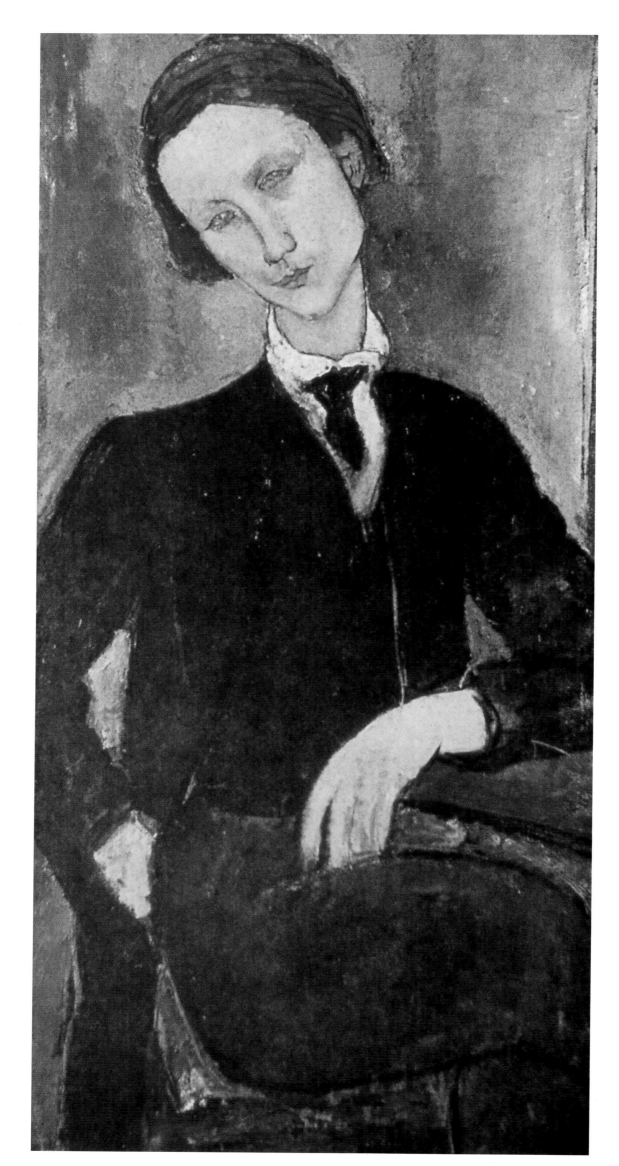

44.

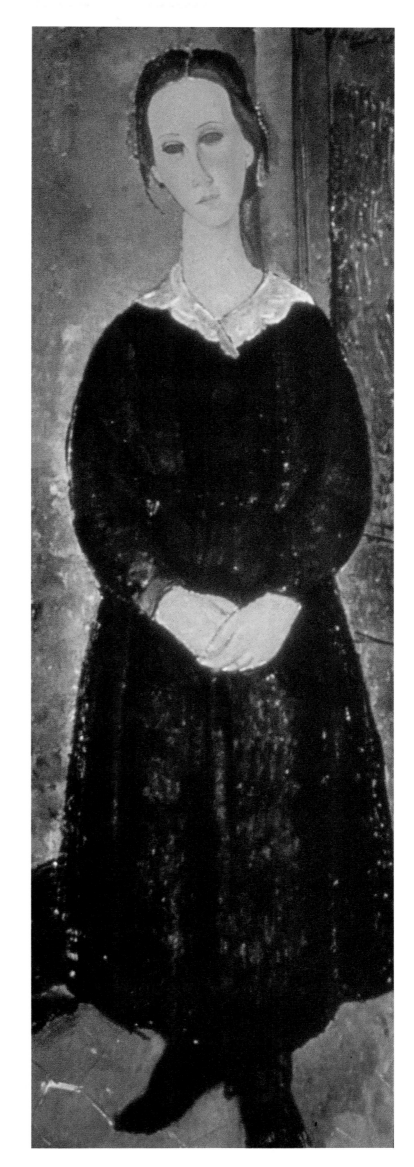

34. *Portrait of Monsieur Baranowski*,
 1918. Oil on canvas.
 Private collection, London.

35. *The Young Servant Girl,* 1919.
 Oil on canvas, 99 x 61 cm.
 Albright-Knox Gallery, Buffalo.

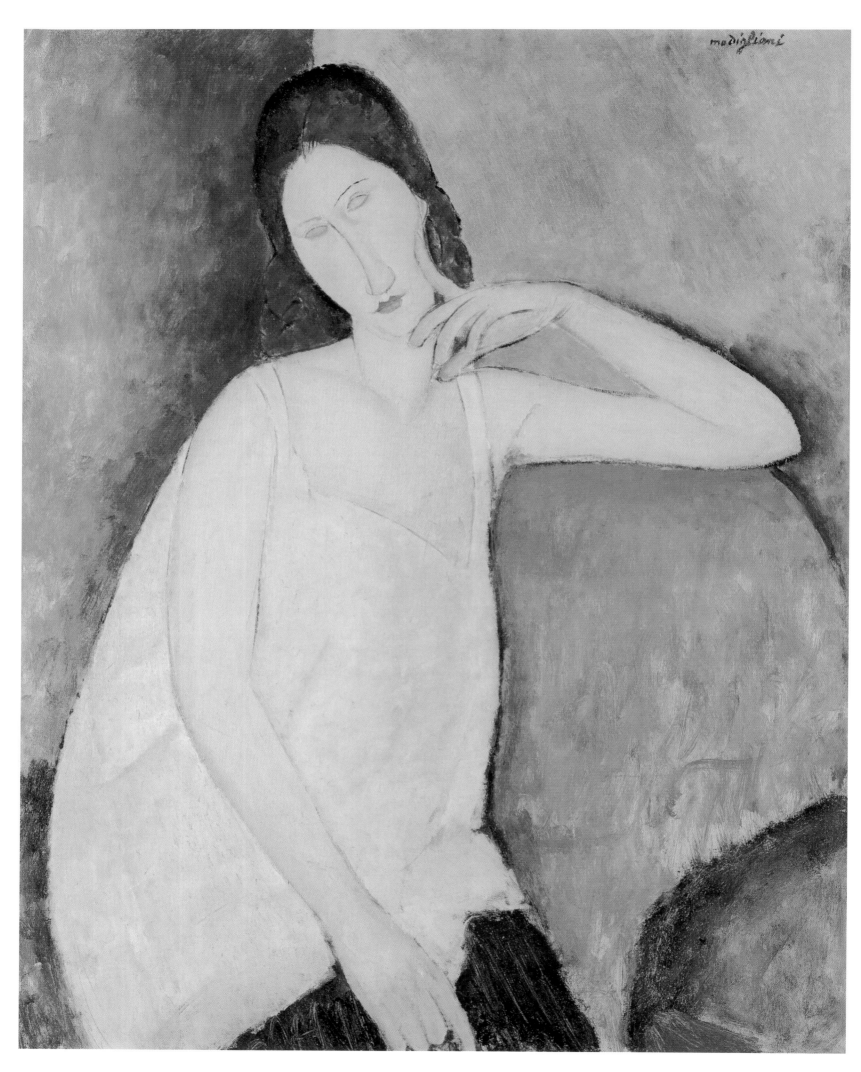

46.

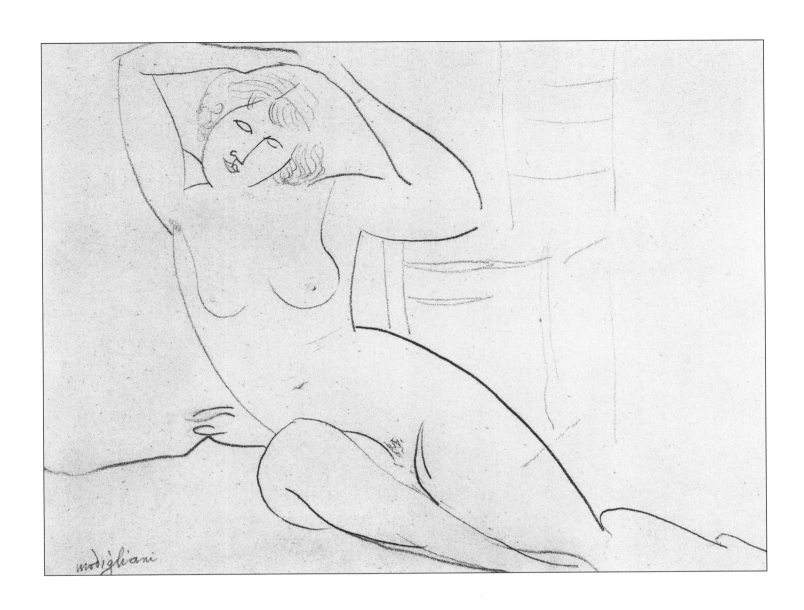

He was neither afraid of the sexuality of the models nor of his own libido, and so his nudes are not contaminated by the petty emotions that social oppression and mean-spirited moral condemnation encourage. For centuries, sleep had been a way of alluding to sexual fulfilment and many of Modigliani's models, especially the later nudes, are asleep. Those that are awake appear calm and unconcerned or have blank eyes and are lost in an introspective world, undisturbed by the observer. Modigliani is primarily interested in the shapes of the bodies of the models, not their characters, and the blank or closed eyes only serve to emphasize this disengagement. Blank eyes not only also represent the inner-directed gaze and introspection that fascinated Modigliani, but also constitute a comment on the nature of voyeurism and observation.

Unlike Edgar Degas (1843-1917), who almost always tried to show his models as unaware that they were being watched, Modigliani sometimes makes it clear that the model is looking back at the viewer, as does the *Nude Looking Over Her Right Shoulder* (1917).

Modigliani was also seeking to go beyond images of individuals to convey a timeless and eternal quality outside of everyday social morality and behaviour. This idea was inspired by the classical concept of beauty but also chimes with Cézanne's abstraction and reduction of complex forms to their simplest essences. Chaïm Soutine said of Cézanne, "Cézanne's faces, like the statues of antiquity, had no gaze."

36. *Portrait of Jeanne Hébuterne,* 1918.
 Oil on canvas, 91.4 x 73 cm.
 The Metropolitan Museum
 of Art, New York.

37. *Seated Nude,* c.1917.
 Pencil, 31.2 x 23.9 cm.
 Private collection, Chicago.

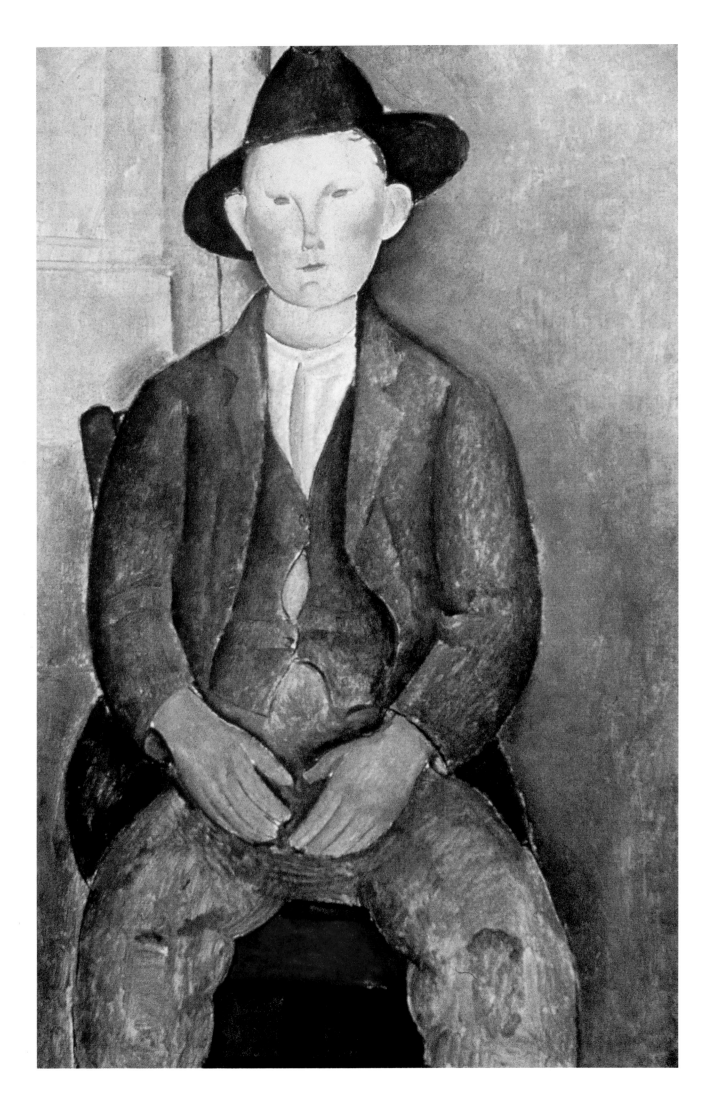

48.

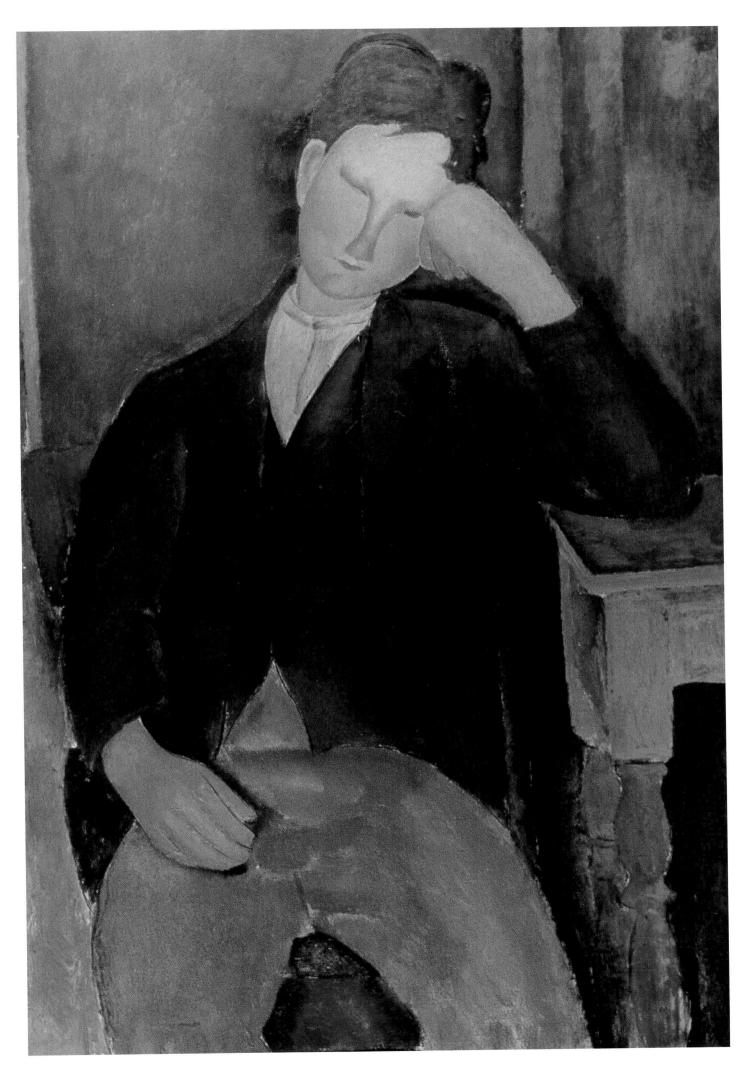

49.

Picasso, too, had looked away from the depiction of particular individuals in his studies of abstract African sculpture, hoping to find something more enduring in an image than the ephemera of one moment of one person's life. Modigliani's depersonalizing of his images can also be seen as part of this artistic aim, especially evident in the portraits that he painted while in the south of France, which include twenty-five of Jeanne Hébuterne. He said, "What I am seeking is not the real and not the unreal, but rather the unconscious, the mystery of instinct in the human race" (Doris Krystof, *Modigliani*).

An Aesthetic Quest

Modigliani's yearning for perfection in shape and form became an almost Platonic quest to find the essence of beauty beyond the attractiveness and sensuousness of the individual. He began to concentrate on balance, harmony, and continuity of form and to lessen the emphasis on heavy plasticity. He wanted to combine the solidity of sculpture with a weightless luminosity of colour and an elegance of line. This aesthetic aim went far beyond the expression of the eroticism of any single figure. The culmination of this endeavour can probably best be seen in his *Nude With Necklace* (1917, p.102), *Reclining Nude (Le Grand Nu)* (c.1919, p.146), and in *Nude* (1919, p.144). Modigliani's skill as a colourist and his precision of line are both evident, especially in *Reclining Nude (Le Grand Nu)*.

The detailing of the breasts and pubic region is more restrained than in earlier nudes, inspiring a gentler but less fleeting erotic response. *Standing Female Nude* (c.1918-19) has a floating grace and the detailing focuses on her face. The swinging line and full curves of her breasts are anatomically accurate, while Modigliani's mastery of line enabled him to use the fewest lines necessary to depict solidity.

By the end of his series of nudes he had mastered the depiction of the sensuality and attraction of the individual and had removed unnecessary idiosyncrasies to reveal only the abstract aspects of beauty. Having explored sexuality on a personal level he looked for the transcendent desire beyond the individual response, and was able to step back from the frenzied carnal intensity of his earlier works to create a less personal and so less evanescent eroticism.

His success in transforming the erotic energy and allure of one model at one point in time into an image that conveys the universality and endurance of human sexuality is perhaps Modigliani's greatest artistic achievement.

Conclusion

Modigliani's love of traditional Italian art and his view of himself as working within and developing this tradition meant that his nudes were not intended to be radical or confrontational.

However, he could not avoid his perceptions being affected by the avant-garde art that was being produced around him and he was inspired by similar influences. This led him to draw together the ancient and the modern, the traditional and the revolutionary. It was this blending of old and new, along with the intensity of his passion and his desire to express himself freely, that enabled him to create a new and unique vision. Despite the tragedy that often accompanied his own short life, his nudes are joyous and appealing and have remained some of the most popular in modern art.

38. *The Little Peasant,* 1919.
 Oil on canvas, 100 x 65 cm.
 The Tate Gallery, London.

39. *The Young Apprentice,* c.1919.
 Oil on canvas, 100 x 65 cm.
 The Solomon R. Guggenheim Museum, New York.

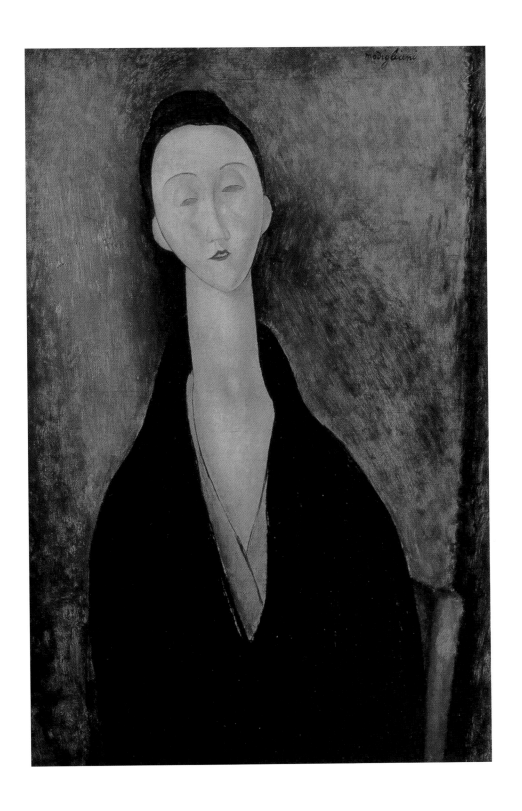

40. *Lunia Czehowska,* 1919.
 Oil on canvas, 80 x 52 cm.
 Museu de Arte, São Paulo.

41. *Seated Female Nude,* 1917.
 Oil on canvas, 180 x 62 cm.
 Private collection.

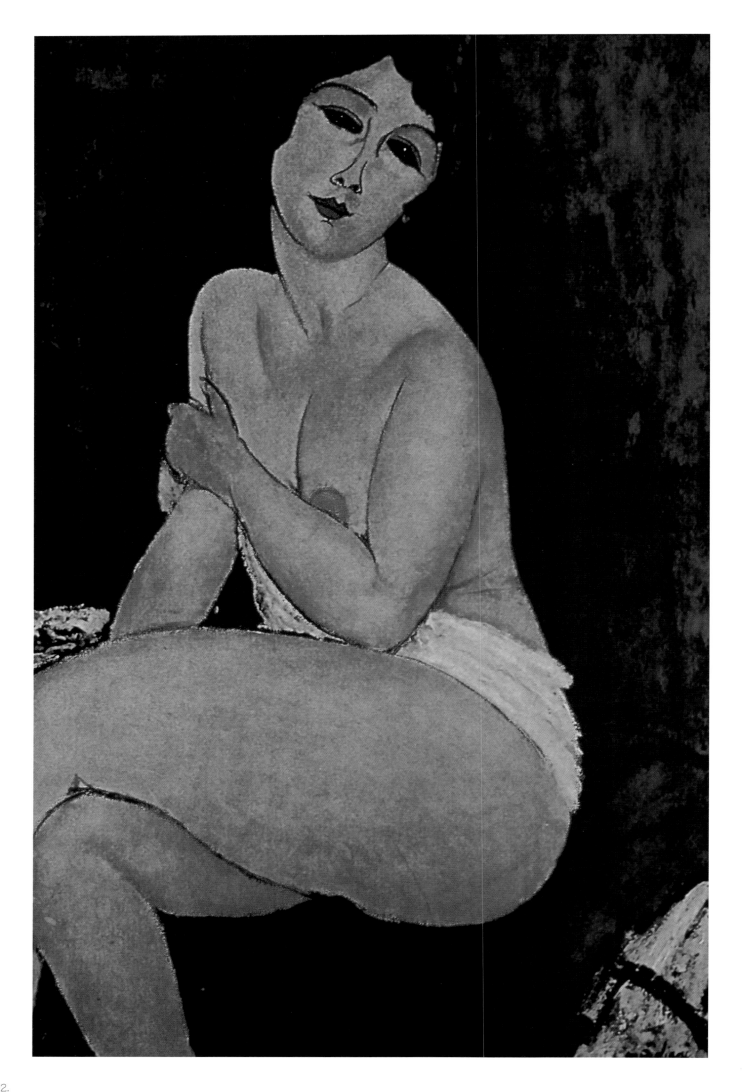

His Work

FEMALE NUDE WITH HAT

1907-08
Oil on canvas, 80.6 x 50.1 cm
Reuben and Edith Hecht Museum,
University of Haïfa, Israel

This early painting dates from Modigliani's first years in Paris. Although he spent much of his adult life in poverty, this period was characterized by extreme hardship, as is illustrated by the fact that in this example he has painted on both sides of the canvas: there is this nude on one side and a portrait, possibly of Maud Abrantes, on the other. There are few features here which one might immediately identify with the later works for which Modigliani is best known, except for the elongated neck. For the rest, the paint is laid on sparingly; the outlines are strong and roughly drawn, reminiscent of Cézanne. The attitude of misery and the harsh depiction of the model's face calls to mind the work of German Expressionists such as Munch.

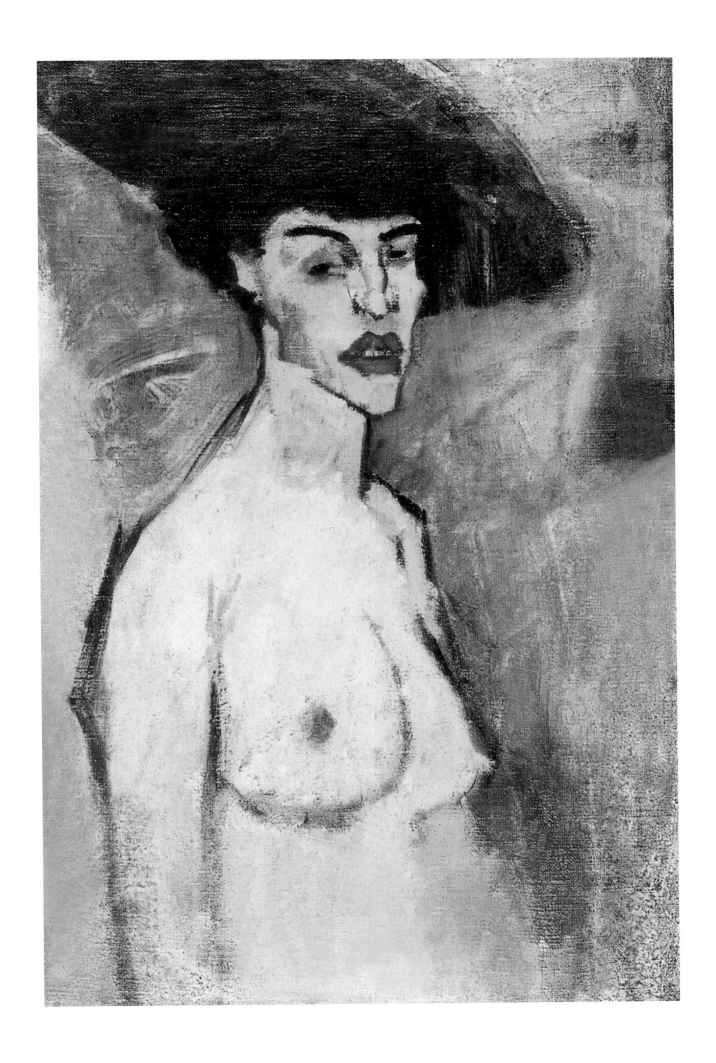

NUDE
(LA PETITE JEANNE)

c.1908
Oil on canvas, 61 x 38 cm
Perls Gallery, New York

Several of Modigliani's early paintings were predominantly blue, which immediately leads to comparisons with Picasso during the same period. However, there are already signs of the preoccupations which would later define Modigliani's art and distance it from that of his more avant-garde contemporaries: the model's eyes, although drawn in some detail, are blank at the centre and her face, whilst possessing certain very specific characteristics – a slight double chin, a perfect cupid's bow mouth, strong arched eyebrows – has a sculptural, almost mask-like quality which renders her a generalized, symbolic figure rather than presenting her as an individual. This search for a universal rather than an individual expression of the human form was characteristic of the Symbolist movement, which influenced the young Modigliani greatly, but it is also an element which comes to define a large part of Modigliani's later output.

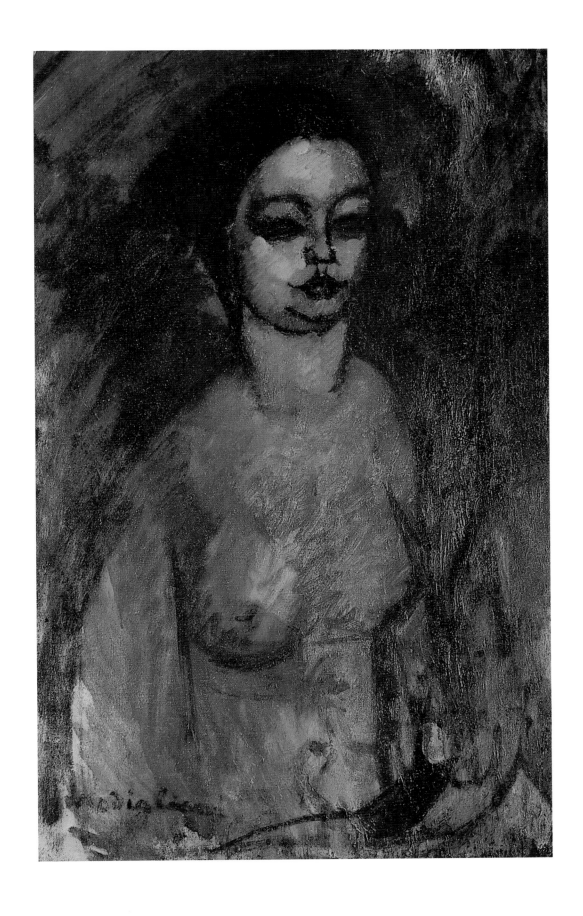

NUDE
(NUDO DOLENTE)

1908
Oil on canvas, 81 x 54 cm
Richard Nathanson, London

This painting could not be more different from those later nudes painted between 1917 and 1919 for which Modigliani is best known. This example clearly demonstrates the influence of the expressionistic style that was dominant in the early 20th century, typical of artists such as Munch or other German Expressionists. The nude, typically a passive, sensual or overtly sexual decorative figure is here transformed into an expression of pain, poverty, even illness or depravity. The paint is applied roughly, scratchily; in parts it looks almost unfinished. The woman's torso is elongated, almost skeletal in its thinness, the breasts are slightly lopsided, the arms exaggeratedly long. There is an enormous, furious tension between the usual sexual associations of the model's pose – her head leaning back, eyes closed, mouth half open – and the animalistic expression of pain and squalor suggested by her body that make her more reminiscent of a martyred saint than a sex object.

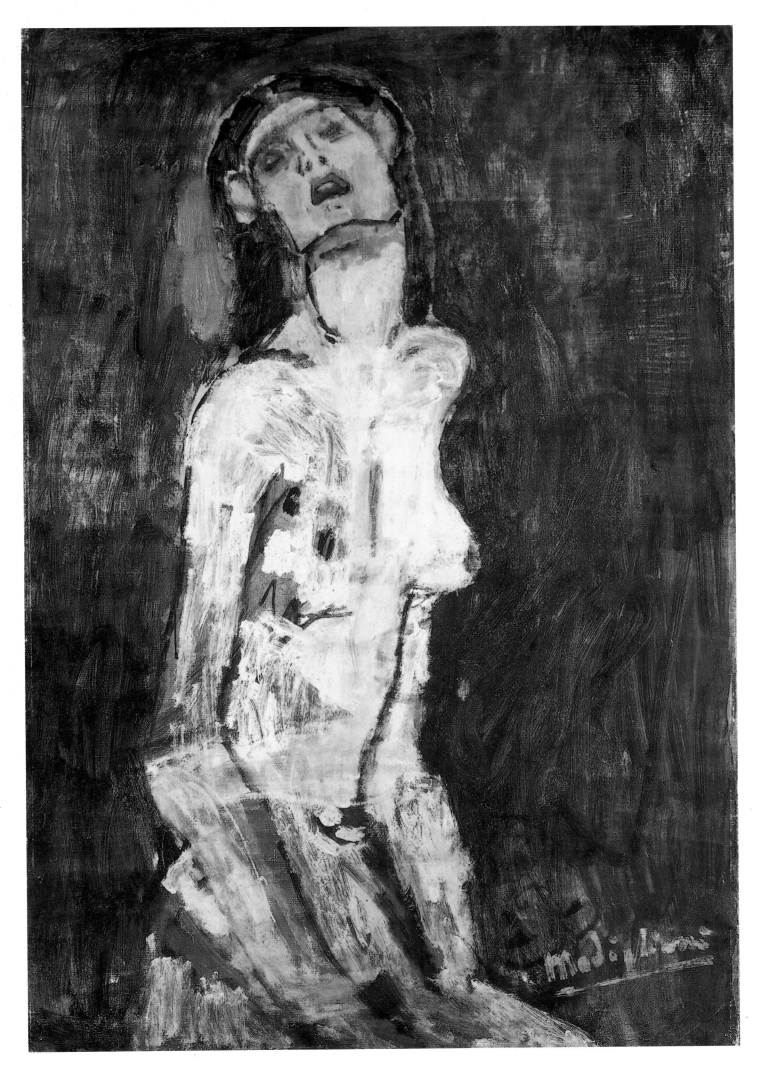

59.

THE BEGGAR OF LIVORNO

1909
Oil on canvas, 66 x 52.7 cm
Private collection

Modigliani painted this picture during a visit to his family in Livorno to recover from a bout of the illness which was to dog, define and finally prematurely end his life. In utter contrast to the strictly interior nature of his Parisian work, here we can sense the Mediterranean sunshine and warmth outside: there is a window visible in the background – an element that rarely reappears until the paintings of his last two years – and the style, with its light, rough brushwork and palette of blues is clearly reminiscent of the work of Cézanne. There is a suggestion that the portrait is based on a 17th-century Neapolitan picture which the family had recently inherited. However, there is no proof of this and it is equally possible that, just as Modigliani in the last two years of his life painted local villagers as his subjects, the artist could have done the same here.

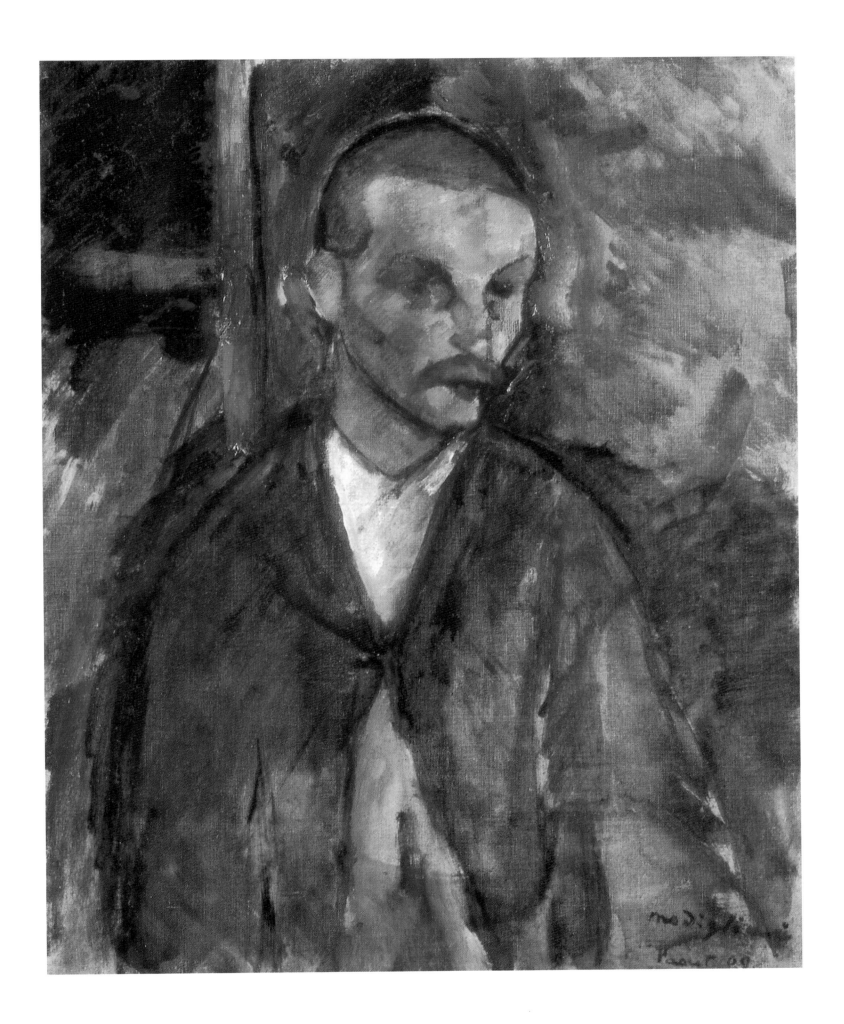

61.

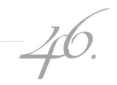

THE CELLIST

1909
Oil on canvas, 130 x 80 cm
Private collection

This is one of a series of portraits of cellists which Modigliani painted in 1909. It was exhibited at the *Salon des Independants* in 1910 and clearly demonstrates the influence of Cézanne on the young artist in the fluidity of its paintwork and the thick black outlines. The detail of the setting – the clear context of the room, the chair, the table in the background – is an element which later became extremely rare in Modigliani's work, who depicted most of his subjects in a virtually contextless setting. It is interesting to note that one of Modigliani's weakest points was in the depiction of hands – here he cannot avoid showing the cellist's fingers curved around the bow, but they are clumsily executed.

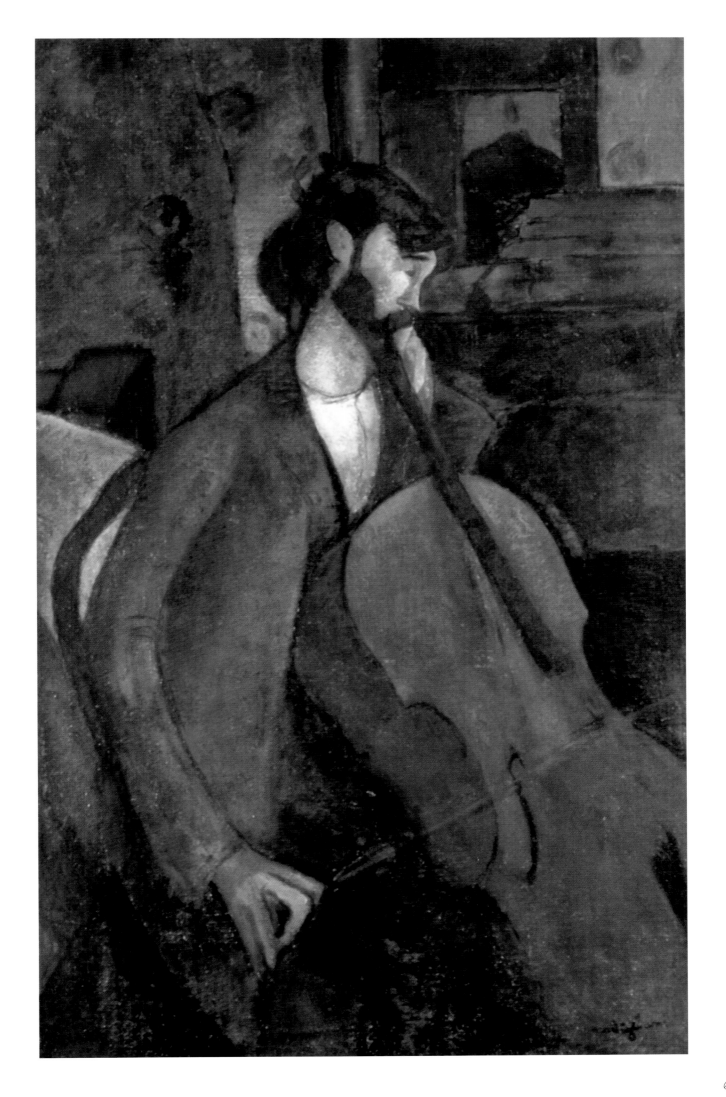

63.

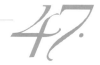

HEAD

1911-13
Sandstone, 64 x 15 x 21 cm
Solomon R. Guggenheim Museum, New York

This is one of several sculpted heads from this period. It appears that Modigliani's aim may have been to exhibit the heads as a group: seven of them were shown at the *Salon d'Automne* of 1912 to great effect. It also appears that the heads were designed with an architectural purpose in mind, since the back of the head is flat, unsculpted, as if intended to stand against a wall. The style of the head is strikingly similar to the head of the one existent standing sculpture, save here Modigliani has given the head a tiny pouting mouth which is perhaps the least successful element of an otherwise powerful, elegant figure of striking universality. Modigliani, like most avant-garde artists of his generation, was deeply influenced by the so-called 'primitive' arts of Africa and Oceania. The absence of overt emotion and of individual features, the immobile, almost expressionless face come directly from these traditions where the human figure is presented symbolically rather than as a representation of an individual human being as was the case in most Western art, and it is interesting to see the way in which Modigliani carried these influences into his later painting.

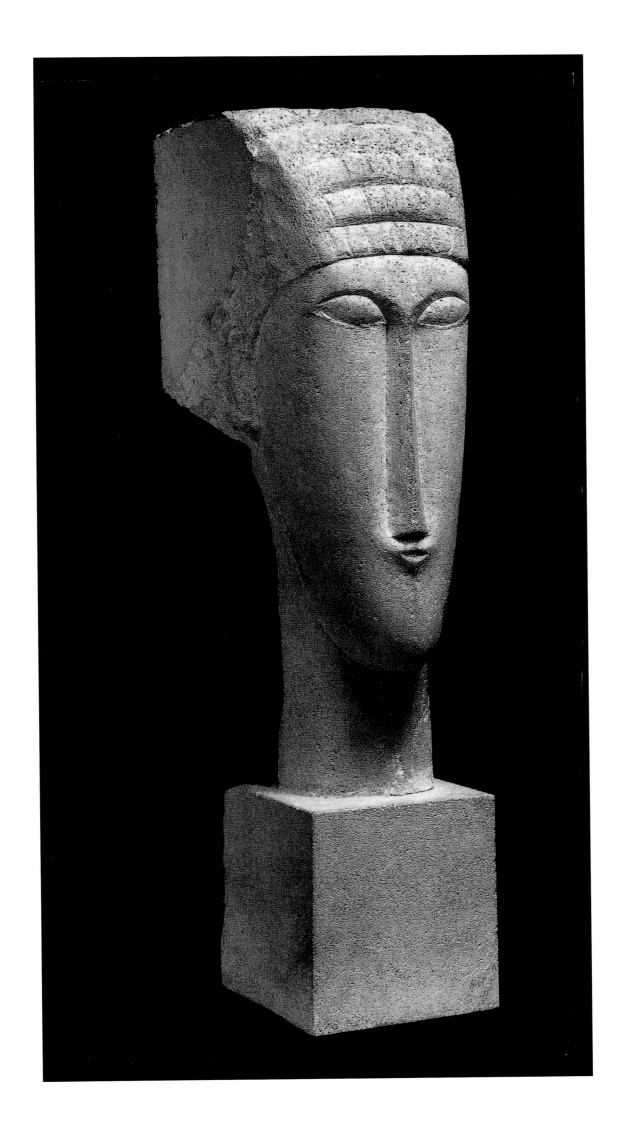

65.

CARYATID

1911-12
Oil on canvas, 72.5 x 50 cm
Kunstsammlung Nordrhein-Westfalen,
Düsseldorf

Modigliani planned to create a temple of beauty with hundreds of caryatids. It was never built, but the sheer number and variety of drawings which he produced during his years as a sculptor suggest that, rather than being preparatory sketches for one specific sculpture, many of them are ideas for later sculptures which were never realised. This example bears a close resemblance to the *Crouching Caryatid* of 1914. The face, as in many of these drawings, bears a resemblance to ancient Egyptian or Mycenaean sculpture. The body is divided almost geometrically into its constituent parts. The arms are elongated and powerful, the torso long and curved at an angle that could never be sustained in stone – the distribution of weight at the base would simply cause the figure to break or topple. This is in no way a sensual portrayal of woman: it is a vision of strength and serenity.

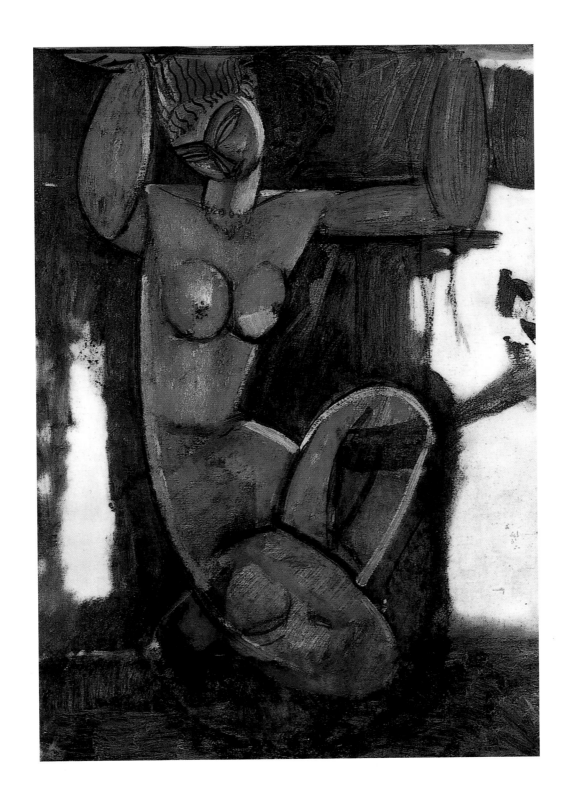

67.

STANDING NUDE

1911-12
Oil on cardboard on wood, 82.8 x 47.9 cm
Nagoya City Art Museum, Japan

This oil sketch is one of a series of preparational drawings for Modigliani's only surviving standing sculpture of 1912-13. It is unusually detailed, and provides a fascinating set of reference points to compare against the sculpture itself. Whilst the position of the arms folded across the stomach is in the drawing very square, similar to ancient Mycenaean sculptures Modigliani may have seen, in his own sculpture he makes the arms completely curved, thus much less realistic, but forming a pleasing symmetry with the curve of the stomach and hips below. The details of beads around the waist and neck, the depiction of the eyes and hair in the drawing are all gone in the sculpture, the elongated face and nose of which actually conform much more to Modigliani's own paintings. It is impossible to know whether the drawing is a copy of a work he may have seen somewhere, or whether it is simply one version, complete in its own terms, of many versions which Modigliani experimented with during the years which he spent devoted to sculpture.

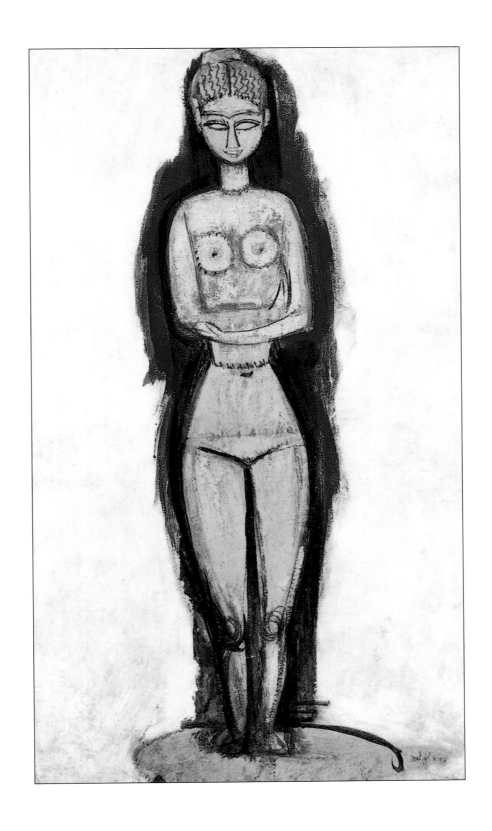

CARYATID

c.1912
Oil on canvas, 81 x 46 cm
The Sogetsu Art Museum, Tokyo

This is almost certainly one of a series of drawings made by Modigliani in preparation for a temple of beauty which was never realised. This and the following illustration (no.26) look as if they were designed to belong to an entire series of standing figures, each of which would be distinguished by small, subtle variations. In this example, the figure stands with slightly bent knees, head inclined forward in an attitude of polite submission. There is jewellery around her forehead, neck and waist, suggesting perhaps an Indian influence, her breasts are depicted in a stylized manner as two perfect circles high up on her chest, and her torso is elongated in the extreme. She looks like an elegant dancer.

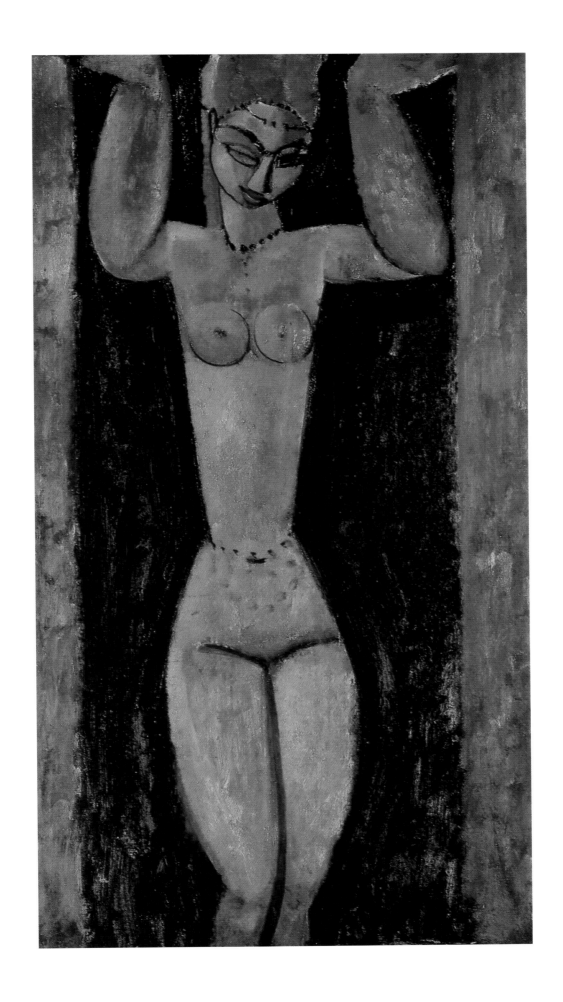

51.

STANDING FIGURE

c.1912-13
Limestone, 163 x 32 x 30 cm
Australian National Gallery, Canberra

This standing figure is one of only two surviving large-scale sculptures, the other being the crouching caryatid. Modigliani spent a long time working on the sculpture, a process he found physically exhausting: the dust troubled his weak lungs, and his lack of experience in working with stone made the work doubly exacting of his limited strength. In the final work, the bulk of the weight of the statue rests on the legs. Looking at one of the preparatory drawings (illustration no.18), we see the legs tapering inwards towards the base; in a later drawing (illustration no.19) both the face and legs are far closer in style to the sculpture. Whether the bulkiness is a matter of choice or the result of an inability to make the sculpture stand otherwise is not known. The arms curve around the body to form a circle that provides a harmonious echo to the roundness of the stomach (delineated like the breasts as a separate rounded mound) and hips. The face is similar in style to the heads which Modigliani was carving at the time.

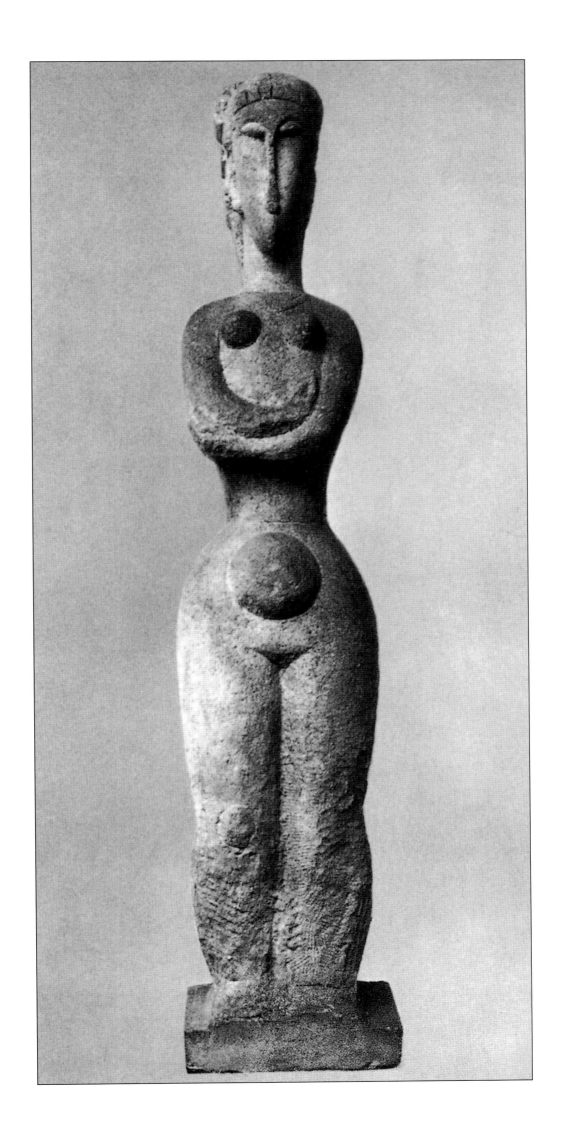

73.

52.

CARYATID

1913-14
Pencil and tempera on paper, 90 x 70 cm
Private collection

I t is incredibly difficult to establish the chronology of Modigliani's sculptural work, let alone the drawings he did during the same period. This detailed drawing could have been made in preparation for the crouching caryatid sculpture. It shows an extraordinary level of elongation of the torso, with the upper body twisting round so that the arms support the temple roof to one side of the head. This is a pose reminiscent of Indian art, where the figures are often drawn as elongated and exaggeratedly twisted to form a beautiful elegant shape. However, it could never have been realised as a load-bearing sculpture: the thin central section of the torso would simply have snapped under the slightest weight.

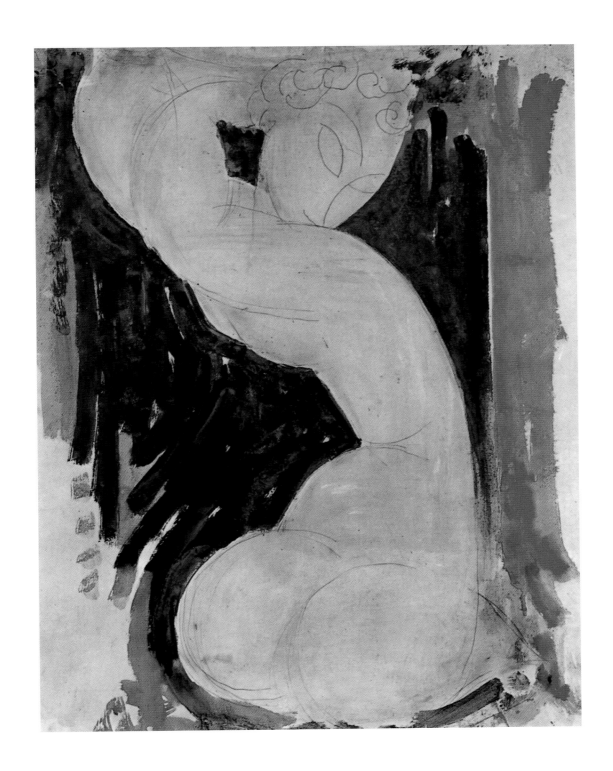

75.

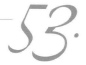

PINK CARYATID

1913-14
Watercolour, 54.6 x 43 cm
Collection Evelyn Sharp

Modigliani's prodigious output of drawings during the period he devoted to sculpture makes it difficult to ascertain whether he was sketching preparatory ideas for sculptures or experimenting with two-dimensional versions of his sculptural ideas.

Certainly there was an incredible variety in the drawings and he went to considerable effort with some of them, painting in oils or, as here, in watercolour. This caryatid is a mirror-image of the final sculpture of the crouching caryatid, dominating the page in a series of ovoid shapes that could not easily have been achieved in sculpture. Indeed, many of his drawings could never have been used as blueprints for the sculptures as they often present impossible physical challenges to a three-dimensional expression of their form. This caryatid plunges forward, as if supporting the temple roof on just one shoulder, head tucked out of the way, arms supporting the weight to one side of it.

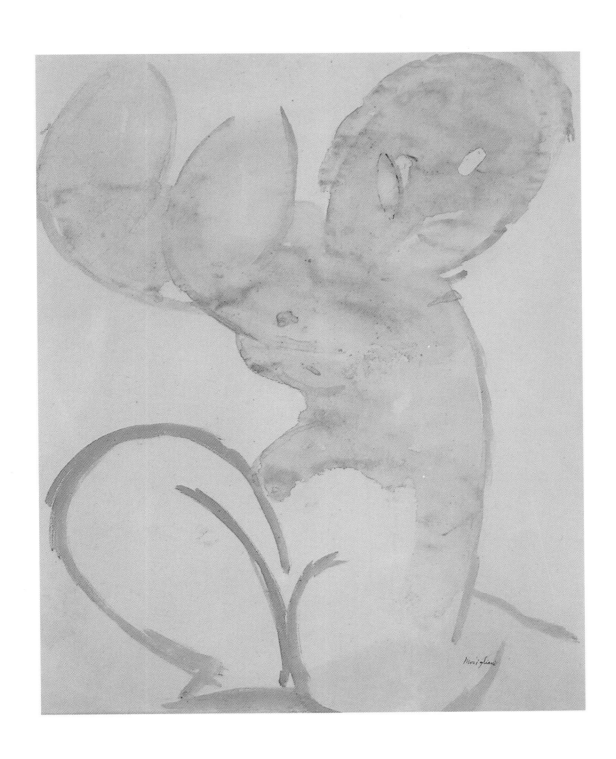

CARYATID

1913
Oil on canvas, 81 x 46 cm
Samir Traboulsi Collection

This figure is similar to the previous illustration (no.25) although dated a year later. Once again, Modigliani is experimenting with minute variations in the style and presentation of the series of standing caryatids which he intended for his unrealised temple of beauty. He took a great deal of care with these, painting them in oil in warm orange tones. This caryatid effortlessly supports the weight above her with her arms lifted directly up on either side of her head, gazing straight ahead. The face has the stylized, blank features which appear later, in a more subtle form, in his portraits and nudes. The breasts are high up on the chest, with nipples that, like the belly button, look as if they are studded with jewels. The waist and hips are encircled with jewellery, dividing the body into separate geometrical sections, and the legs are not quite straight: one leg poses elegantly in front of the other, emphasizing, as in the previous illustration, the dancer-like ease with which these figures support the weight above their heads.

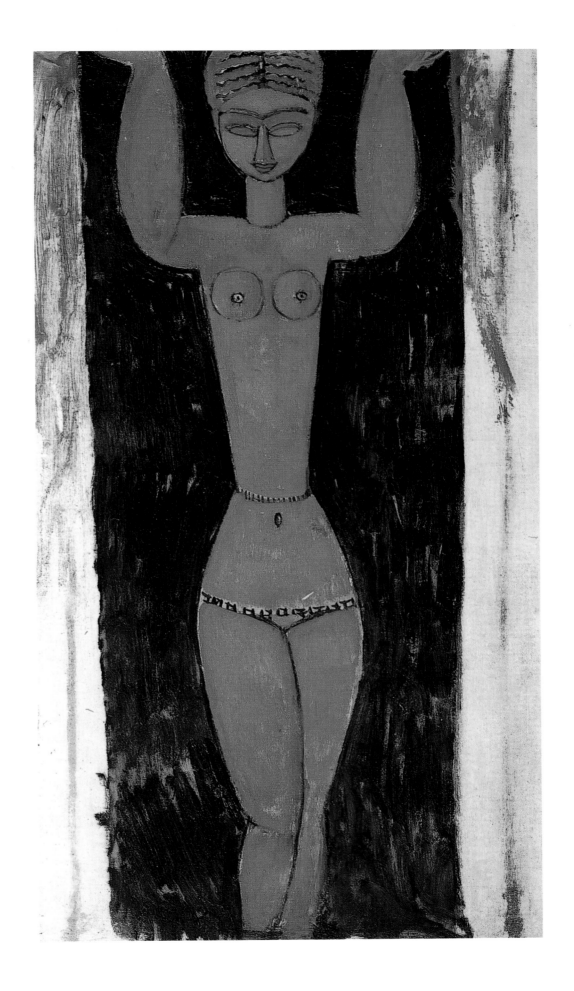

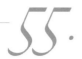

STANDING NUDE
WITH GARDEN
BACKGROUND

1913
Oil on board, 81 x 50 cm
Private collection

This study, painted in oil, dates from around the same time as the only existent sculpture of the standing figure. Here, Modigliani has sketched in a garden background, perhaps the setting in which the sculpture was intended to be shown. Or perhaps this is one of the series of drawings which he made for an intended temple of beauty that was never realised. The figure here stands like an ancient goddess, hands resting in an unusual manner on what appears to be a stone casing or wall. The legs are remarkably similar to those of the realised statue: weighty, bulked out like tree trunks. The feet disappear into the ground although there is no pedestal depicted here. Unusually, this figure has no bodily features at all: there are no breasts, the normally strongly-drawn line between the hips and pubic region is scarcely visible, the facial features are reduced to an elongated nose (again very similar to that of the finished sculpture), barely sketched in eyes and exaggeratedly long ears set in an enormously elongated head.

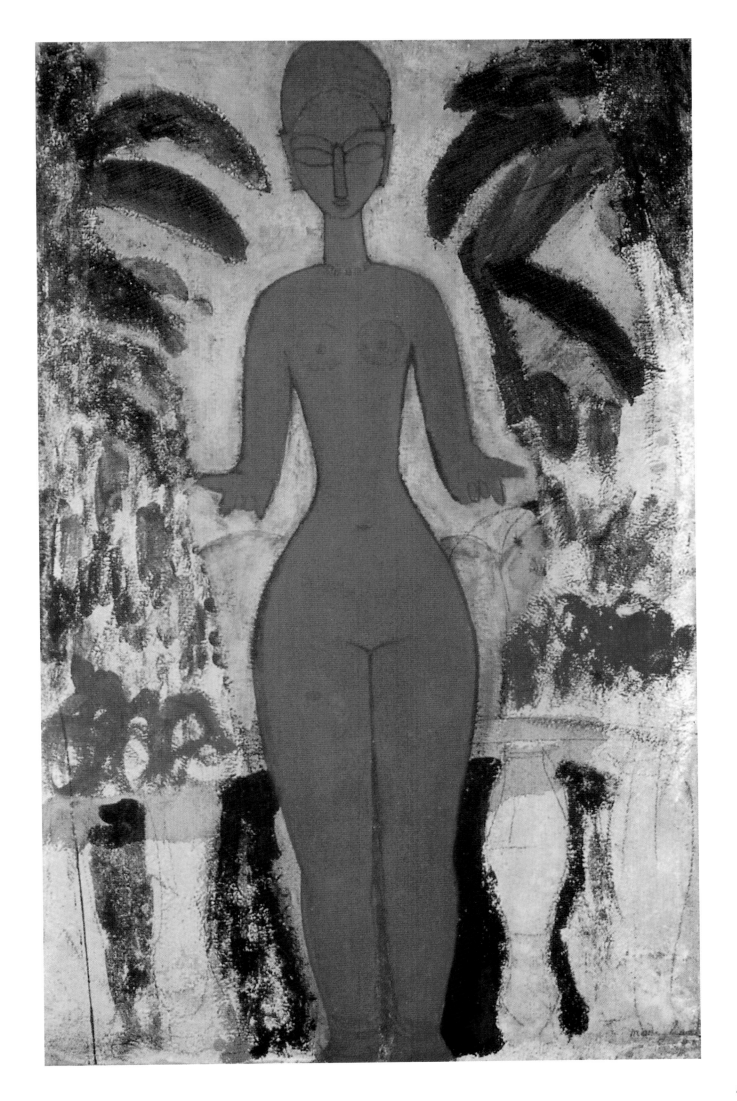

56.

CARYATID

1914
Gouache on canvas and wood, 140.7 x 66.7 cm
The Museum of Fine Arts, Houston

Modigliani's interest in the human form never flagged, and his endless experimentation with the caryatids is testimony to this. In this example, painted in gouache, he creates a figure that clearly has a sculptural intent, since it sits on a pedestal, composed of two sets of balancing circles, one on either end of an elongated torso. The caryatid's head, behind which her arms disappear, is sunk between her shoulders. The breasts are perfectly round, and the legs, bent at the knees, are foreshortened into two balls. This is pure experimentation with form with apparently little that could be translated into stone but, interestingly, if one looks at the actual sculpture of the crouching caryatid, the essence of this picture has been translated into three dimensions, at least in the legs and arms. The torso has of necessity become a weightier, more massive thing, but the curves of the rest of the body remain.

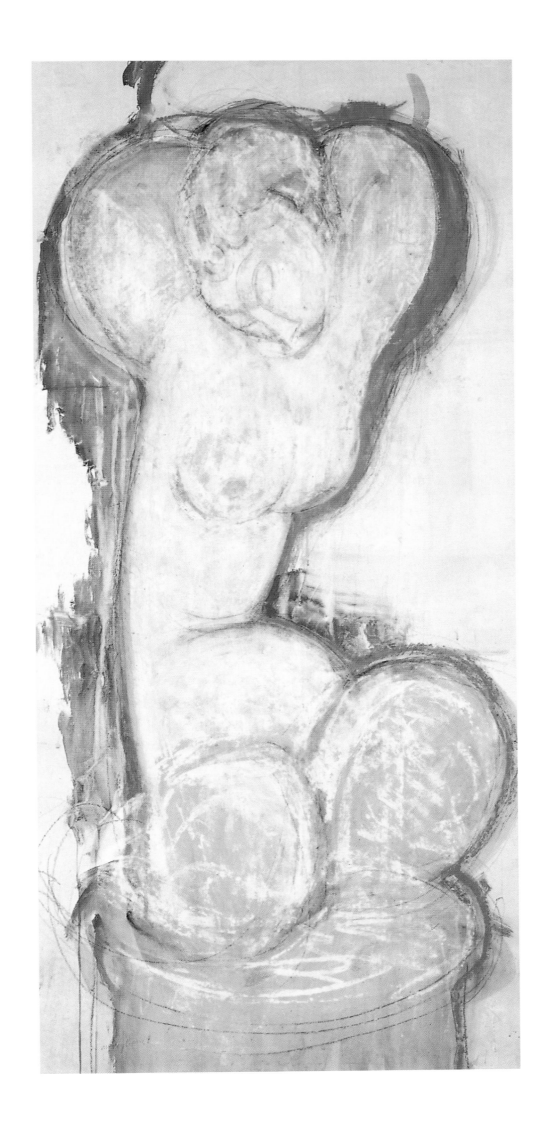

83.

CROUCHING CARYATID

1914
Limestone, 92 x 42 x 43 cm
The Museum of Modern Art,
Simon Guggenheim Fund, New York

In 1911-12 Modigliani began work on his *Crouching Caryatid*. In classical Greek architecture, a caryatid is a female figure that supports the roof of a temple. Modigliani made a series of watercolour sketches in preparation, experimenting with the idea of the female figure supporting a heavy weight. The final sculpture differs enormously from them in many respects, most of all in its unusual naturalism and raw power. The finish of the sculpture is rough instead of smooth, as if the powerful human form were merging from the rock in a manner reminiscent of Michelangelo's *Slaves*. The figure curves forward, bulky, the weight concentrated entirely around the central axis. The breasts are uncharacteristically realistic for Modigliani - we see the muscular connection between the uplifted arms and the breasts, emphasising the sheer force involved in supporting the weight above. The arms are huge, joined at the head to provide support. And there is no face. This is a raw, rough, powerful Mother Earth rather than a sensual young girl and it is difficult to tell just how much of the roughness was part of a new artistic departure for Modigliani and how much a simple result of his technical inexperience as a carver. Sadly for us, he gave up sculpture soon after this, the combination of the dust and effort proving too much for his weak health.

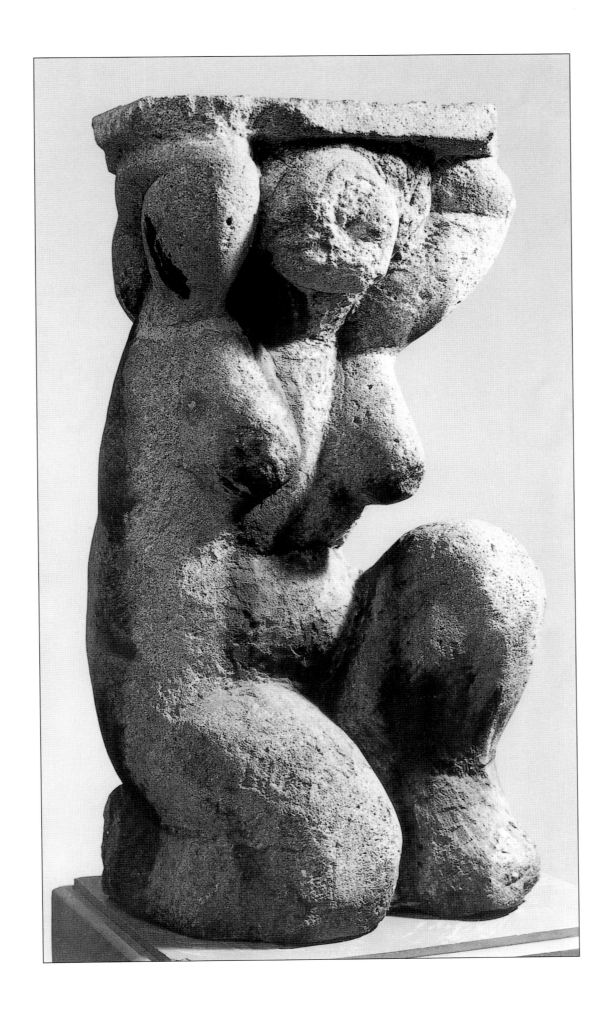

PORTRAIT OF MOÏSE KISLING

1915
Oil on canvas, 37 x 29 cm
Pinacoteca di Brera, Milan,
Donation by Emilio und Maria Jesi

In 1915 Modigliani produced a series of small portraits of friends and acquaintances which have in common a strong sense of charm, humour, directness and intimacy, which expresses his warm relationship with the sitter. Moïse Kisling (1891-1953) came from Poland to Paris in 1910 and soon became an essential component of the group of artists that included Modigliani, Utrillo and Soutine. Like the others, he was a big drinker and an enthusiastic party-goer. Unlike the others, he managed quite quickly to obtain a degree of commercial success and after a few years was in a position to help out his friends which he generously and frequently did,

often paying for Modigliani's food and sharing a studio with him. This portrait is a flattering one, making Kisling look handsome and almost childishly youthful, like a schoolboy, an impression emphasized by the point at which the portrait is cut off, just below the neat white collar and tie. His expression is calm and thoughtful, his enormous almond-shaped eyes gazing directly at the viewer with just a tiny hint of humour. Kisling was a thickset man and here his face, square and full, almost fills the painting – there is no elongation of the image as is generally found in Modigliani's portraits.

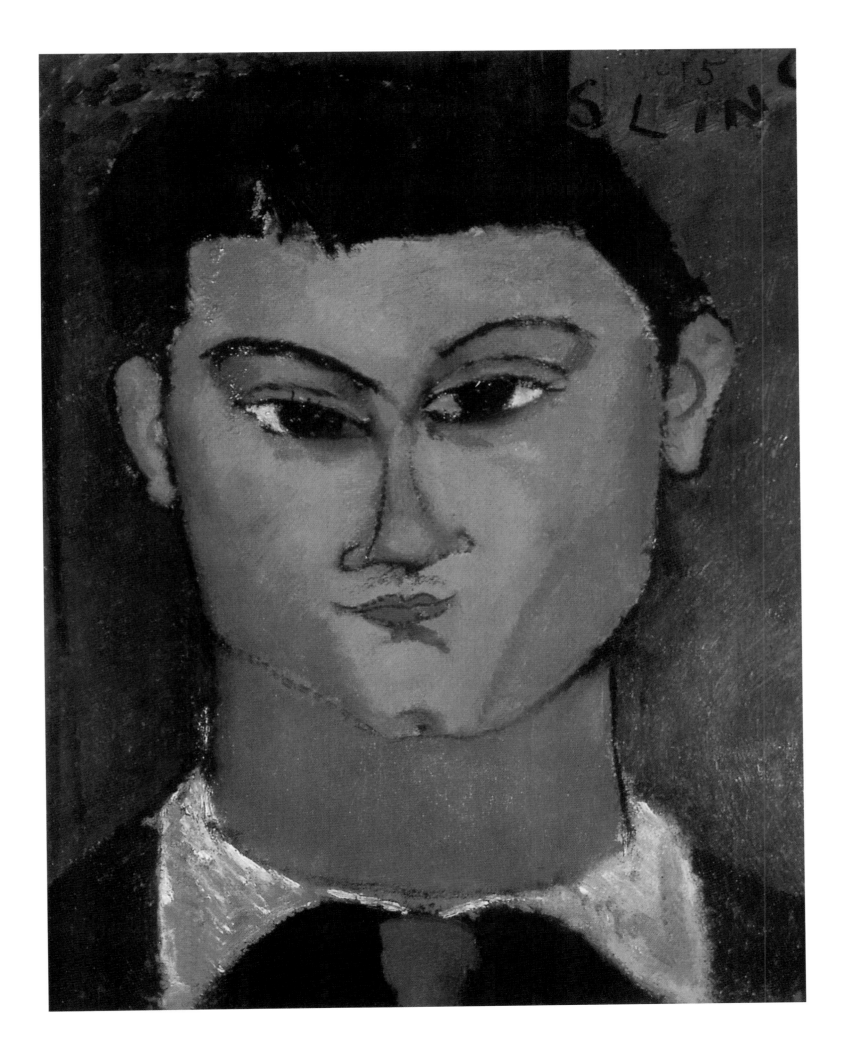

87.

BRIDE AND GROOM

1915
Oil on canvas, 55.2 x 46.3 cm
The Museum of Modern Art, New York

Many critics have pointed to the similarities between this painting and the work of Paul Klee, although it is uncertain whether Modigliani would have been familiar with Klee's work. The composition is Cubist through and through: the vertical and horizontal planes fit together like a puzzle and serve – rarely for Modigliani – to emphasize a powerful element of humour in the portrait. The vertical lines which run down the centre of each face and the way the facial features are arranged around these lines create a wonderfully comic effect: the noses sit on either side of the vertical, lending the characters a faintly ridiculous air. Similarly, the way in which Modigliani chops the man off at the bottom of his hat whilst emphasizing the smallness of the woman with the composition of the planes behind her accentuates the contrast in their respective heights while the fact that each character is strictly confined to one half of the painting also serves to separate them. Everything about these two is in contrast – he is tall and old, absurd in his top hat and tails and with his marvellously wonky moustache, while she is short and young, wearing enormous hooped earrings. Perhaps the term bride and groom is an ironic reference to their relationship, which could more simply be that of a couple who have met for the night. Although the style is Cubist, Modigliani sticks to the subject that interests him most: the human body and face.

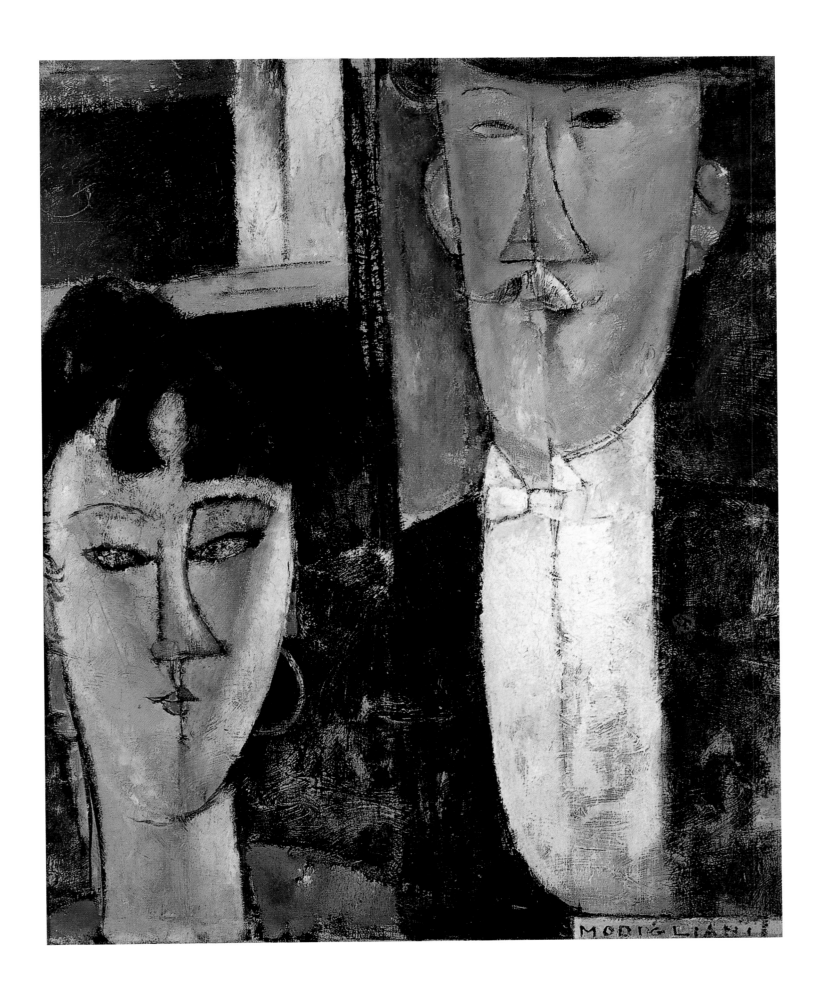

PORTRAIT OF BÉATRICE HASTINGS

1915
Oil on canvas, 55 x 46 cm
Art Gallery of Ontario, Toronto

Béatrice Hastings was a South-African born writer and editor who had lived for many years in England and moved to Paris at the outbreak of the First World War. She edited an artistic magazine entitled *The New Age* and was known as a fiercely intelligent, passionate and deeply eccentric woman. She became Modigliani's lover, his first serious and long-lasting relationship, and they remained together for two years. He painted around fourteen portraits of her. Their relationship was by all accounts extremely stormy; they drank and took drugs together, they fought and argued constantly, which makes it a surprise to find this extremely expressionless portrait of her which tells us almost nothing about her personality at all. Modigliani was just coming out of his period as a sculptor and there is a close similarity between this depiction of Béatrice and his caryatid drawings: the elongated neck and ovoid head, the simplicity of the outline are all profoundly sculptural in style. The background provides no context, apart from the back of the chair on which she is sitting, which bizarrely disappears somewhere behind her neck.

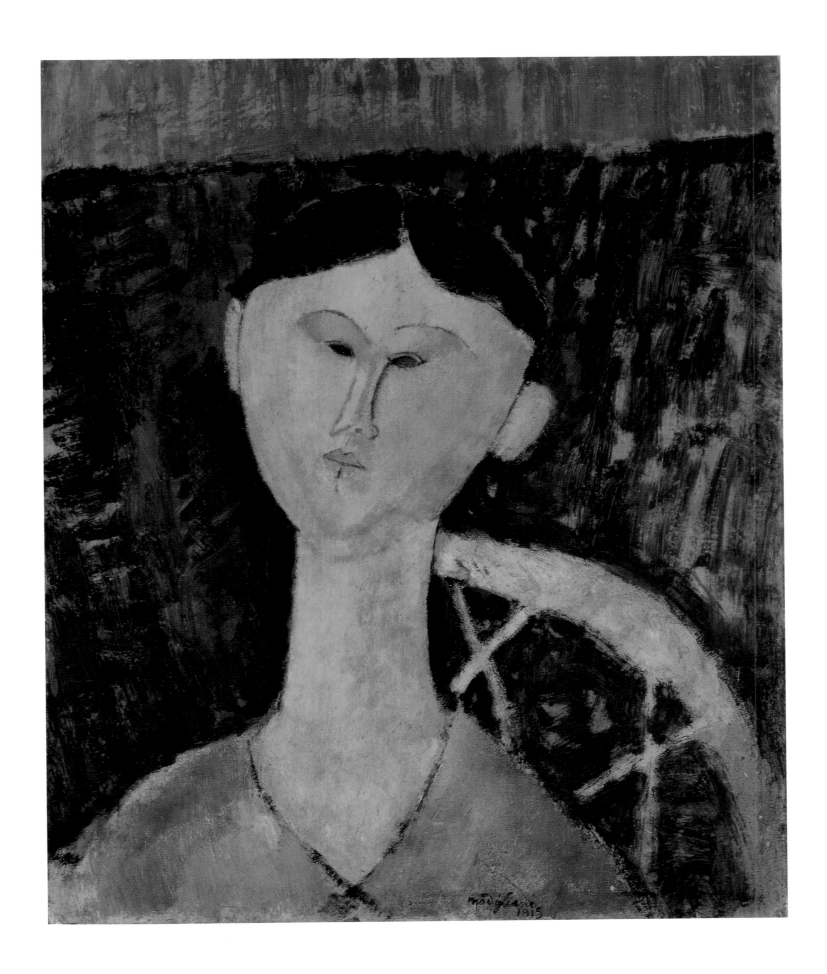

PORTRAIT OF LEOPOLD ZBOROWSKI

1916
Oil on canvas, 65 x 43 cm
Private collection

Zborowski originally came from Cracow in Poland and had been in Paris since 1914. He became a successful art dealer and in 1916 he succeeded Paul Guillaume as Modigliani's agent. Zborowski was in many ways a romantic, much more enthusiastic about art for art's sake than the more commercially minded Guillaume, which endeared him to the equally high-minded Modigliani. With his dealership came a small degree of stability for Modigliani: Zborowski made an agreement with him that required Modigliani to produce a specific number of works in return for the payment of a regular retainer. Modigliani painted at least six portraits of Zborowski and also painted Zborowski's noble-born wife, Hanna. In all his portraits Zborowski comes over as a friendly, gentle and patient man who liked to dress elegantly. This example is beautifully informal, almost photographic in the directness of its pose: Zborowski looks directly at the viewer, arms crossed, a humorous smile playing on his lips, as if Modigliani had asked him there and then to paint him and he has acquiesced because, after all, he is paying! His face is youthful, his features softly delineated, the overall effect almost watercolour-like in its softness.

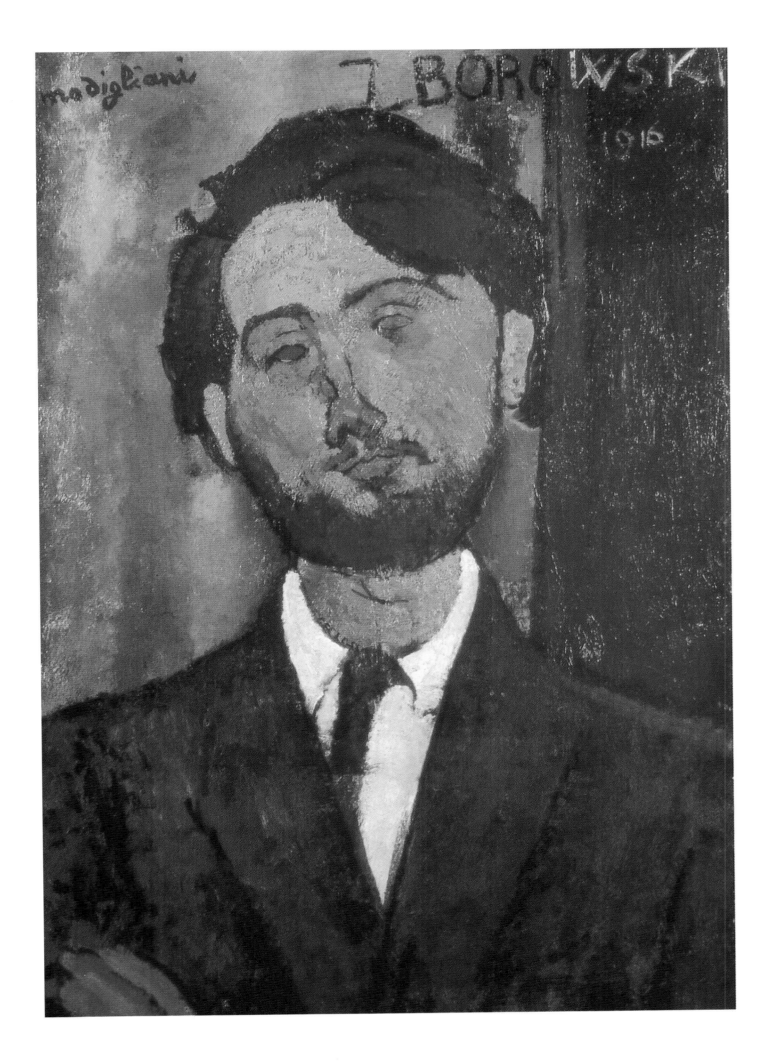

SEATED NUDE

1916
Oil on canvas, 92 x 60 cm
The Courtauld Institute of Art Galleries,
London

Modigliani painted a whole series of nudes between 1917 and 1919. This 1916 painting is thus a very early example of Modigliani's extensive exploration of the naked female body and one which contains both elements that will go on to become typical of the main series and some important differences. In this example, there is a delicacy in the way the woman is portrayed: her skin tones are pale, suggestive of youth, her hair is depicted in unusual detail, with thick scratch marks delineating the individual strands, and her face is given a degree of naturalism that is markedly different from the mask-like, often empty-eyed women of later works. Her eyes are closed and her chin rests on her shoulder in an attitude of extreme modesty (it is unlikely that anyone would fall asleep in such an uncomfortable position) which creates a powerful tension with the sexuality of the rest of the pose: she is leaning somewhat awkwardly against a seat or bed, a position which automatically thrusts her hips forward. Her legs are cut off at the thigh – a device repeated many times by Modigliani – so the emphasis is entirely on her torso, her breasts and pubic region. It is a very delicate picture, deeply sensual without being overtly sexually provocative as some of the later nudes can be.

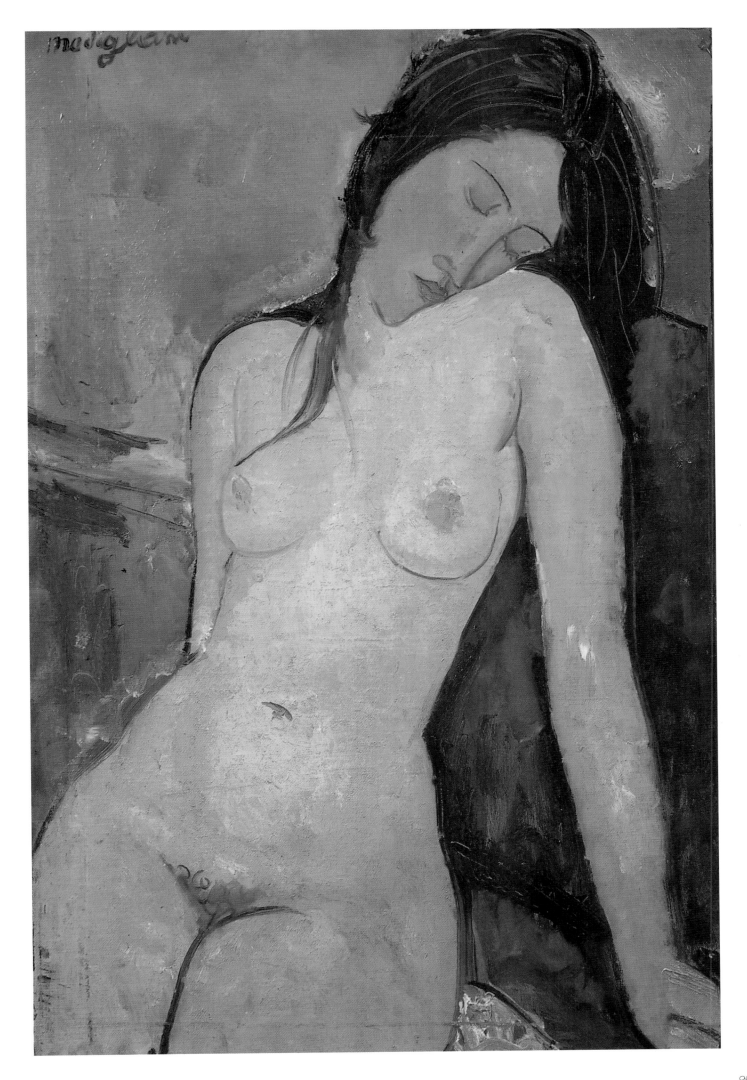

95.

PORTRAIT OF CHAÏM SOUTINE

1916
Oil on canvas, 100 x 65 cm
Private collection

Chaïm Soutine (1893-1943) was a Jewish peasant from Minsk who came from a background of such extreme poverty that when he arrived in Paris he didn't even know how to use a knife and fork. Modigliani – a highly educated and cultured man – took Soutine under his wing and made great efforts to help him. He taught him how to eat properly, how to blow his nose with a handkerchief instead of his fingers, and became his friend. Soutine's artistic style was entirely the opposite of Modigliani's – his work was wild, expressionistic and often macabre – but they shared in common a uniquely personal style that was at odds with the fashions of the time. Soutine reportedly adored Modigliani and Modigliani in return accorded him a certain dignity and respect which comes through powerfully in this portrait. Soutine sits awkwardly, hands splayed on the knees of a shapeless brown coat. His features are not glamorized – Modigliani does not shy from showing his wide, flat nose and full lips – but there is a directness in the portrait and in Soutine's soulful gaze, directed away from the viewer, that gives him dignity.

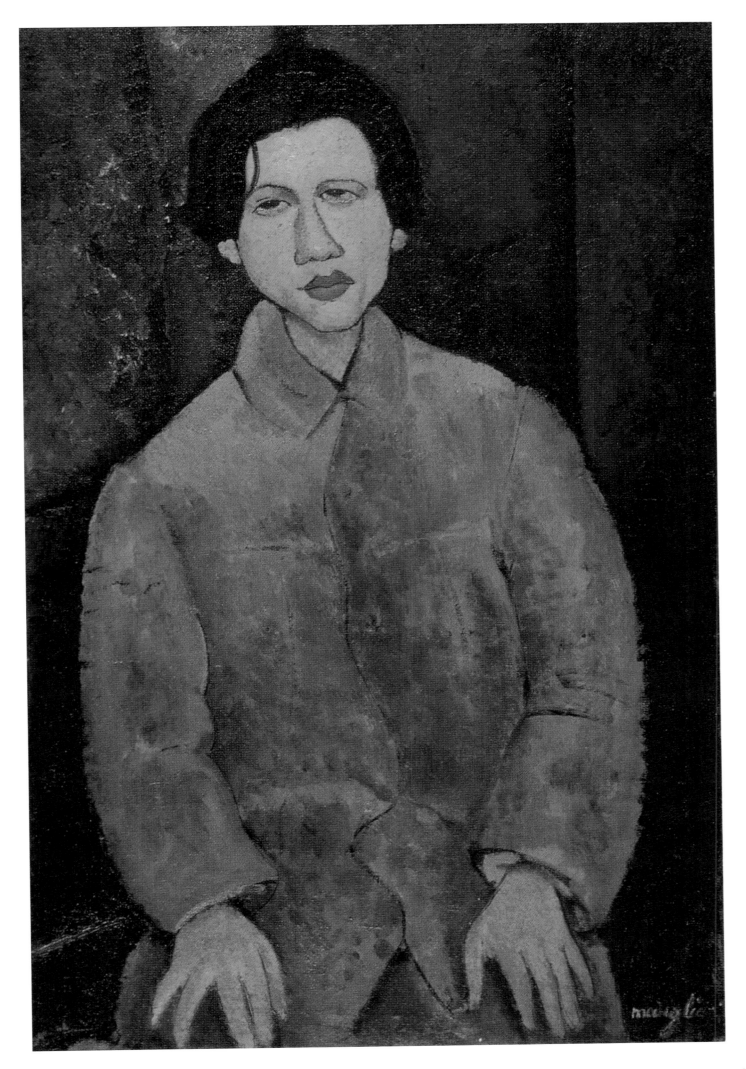

97.

SEATED NUDE WITH NECKLACE

1917
Oil on canvas, 92 x 60 cm
Private collection

Modigliani produced the majority of his nude paintings as a series between 1917 and 1918. Although there has always been much discussion and controversy surrounding the paintings (which caused outrage for his depiction of pubic hair when they were first exhibited in Paris), they do not in reality form more than around a tenth of his total painted output. He did produce a relatively large quantity of them, however, and they vary enormously in style and success. What they have in common, however, is the fact that – in direct contrast to his portraits of friends and acquaintances – none of the women depicted is ever presented as an individual. He is interested in the universal qualities of the female body and its many possibilities as represented in paint, not in a psychological reading of the character of the model. This is an example of remarkable delicacy and serenity. The woman's dark hair almost disappears into the black background. Her eyes are closed, her features simply delineated. She sits upright, but appears comfortable rather than formal. With one hand she fingers her necklace, the other is placed between her thighs. Her figure is not elongated but is rather solid and heavy, carefully outlined against the dark background. The mood is one of great serenity, with a subtle, delicate sexual tension created by the placing of the woman's hands and her distant, dreamy expression.

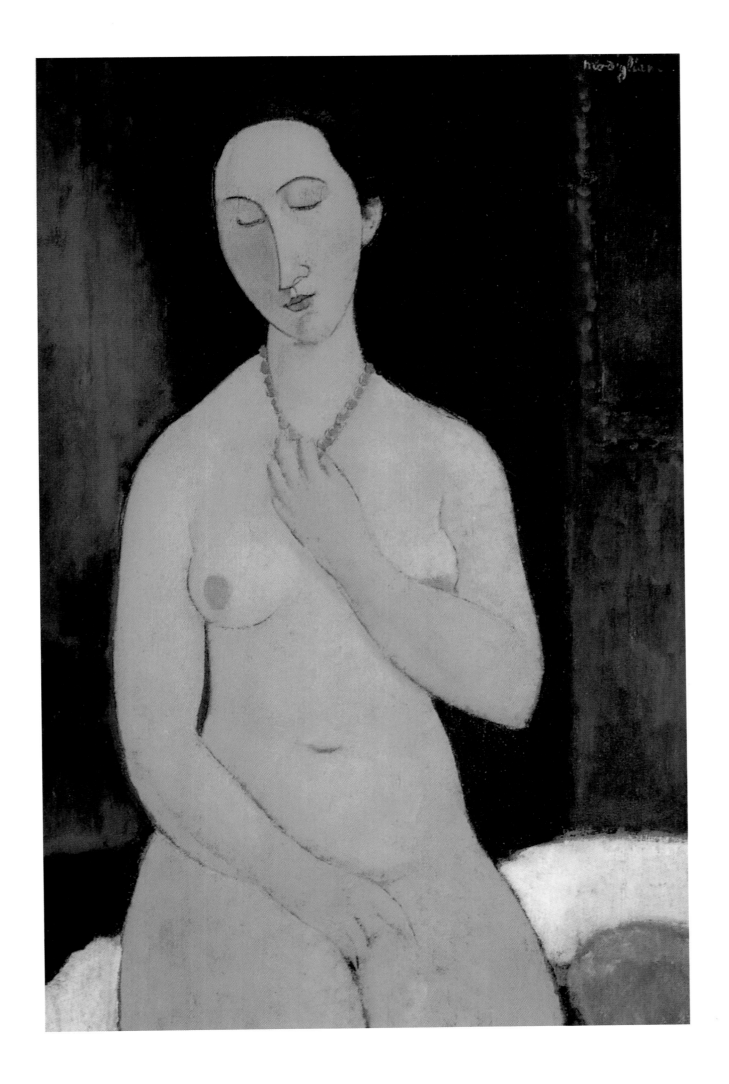

99.

SLEEPING NUDE WITH ARMS OPEN (RED NUDE)

1917
Oil on canvas, 60 x 92 cm
Collection Gianni Mattioli

Reminiscent of Goya's *Naked Maja* (1800), this painting bears many of the hallmarks of Modigliani's nude work during the years 1917-19. It is an overtly sexual picture: the model lies on her back, propped up on a cushion, one breast in profile, arms behind her head; the torso is elongated, the pelvis twisted towards the viewer. The legs are cut off around the thigh so that all the emphasis is on the sexual elements of the woman's body. The hair and lips are depicted in some detail and the eyes, although black and blank, look made-up, giving a modern look to the woman's face. The blankness of the eyes effectively depersonalizes her so that although she looks at us provocatively, sexually, there is no expression of her individual personality in the gaze. Modigliani's affinity with sculpture is clear here, inviting us to examine the sheer physicality and mass of the body through the medium of paint.

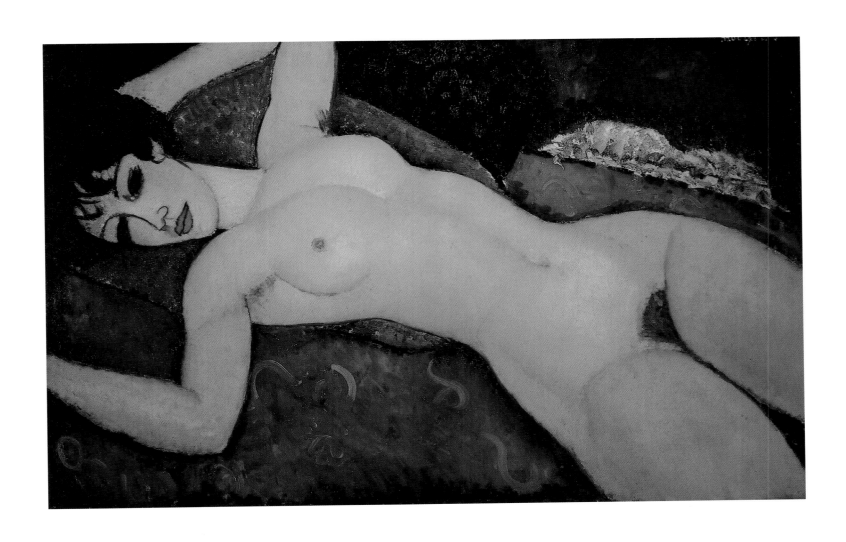

NUDE WITH NECKLACE

1917
Oil on canvas, 73 x 116 cm
Solomon R. Guggenheim Museum, New York

The brushwork in this painting is particularly smooth, with the body depicted in warm orange tones and the stomach and breasts highlighted in paler tones. The reclining pose, although in many ways typical of Modigliani, is different in the way in which the artist has depicted the upper part of the torso. Most commonly, he shows one breast in profile, the other directly facing us and he twists the pelvis in order to draw the viewer's attention to the pubic region. In this case, the entire body faces towards us, an unlikely pose which belies the closed eyes and relaxed mien of the woman. The model has her arms behind her head and her eyes closed as if she is asleep or at least relaxed, whilst her body is perched precariously on one side, with her legs disappearing in a somewhat ungainly fashion down at the bottom of the frame. Her features are simply drawn, and there is an oriental feel to the way her face is depicted that is almost reminiscent of Gauguin.

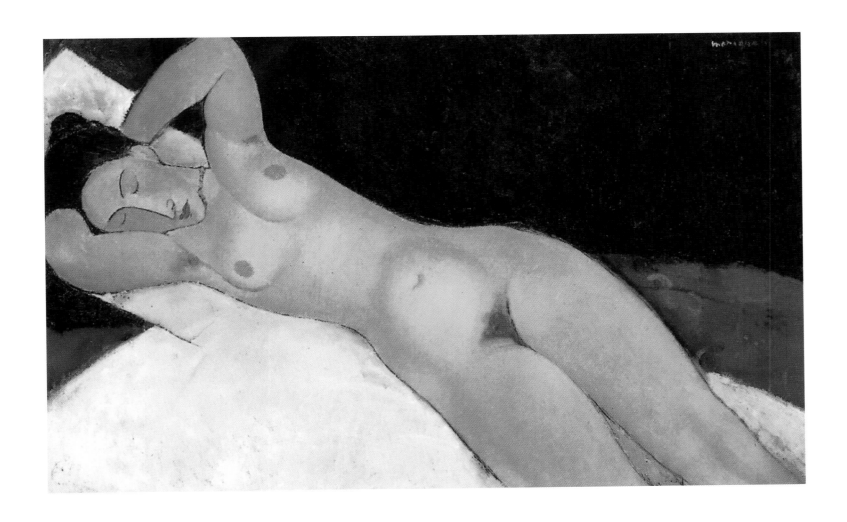

RECLINING NUDE

1917
Oil on canvas, 60 x 92 cm
Staatsgalerie, Stuttgart

There is much of the influence of both Titian and Goya in this painting. The woman's body lies directly on the diagonal of the picture, bisecting it. One arm is placed behind the model's head in order to best expose the breasts, with even a little underarm hair on show, while the other arm has mysteriously disappeared. What is extraordinary is that, so completely does the focus of this painting rest on the woman's torso and hips, one scarcely even notices the unnatural absence of her left arm, presumably understood to be hidden behind her twisted torso. The breasts are shown as so often in Modigliani's nudes, one in profile, the other pointing towards us. The torso is elongated and nipped in at the waist to emphasize the heavy curve of the hips which are twisted towards the viewer, pubic hair and all. The legs are cut off just above the knee in one of the more successful examples of this device. There is scarcely any context here, just a black background, red cover and white cushion, so there is nothing to distract from the warm orange tones of the body and the forward and downward tension which draws our eyes immediately to the pubic region. Although the eyes are not blank or dark, they are not personalised. Instead they have the enormous, heavy quality of an ancient Greek or Indian picture – universalized rather than particularized, and overtly sexual in their lazy, sleepy gaze.

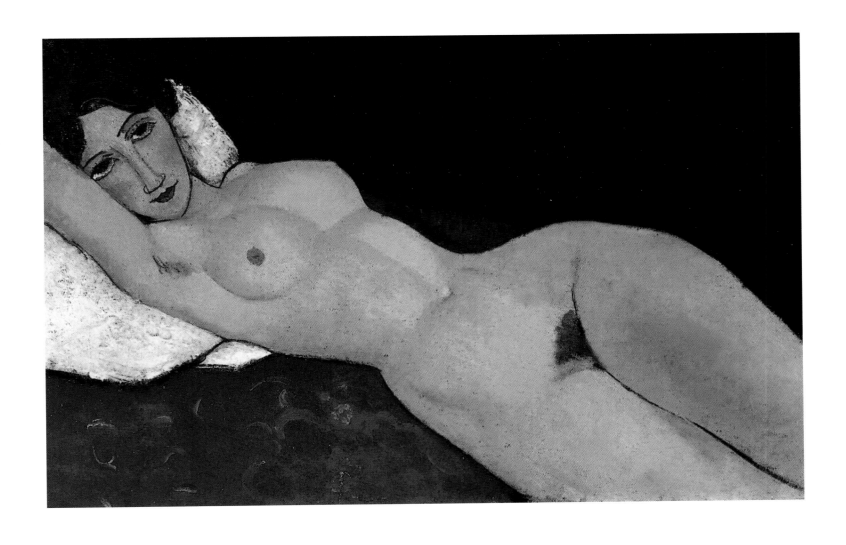

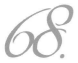

NUDE

1917
Oil on canvas, 72 x 117 cm
Private collection

This is one of the most overtly sexual, almost pornographic, of Modigliani's nudes. It is also one of the most stylized and geometric in the way the body is divided into a series of curved shapes, heavily outlined so as almost to appear like a cut-out. The woman's body lies sprawled across the canvas, arms and legs splayed. The torso is elongated and, instead of twisting the pelvis towards the viewer as he so frequently does, Modigliani here chooses to show it in profile, emphasizing the arched back and even giving the woman's pubic hair a profile view which appears as a simple slit, provocatively sexual in nature. Despite the touches of realism in the pubic and underarm hair, the face is stylized in the extreme, a blank mask that stares out at us expressionlessly, depersonalizing the woman to such an extent that she appears almost inhuman. She offers herself to the viewer without emotion, without personality, thus heightening the overtly sexual nature of the image.

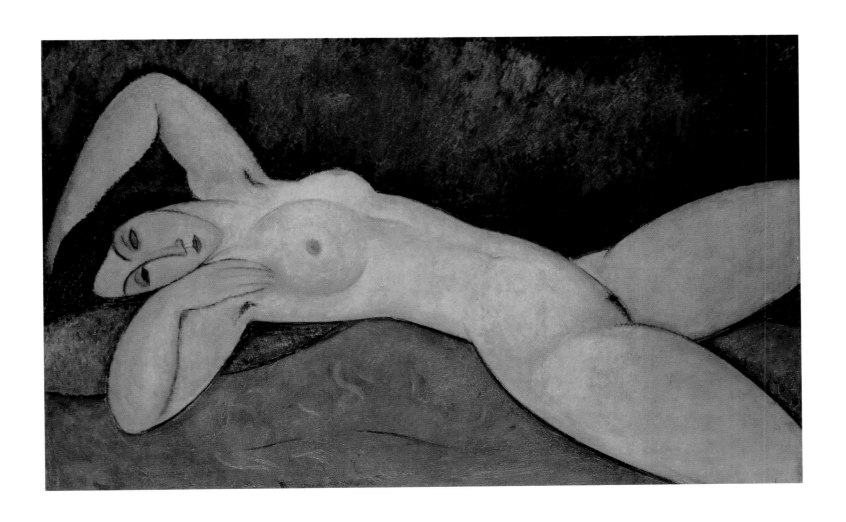

107.

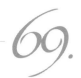

RECLINING NUDE

1917
Pencil on paper, 26 x 41 cm
Private collection

This simple drawing calls to mind the work of Matisse in its devotion to line above all else. With a few strokes of the pencil, Modigliani creates a reclining human body that consists entirely of rhythmically interlinked curves. He shades in the suggestion of a bed, and places the woman's figure diagonally across the paper to form a counterbalance to the straight lines of the bed which bisect the opposite diagonal of the paper. This is not in any way an erotic image, but instead rather an innocent, pretty, deeply peaceful one. The disappearing legs – which are not even differentiated into two separate limbs – look almost like a fishtail, as if this were a mermaid caught unawares whilst lying sleeping.

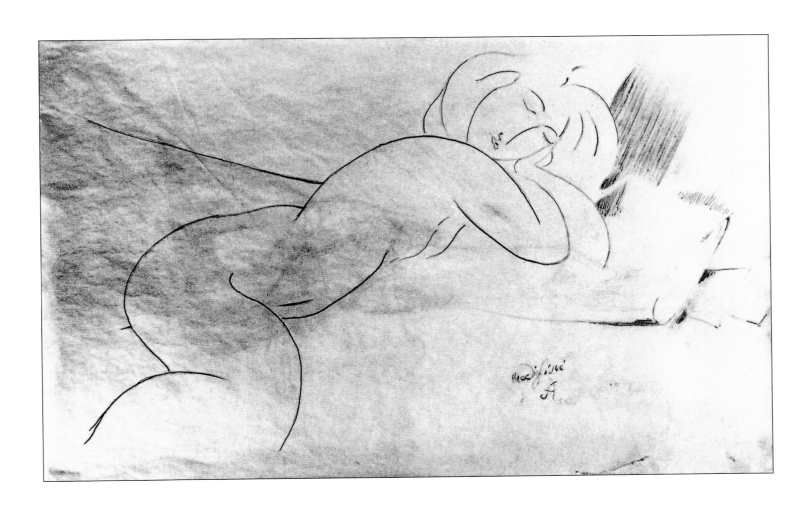

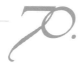

SEATED NUDE

1917
Oil on canvas, 73 x 116 cm
Koninklijk Museum voor Schone
Kunsten, Antwerp

The setting of this painting – unusual for Modigliani who more commonly depicted nudes in a virtually contextless environment – appears to be something like a Turkish baths: there is a pool of blue water beside a mosaic-covered floor and, over the model's legs, a white sheet or chemise draped modestly like a towel. This is not a common pose for Modigliani. It offers fewer possibilities for experimenting with the female form than a reclining posture does and here, instead of focusing on elongation as he usually does, he has created a figure that is short and bulky. The legs are awkwardly drawn, especially the left calf, which is heavily outlined as if alterations had been made to it and which disappears before the foot is reached as if Modigliani couldn't quite face drawing this far. The combination of the white cloth and the model's expression – her eyes focused somewhere beyond the frame of the canvas on something quite other than the viewer, her lips unsmiling – makes this a far less erotic picture than the majority of his nudes.

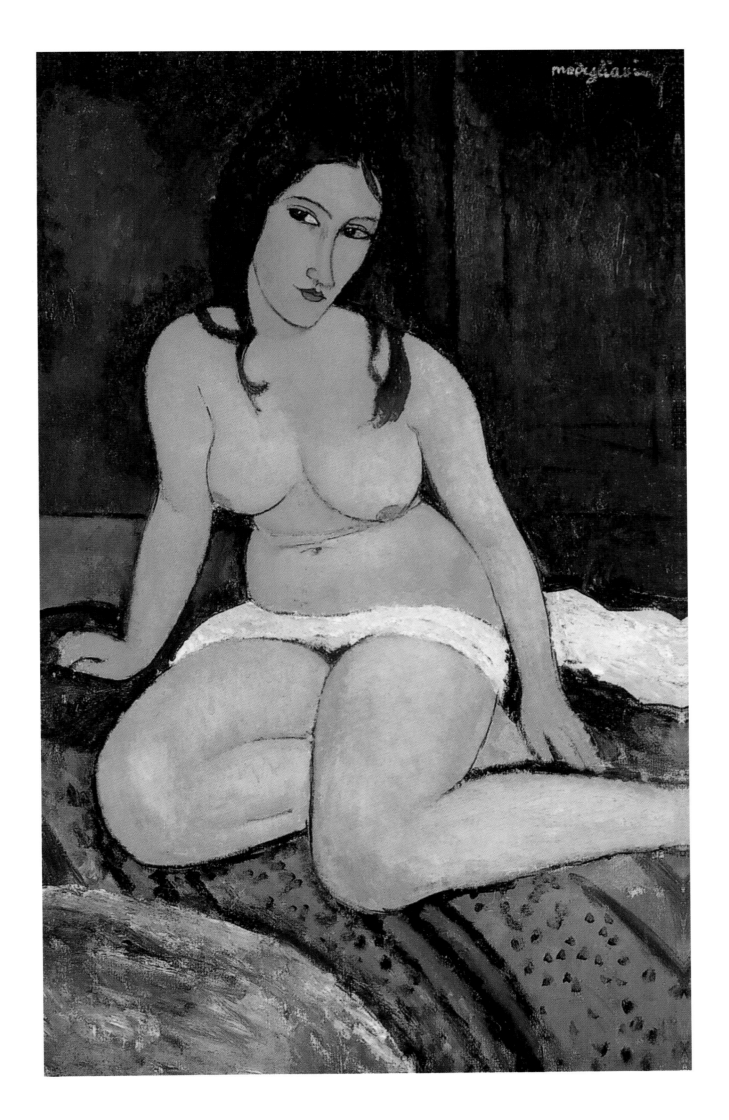

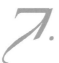

NUDE ON A BLUE CUSHION

1917
Oil on canvas, 65.4 x 100.9 cm
National Gallery of Art, Washington DC

This is a relatively individual nude: the woman's face is depicted in some detail, her eyes specifically show an expression of relaxed good humour. Apart from the face, the upper half of the body is also well-observed: she lies propped up on one elbow, leaving one breast hanging heavily towards the blue cushion, and her torso curves convincingly as it would in such a position. The legs, however, are not only cut off at the knees, a much lower and less successful cutting point than the more usual point halfway down the thigh, but they dangle most unconvincingly in the corner of the picture, as if they were hanging off the end of the surface on which the model is lying. Modigliani's directness in depicting nudes caused a huge amount of scandal in his lifetime, not least because of his depiction of pubic hair.

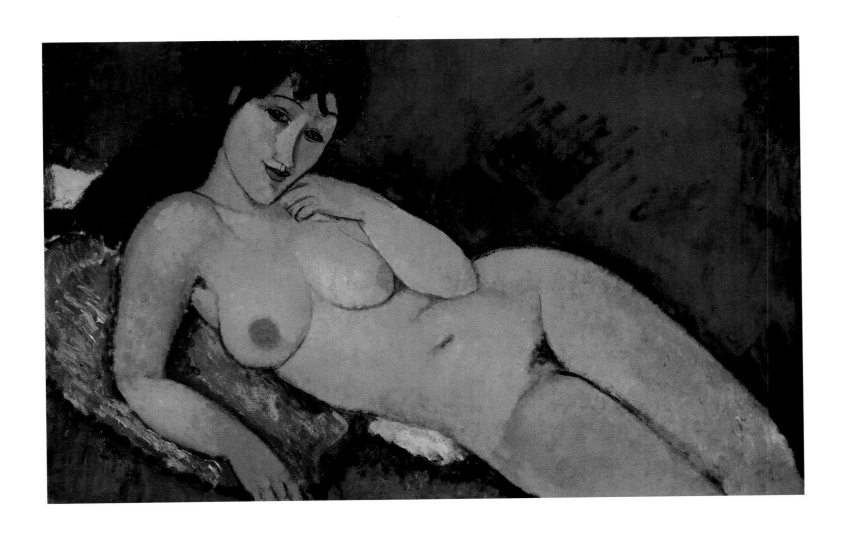

PORTRAIT OF JEANNE HÉBUTERNE WITH LARGE HAT

1917
Oil on canvas, 55 x 38 cm
Private collection

Modigliani painted many portraits of his lover Jeanne. This example dates from the year they first met and perhaps for this reason expresses little either of her personality or of her relationship to the artist. It is an elegant painting, but the blank blue eyes of the model and the use of black for her hair (which in reality was reddish) serve to remind us that this is not a portrait as such, but an exercise in shape and form: the two-toned palette of pinky-oranges and black (somewhat reminiscent of Matisse) divides the space into big blocks of colour, while the elongated neck, long oval face, exaggeratedly sloping shoulders and curved hand of the model serve to give rhythm and shape to a picture that is above all dominated by a hat. Modigliani has taken care to position the model slightly off-centre so that the oval brim of the hat, which would fit into the frame if it were centrally placed, extends beyond the boundary of the painting, emphasising its size, which completely overwhelms the face below it.

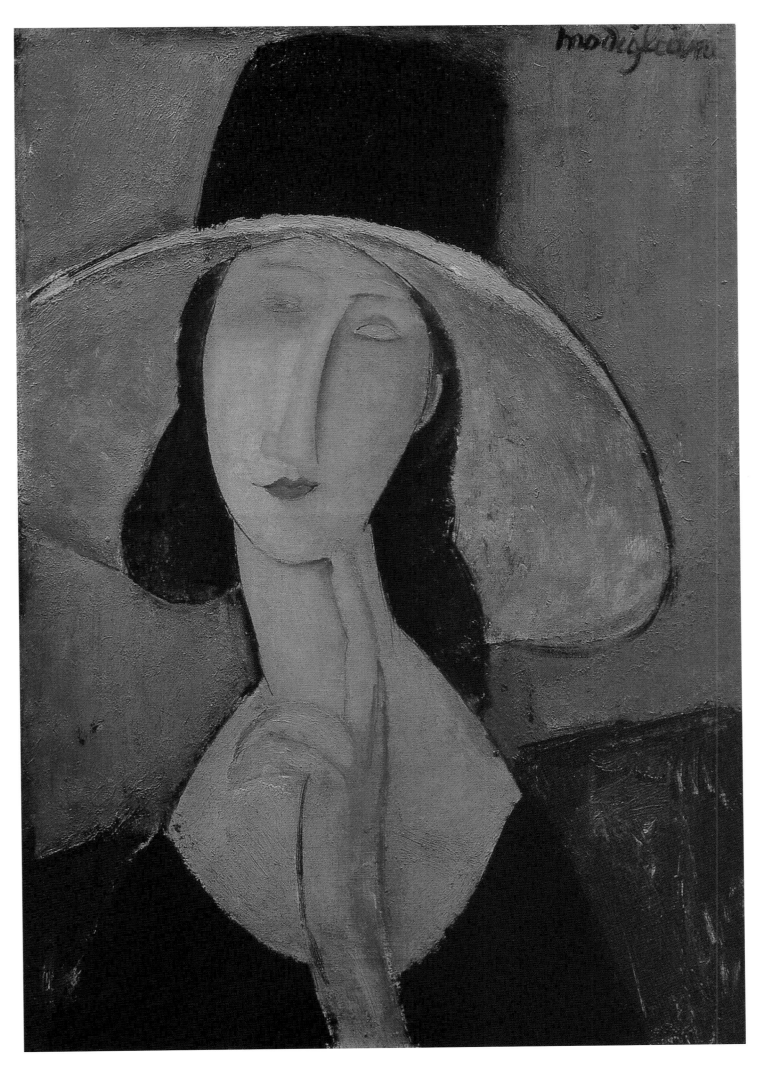

115.

RECLINING NUDE
WITH LOOSE HAIR

1917
Oil on canvas, 60 x 92.2 cm
Osaka City Museum of Modern Art, Osaka

There have been many debates about whether Modigliani slept with his models or not. Many have argued that his nude paintings possess such an erotic charge that it is inevitable that some form of sexual relationship had occurred. There is no proof of this, however. Modigliani's nudes were deeply influenced by earlier masters such as Titian, Giorgione and Goya and they represent above all an idealized view of sexualized womanhood. Most contemporary nudes would be depicted in a context of some sort, surrounded by objects, furniture, a bed. Modigliani used almost no context, focusing almost exclusively on the body. He never painted his friends or his long-term lovers naked: he was trying to create a universal image of woman, not a personalized one. In this example the woman's body dominates the frame to such an extent that it does not fully contain her: her head is cut off at the top, her left knee is sliced at the edge, and her right leg disappears into the corner of the canvas. The woman's back is slightly arched, she places her hand between her legs in a distinctly sexual gesture and stares out at the viewer, her head propped up on a pillow, her gaze calm and slightly smiling.

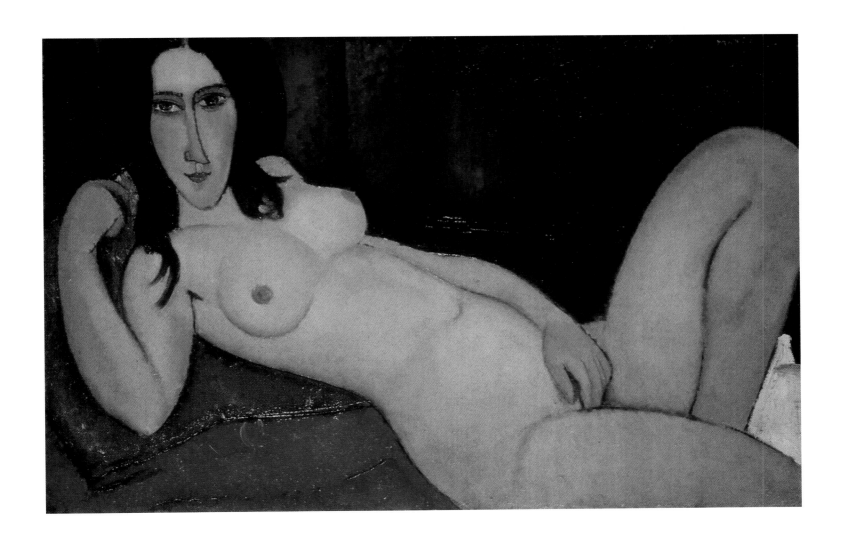

NUDE WITH NECKLACE

1917
Oil on canvas, 64.4 x 99.4 cm
Allen Memorial Museum, Oberlin, Ohio

This is not one of Modigliani's most successful nudes. As with other nudes painted at the same time, the woman's body lies diagonally across the canvas, her legs cut off above the knee, her head sliced off at the top. Whereas most of the nude paintings depict a background that is dark in colour – often a mixture of black, orange or red – here the white sheet on which the model is lying takes up half of the picture. The effect is to make the tone generally cooler, therefore less inviting. Instead of the woman's body luxuriating in the warmth of the bed beneath her, she looks cold and uncomfortable. The effect is heightened by the face, the features of which are slightly haughty, and the presence of the necklace, an incongruous remnant of clothing that serves to emphasize her nakedness. The woman's nipples are painted as two blobs of colour that look like enlarged versions of the necklace beads.

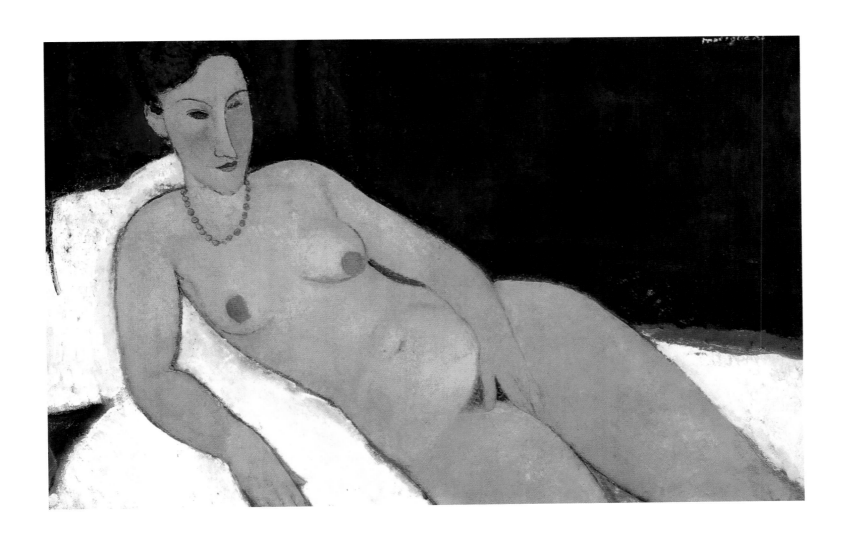

SEATED WOMAN IN BLUE DRESS

1917-19
Oil on canvas, 92 x 60 cm
Moderna Museet, Stockholm

This unknown young woman sports a distinctly modern hairstyle, emphasized by Modigliani in the extreme, flat darkness of her hair which matches her fashionable black clothes. Indeed, this portrait very much resembles fashion plates of the time in the stylized, flat simplicity of the hair and clothes and the delicate, almost pencil-like facial features and outlines. The woman sits perched on a black chair, her presence dominating the frame – her head just touching the top of the canvas. Her skin is pale, her eyes blank and expressionless. There is precious little sense of character in this painting; there is no background to give any hint of context, no indication as to what kind of a person she might be. The uncertain dating makes it difficult to ascertain if it was one of the series painted by Modigliani during his stay in the south of France or whether this was painted in Paris.

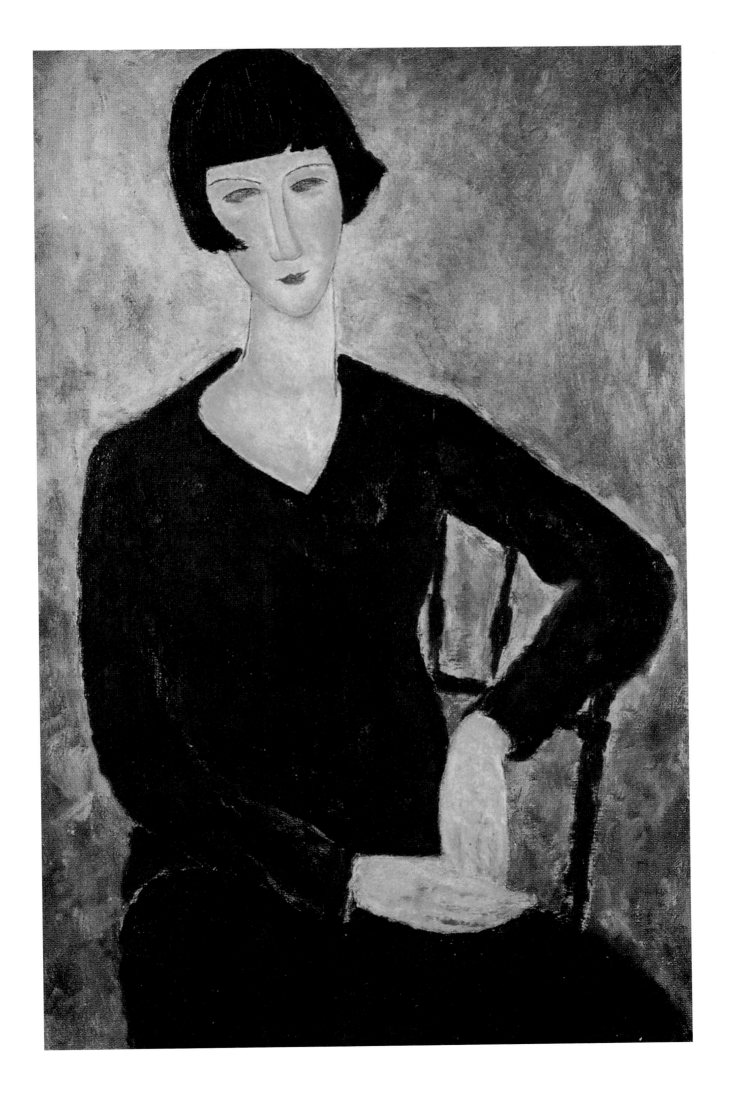

RED-HAIRED YOUNG WOMAN IN CHEMISE

1918
Oil on canvas, 100 x 65 cm
Private collection

This is one of a series of paintings which Modigliani made in the south of France towards the end of his life. The model here is most likely a local girl rather than a professional model: during his stay in the south there were few models available and it was expensive to find them, so Modigliani used locals instead. This might account for the extreme ungainliness of the pose: the room is bright, the girl is seated uncomfortably on the edge of a bed holding a chemise around her in an effort at modesty, one hand holding her breast (a reference to Botticelli's *Birth of Venus*). She looks at the artist with her head tilted to one side, slightly ridiculous bands of hair falling on either side of her face, her eyes blue and blank, her mouth open to reveal her teeth. She is broad and plump, pale skinned, rosy cheeked. The overall impression is of a simple, awkward village girl who is uncomfortable with the artist's desire for nudity and who has been depicted with faint cruelty by the artist.

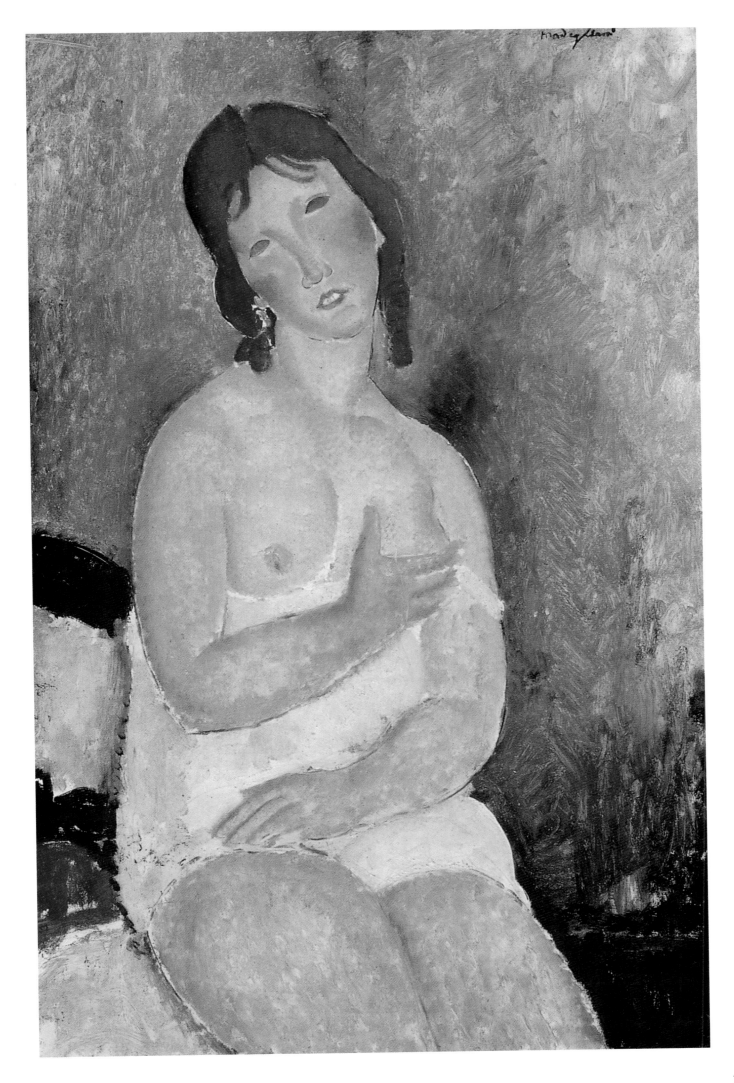

123.

RECLINING NUDE

1918
Oil on canvas, 73 x 116 cm
Galleria Nazionale d'Arte Moderna, Rome

This reclining nude presents another variation on and reference to Goya's *Maja Desnuda* (1800). Here the mass of the body is surrounded by planes of colour using dabbed brushstrokes in shades of orange, pink and black. The effect is to focus the attention on the body as a mass of colour rather than as a body: it is the outline which we see here above all, and although Modigliani uses many of the techniques he employed in so many of his nudes – the arm behind the head, the twisted pelvis – this is one of the least overtly sexual of images. Unusually, we see the model's legs almost to the feet, but not quite, tapering off into a somewhat unconvincing point at the edge of the frame. Modigliani noticeably avoids both hands and feet in his nudes, largely in an effort to focus on the body, but it was also partly because this was not his strong point as a painter. The face is extremely stylized, almost mask-like, and does not quite fit onto the body. The hair blends with the cushion beneath the model's head, making it impossible to distinguish which is which.

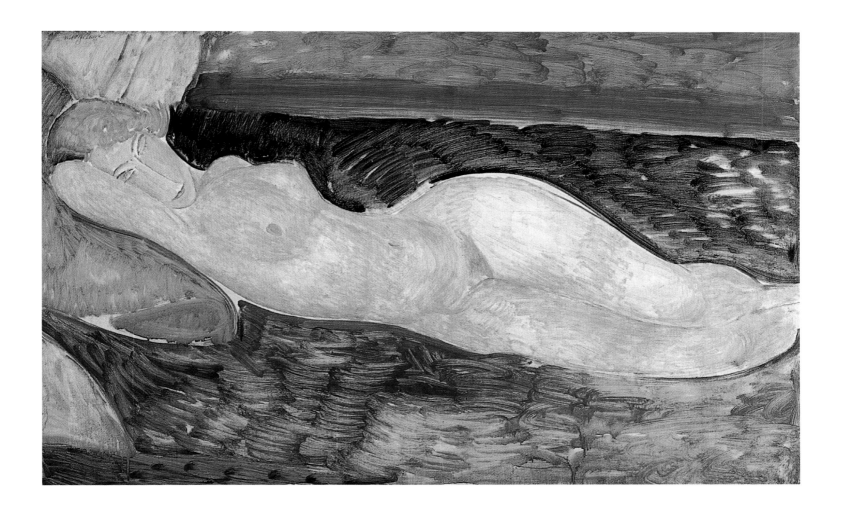

SEATED NUDE

1918
Pencil, 42.5 x 25 cm
The Art Institute, Chicago
Given by Claire Swift Markwitz
in memory of Tiffany Blake

The young woman in this drawing bears some resemblance to the girl depicted in illustration no.8, *Standing Nude (Elvira)*. There is something in the expression of the face and the shape of the body that suggests they might be the same person. In this rough sketch, drawn with Modigliani's characteristically sure hand, the girl slouches on a curved surface that looks like a rock. As in many of his drawings, Modigliani sketches in a line to suggest the corner of a room. This is far from the relaxed, sensuous poses of his painted nudes: the model's body expresses lassitude and boredom. She slumps on her seat, back curved, shoulders drooping, stomach relaxed. Half of her face has been depicted naturalistically, in some detail. One eye, however, has gone adrift and is not fully filled in, marring the girl's pretty face. Modigliani's sketches were not often reworked, so the girl remains boss-eyed.

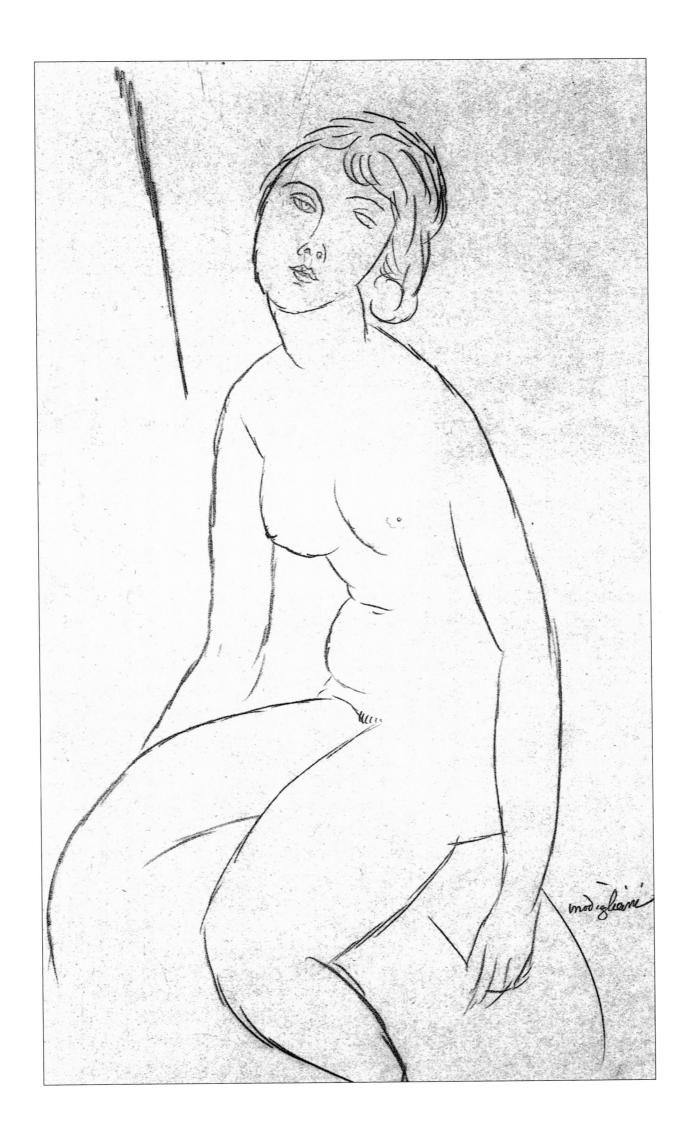

PORTRAIT OF JEANNE HÉBUTERNE – HEAD IN PROFILE (YOUNG REDHEAD)

1918
Oil on canvas, 46 x 29 cm
Private collection

Modigliani met Jeanne Hébuterne in 1917 at the Academie Colarossi, where they both attended life-drawing classes. Jeanne was 19, Modigliani 33. She was a talented art student who gave up everything to devote herself to Modigliani and remained with him until his premature death in 1919, when she took her own life whilst heavily pregnant with Modigliani's second child. Modigliani's previous lovers had tended to be strong, passionate, confident and challenging women. Jeanne, in contrast, was devoted, trusting and passive. This is a relatively naturalistic portrait, using muted colours and soft curves in the background to emphasize the curved softness of the model's face, hair and clothes. There is not a single straight line in the whole picture. Jeanne's eyes were blue, but although Modigliani decides to make them brown here, he makes them a great deal more expressive than the blank gaze typical of so many of his paintings. Although there is some elongation of her neck and face, many of the elements here – the hair, the nose, the eyes and mouth – are uncharacteristically conventional.

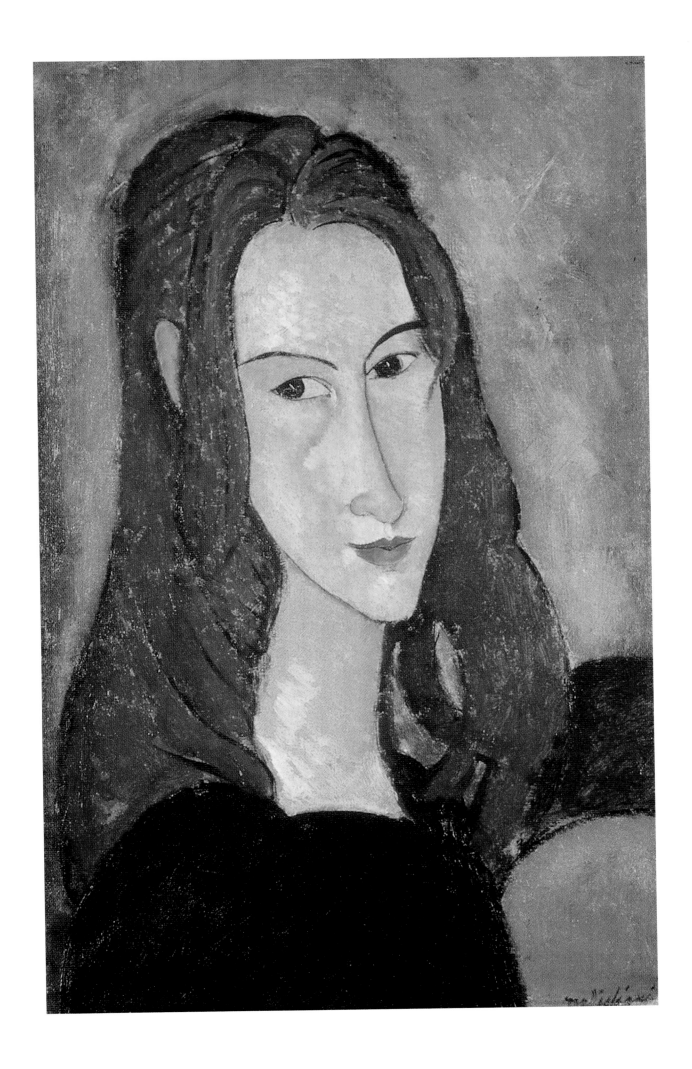

129.

STANDING FEMALE NUDE

1918-19
Pencil, 39.5 x 25.5 cm
Private collection

This simple line drawing is created with the incredible sureness of hand that typifies so many of Modigliani's sketches: there is no scrubbing out, no sign of indecision; it is just a swiftly and perfectly executed sketch. Here, the artist experiments with a standing pose, the model perched on one leg while the other knee rests on something. It is an awkward position and there is little that is erotic about the resultant image. The woman's heavy stomach is unsparingly depicted, as are her solid legs, though typically they taper off at the edge of the paper, whilst the hands, equally typically, are barely drawn. The profile and hair are drawn with remarkable naturalism and show none of the elongation or long-nosed elegance with which he imbues his paintings.

PORTRAIT OF JEANNE HÉBUTERNE

1918
Oil on canvas, 100 x 65 cm
Norton Simon Art Foundation, Pasedena,
California

There are many different portraits of Jeanne, and they differ enormously in terms of style and mood. Typically, however, she is depicted with extreme elongation of the neck and arms. Here she is shown during her pregnancy, languidly posed upon a chair. The graceful, elegant curves of her arms and neck are almost baroque in style and the warm palette of colours suggest that this may have been painted in the south of France. However, there is little in the portrait to tell us much about Jeanne's character. Her blue eyes are blank and she sits with rather passive elegance, a subject for a painting rather than a person in her own right. If we contrast this to the *Portrait of Jeanne Hébuterne* from 1918, we see how enormous a difference it makes when Modigliani simply gives expression to the eyes: whereas here we see an image of a woman, in the later portrait we see an individual.

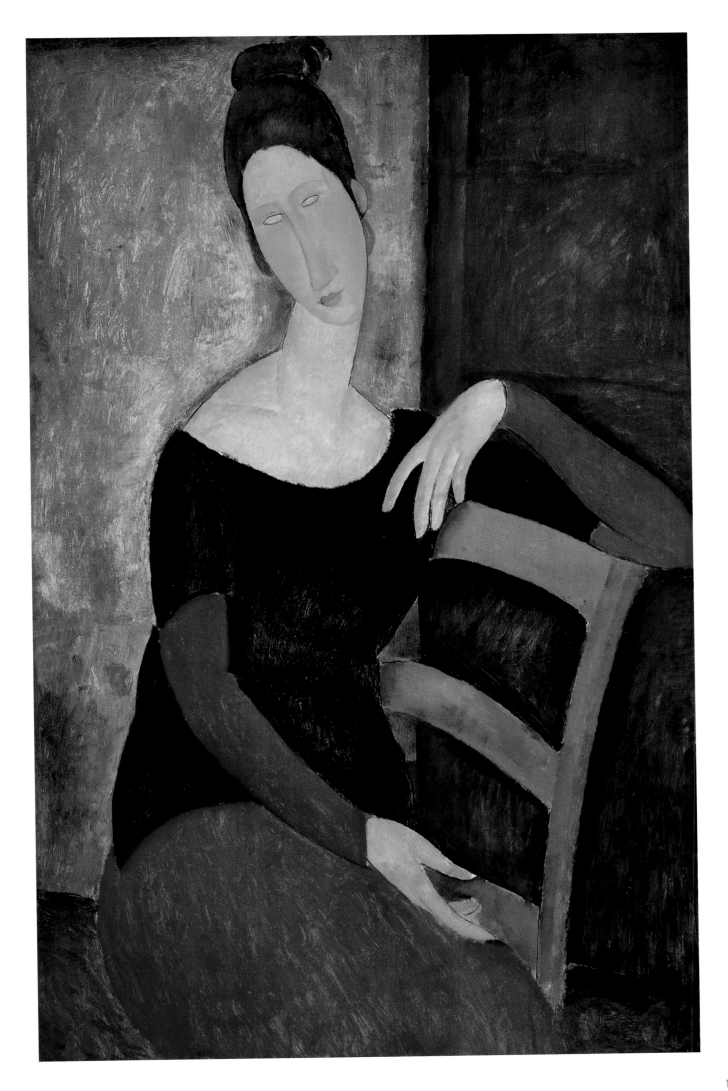

LITTLE GIRL IN BLUE

1918
Oil on canvas, 116 x 73 cm
Private collection

This painting, one of a series Modigliani painted during a trip to the south of France in the final years of his life, depicts a little girl standing in the corner of a room. The bright shades of pastel blue and the presence of the girl's shadow on the floor suggest a warm, sunny day outside. It is extremely rare for Modigliani to show the floor in his paintings, and here he paints it to powerful effect to show us clearly that the little girl is standing in the corner of the room. The floor tilts up, her feet point down – she almost looks as if she is floating. She stands with her hands clasped tightly together, her blue dress a lovely echo of the blue walls, her equally blue eyes gazing with incredible directness at the painter who, according to one story, had sent the child out for wine but she brought him lemonade instead. Perhaps this explains her position in the corner of the room – sent there perhaps by the irate artist – but the steady seriousness of her gaze does not suggest contrition or fear, she looks more as if she rather disapproved of the artist's dependence on alcohol and consequently was not sorry to have brought the wrong drink. Since there is no proof either way, we can only guess. However, this remains an exceptionally charming portrait, sweet without being sentimental.

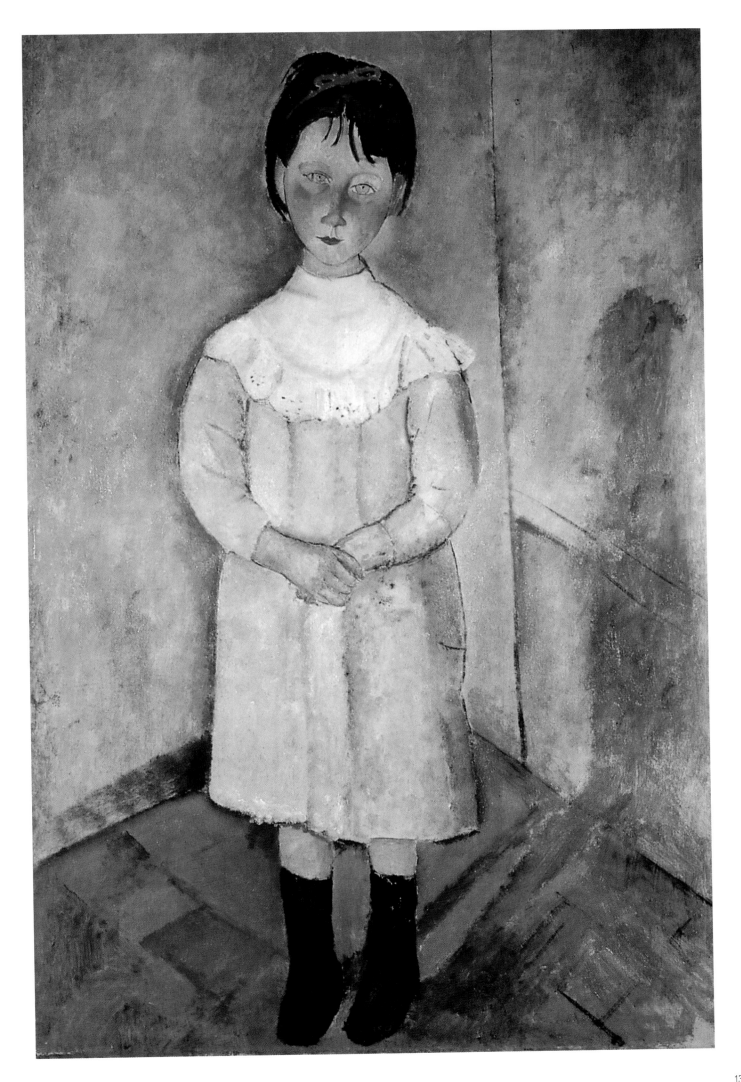

STANDING NUDE (ELVIRA)

1918
Oil on canvas, 92 x 60 cm
Kunstmuseum Bern

There are many elements in this picture that suggest it was painted during Modigliani's stay in the south of France between 1918 and 1919 rather than in Paris, where the great majority of his nudes were painted. The brightness of the blue background, suggestive of warm sunshine, is for a start untypical of Modigliani's nudes who normally inhabit a dark, warm interior of reds, blacks and oranges. The standing pose is also extremely unusual. The model is presented face-on to the viewer, her hands holding onto a white cloth to protect her modesty, her pose stiff and somewhat formal. Her body is carefully outlined and is neither elongated nor twisted in any way. Her hair is depicted in some detail, the tones of her flesh relatively pale, suggestive of youth. Her expression is serious and although her eyes are blank, the gravity and directness of her gaze has something personal about it that is more typical of Modigliani's portraits than his nudes. She holds herself awkwardly, certainly not provocatively. If this was painted during his stay in the south of France, this girl would almost certainly be a local from one of the nearby villages, not one of the models Modigliani was accustomed to use in Paris. This would certainly explain her modesty and the relative formality of the pose.

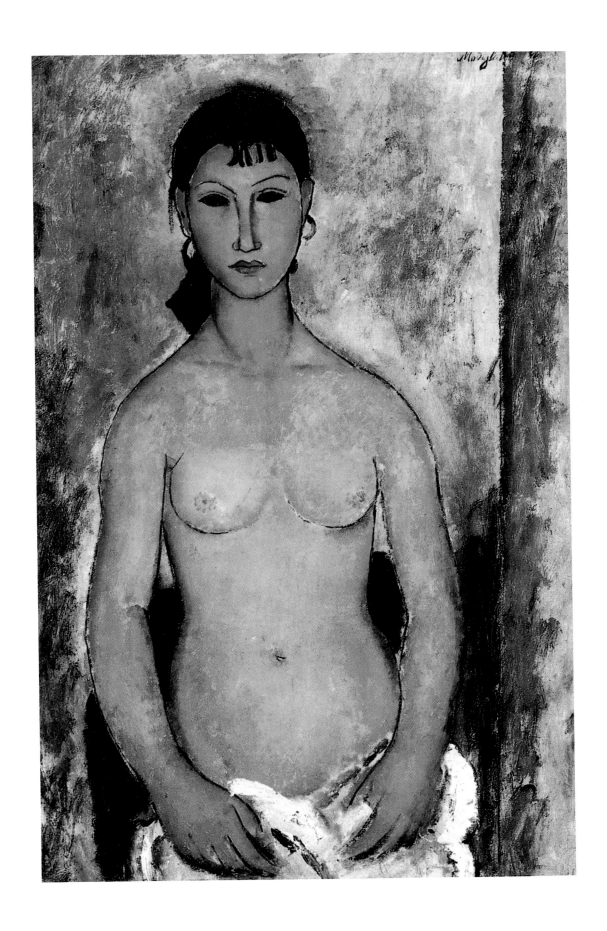

137.

PORTRAIT OF JEANNE HÉBUTERNE

1918
Oil on canvas, 100 x 65 cm
Private collection, Zurich

This portrait was painted when Jeanne was heavily pregnant. Modigliani makes no attempt to disguise her condition, choosing instead to emphasize it with a band of stripes around Jeanne's waist to draw our attention to her rounded belly. There is a beautiful balance of colours in this portrait: the dark mass of her dress and hair is balanced by the stripes around her waist and arms, which find an echo in the colour of the left-hand wall and the chair on which she sits. The rectangle of warm orange on the right-hand side of the painting contains elements of blue while the blue of the chair contains elements of the orange wall. Then there are Jeanne's eyes, startlingly blue as she gazes steadily at the viewer. Although her neck is elongated in the extreme, there is a little hint of a double chin which suggests the heaviness of late pregnancy and, in an odd gesture, Modigliani seems to have made her finger point up to her belly, as if indicating her state. Her posture, with her right arm curved inward and her head tilted sideways, and her solid, almost regal presence in the frame, make her almost Madonna-like, a symbol of womanhood.

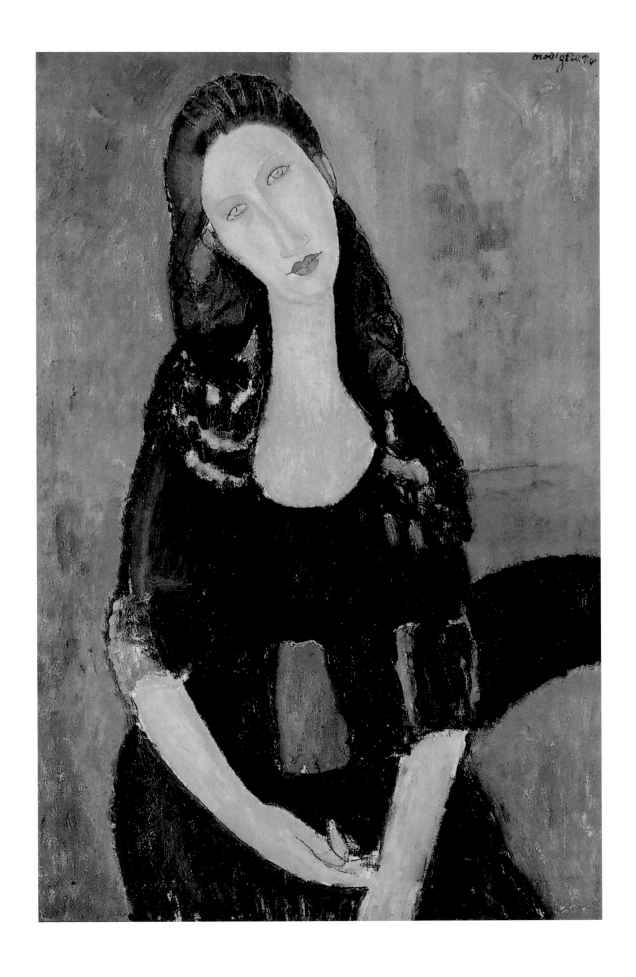

LANDSCAPE IN THE MIDI

1919
Oil on canvas, 60 x 45 cm
Private collection

In 1919 Modigliani left Jeanne and their baby in Nice and came to Cagnes where he shared a studio with Chaim Soutine and painted this rare landscape. The homage to Cézanne is clear, in the subject matter and in its execution, although interestingly, and perhaps unsurprisingly for an artist primarily concerned with the human form, he chooses the vertical portrait format even for his landscapes rather than the more typical horizontal form. It is not an idyllic scene: the sky is filled with a mass of grey clouds whose rounded forms are echoed in the clusters of tall, spindly trees which obscure the village in the background. The landscape between the trees and village, also greyish, is stepped, creating a sense both of distance and clutter. Then, slicing across the foreground of the painting, is a deep red band that is either a road or possibly the side of a bridge over which the artist is looking. In terms of colour it echoes the roofs of the village houses, but it also adds to the crowded, almost claustrophobic feel of the painting.

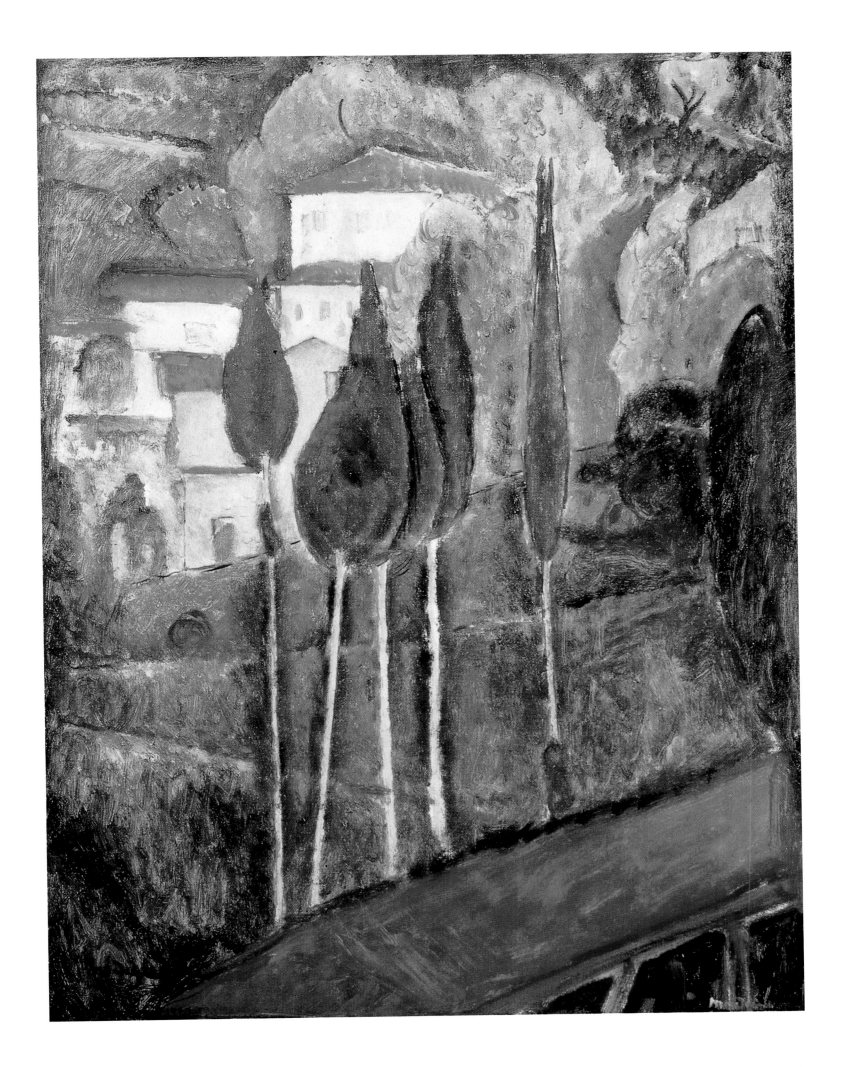

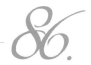

TREE AND HOUSES

1919
Oil on canvas, 57 x 45 cm
Private collection

This soft, calm painting was made during the same period as *Landscape in the Midi* but could not be more different except in one respect: both paintings depict houses obscured by trees. In this case it is the focal point of the painting: are we looking at a house, or are we looking at the bare tree in front of it? Our eye is drawn to both in equal measure. The influence of Cézanne is far less pronounced here. Modigliani's lines are wonderfully soft, the delicate blues, greys, greens and ochres merge into one another. The sky is blue, the path beside the house appears to lead towards an equally blue sea. Everything is still. This is a deeply satisfying picture which makes one regret that Modigliani spent so little time on landscapes.

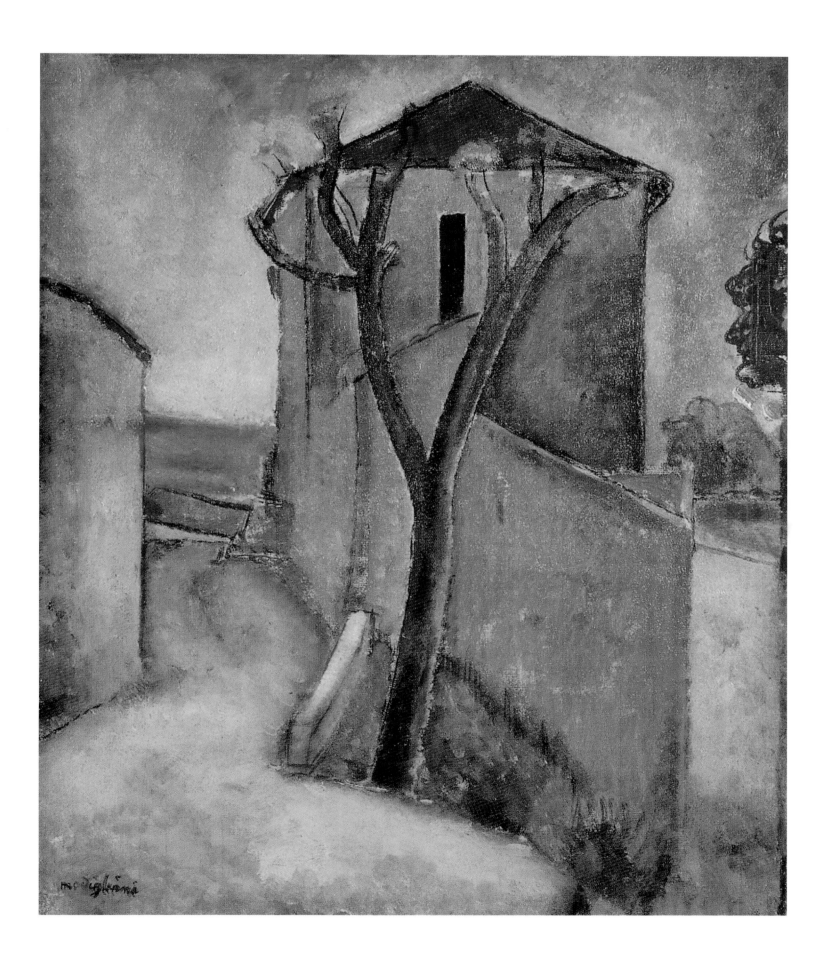

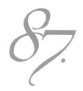

NUDE

1919
Oil on canvas, 73 x 116 cm
Private collection

This painting bears some similarity to Giorgione's *Sleeping Venus* (c.1508). Like Venus, she is asleep, head resting on one arm. Her other arm, as in some other of Modigliani's nudes, is invisible. Her body, which unusually for Modigliani is depicted in its full length, lies elegantly draped across the horizontal of the canvas, the lower part of her body a single curved line from the top of her elbow right down to her knee. Her pelvis is characteristically twisted towards us and her torso elongated. Her waist is thin, emphasizing the curves of her hips and breasts, an effect heightened by the black bed on which she lies, the edge of which is strongly delineated, creating the effect of a horizon. The woman looks extremely peaceful with her head resting on the large, very comfortable-looking pillow. This fact, combined with the delicate tones of her skin, makes this an elegant rather than an erotic work.

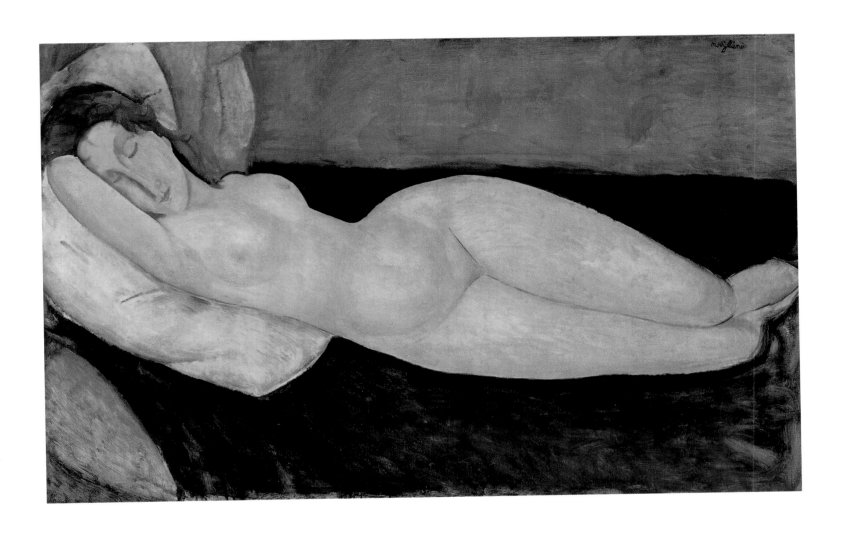

RECLINING NUDE (LE GRAND NU)

c.1919
Oil on canvas, 72.4 x 116.5 cm
The Museum of Modern Art, New York,
Mr. and Mrs. Simon Guggenheim Fund, 1950

This is considered the greatest and most quintessential of Modigliani's nudes. The body cuts across the canvas horizontally, inhabiting the upper half of the frame. The torso is elongated to an extraordinary degree, emphasized still further by the profound black beneath it, creating the impression that the model is suspended above an empty chasm. This creates a fascinating tension between the complete relaxation of the model's face – her closed eyes, her stretched, relaxed arms – and the apparent effort required to hold the centre of her body straight over nothingness. This is above all a decorative painting more than an erotic one, despite the usual techniques employed by Modigliani to draw the viewer's attention to the woman's pubic region by twisting her pelvis (here by 90 degrees) and cutting off the legs above the knees. The flesh tones are pale and delicate, in strong contrast to the usual warm pinks and oranges employed by the artist. Her face and hair are depicted in some detail, almost naturalistically; her eyes are closed, lost in a dream of her own. All of these elements combine to create a painting that is beautiful, delicate and mysterious rather than overtly erotic.

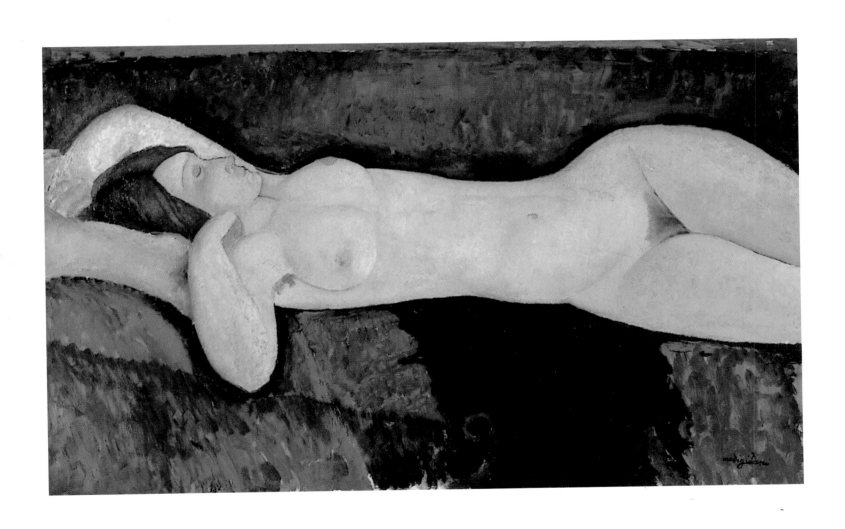

SEATED WOMAN
WITH CHILD

1919
Oil on canvas, 130 x 81 cm
Musée d'Art Moderne, Villeneuve d'Ascq,
France

This is one of a series of works which Modigliani painted whilst in the south of France using local people as models. The background, divided into vertical planes of colour, is reminiscent of Modigliani's earlier Cubist-influenced works, whilst the sculptural monumentality of the mother and child is much closer to Medieval or early Renaissance depictions of the Madonna and Child. This is a generic, symbolic portrait which also has a social context: we can see that this is a peasant woman; she wears a simple grey shawl, her face is ruddy, harsh, expressionless, her hands are red from work; the child lies across her knees, stiff like a doll, dressed in a little peasant scarf and boots. Like early Madonnas, the mass of the woman is flat, triangular, the fact that she is sitting understood rather than depicted in perspective, the child floating across her lap. There is an innocent solemnity in these rustic portraits, a dignity which Modigliani gives his subjects and a formality reminiscent of early photographic portraits. This particular painting also calls to mind the Socialist Realism of 1930s Soviet Russia, with its stylized, heroic depiction of peasant women and children.

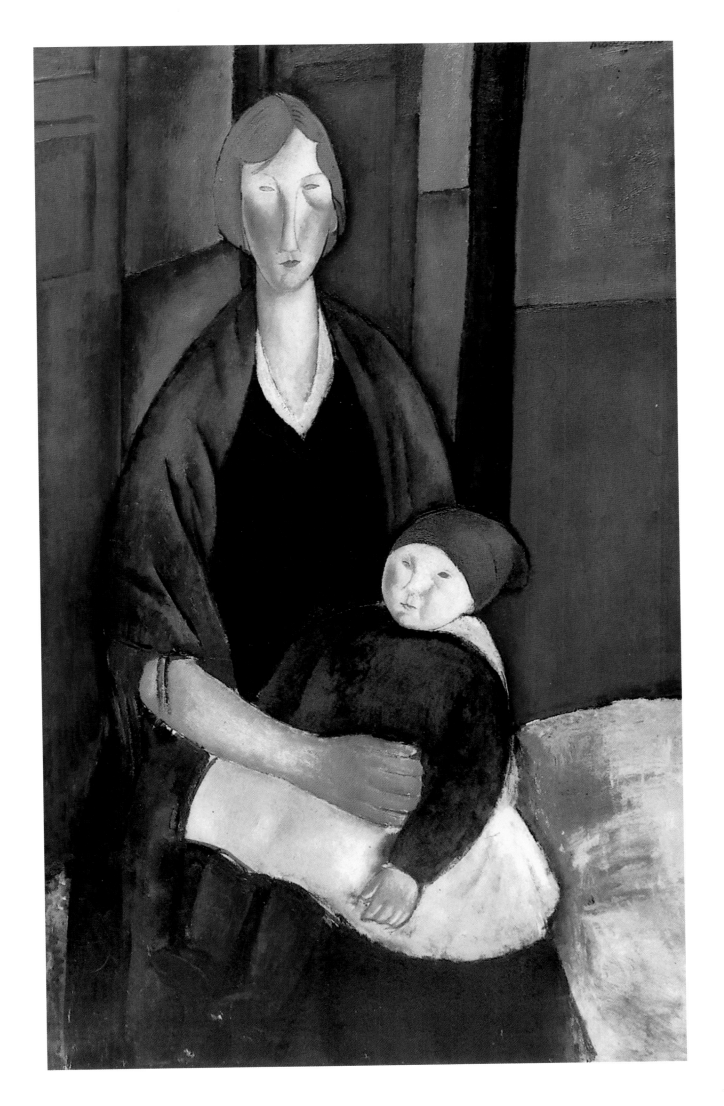

YOUNG MAN
(THE STUDENT)

1919
Oil on canvas, 60.9 x 46 cm
The Solomon R. Guggenheim Museum,
New York

Painted during the last year of Modigliani's life, this portrait most probably belongs to the series of paintings of local people which Modigliani made during his stay in the south of France. Most noticeable about the painting is of course the incredible elongation of the neck, an element emphasized by the young man's short hair. The colour scheme is almost monochrome: the black door or window frame matches the boy's black jacket, while the blue background finds an echo in his shirt collar and startlingly empty blue eyes. The young man's face is delicate, almost girlish: his cheeks are lightly flushed, his lips a full red, his eyebrows a thin arched line. There is an almost effete quality about the young man which is in marked contrast to the stocky sturdiness of the peasant men and women which Modigliani painted at the same time. Presumably his status as a student goes some way to explaining this and his slightly haughty air.

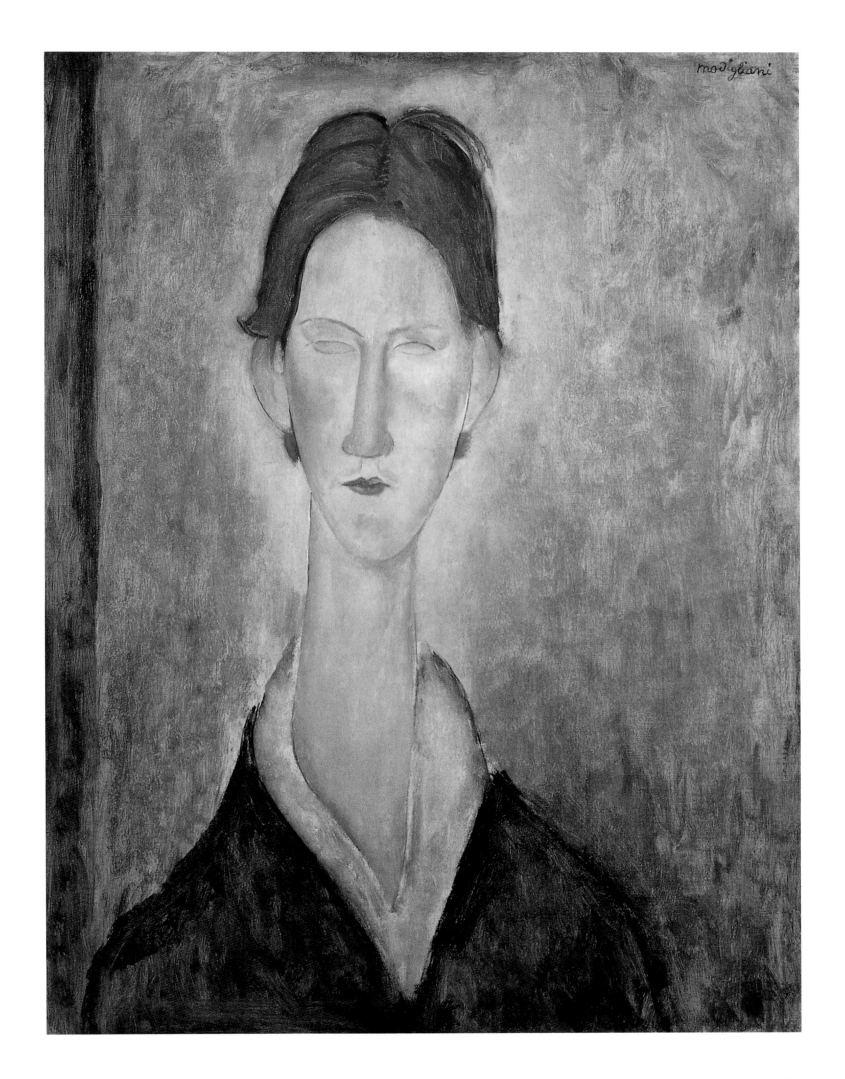

151.

SELF-PORTRAIT

1919
Oil on canvas, 100 x 65 cm
Museu de Arte Contemporanea da
Universidade de São Paulo

Modigliani painted this rare self-portrait in the last year of his life, when he was ill, impoverished and desperate despite the fact that his paintings were beginning to command reasonable prices. He depicts himself as the archetypal artist: with brush and palette in front of his easel, head tilted backward in a theatrical pose. But there is no painting on the easel, the youthful good looks he purports to show us have gone, his eyes are blank. It is an unconvincing, even chilling picture on many levels, expressing nothing about the artist or his art. The thick scarf which he wears around his neck is perhaps the only truthful element here: it suggests both the winter cold which would exacerbate Modigliani's illness and the artist's poverty in being unable to heat his studio sufficiently to combat the cold. The rest of it is the bravado of a fading man.

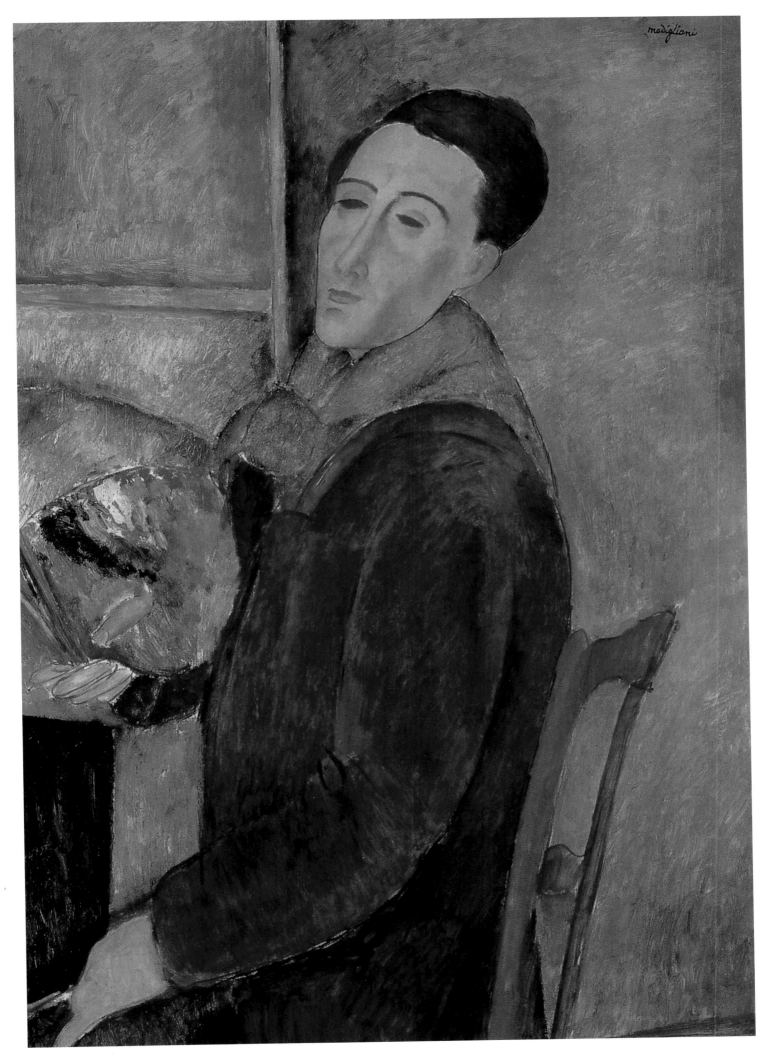

Modigliani 1884-1920: Biography

1884

Amedeo Clemente Modigliani is born on July 12 in Leghorn, a town on the Italian coast in the province of Lovorno. The youngest of four children, he receives a Jewish education. Since early childhood, he suffers from health problems and consequently undertakes many trips for convalescence. He thus gets to know southern Italy as well as the museums and cathedrals of Rome and Naples that introduce him to the art of the Italian Renaissance.

1898

Modigliani enters the art academy in Livorno. His teacher Guglielmo Micheli makes the 14-year-old familiar with Impressionist art.

1902

At the Scuola Libera di Nudo dell'Accademia de Belle Arti in Florence, he establishes ties with the Tuscan Impressionists around Giovannu Fattori. Travelling around Tuscany raises his interest in sculpture.

1903

In March, Modigliani enrolls at the Scuola Libera del Nudo in Venice. At the Biennial exhibitions, he is especially fascinated by Cézanne and van Gogh. French painting – the works of Henri Toulouse-Lautrec in particular – inspires him to go to the centre of avant-garde art, Paris.

1906

Modigliani settles in Paris (initially in Montmartre) and takes drawing lessons at the Accademia Colarossi. He completes more than 1000 sketches during his studies. His dissipated lifestyle, characterised by affairs, drugs and alcohol, quickly renders him infamous in the district. His circle of acquaintance includes reputable artists and literary figures, such as Pablo Picasso, Guillaume Apollinaire, André Derain and Diego Riviera. He is moreover closely associated with Jewish intellectuals and artists like Max Jacob, Chaim Soutine and Moïse Kisling.

1907

The artist gets to know Dr. Paul Alexandre, who is the first to buy his pictures. The doctor enables Modigliani to exhibit in the Salon d'Automne. Already at this stage, the painter is predominantly working on portraits and nudes. He becomes a member of the Société des Artists des Indépendants.

1908

Amedeo exposes six of his works at the Salon des Artistes des Indépendants.

1909

Modigliani moves to Montparnasse, the real heart of art in Paris, and makes the acquaintance of Constantin Brancusi, who introduces him to sculpture. Sculpting becomes Modigliani's preoccupation; a new style is meant to promote an air of solidity.

He steals the material for his figures from unattended building-sites. For health reasons, he resumes travelling to Italy.

1910

The sculptures displayed at the Salon des Artistes des Indépendants receive excellent criticism.

1911-12

Modigliani exhibits sculptures and paintings in the studio of Souza Cardoso and again at the Salon d'Automne. For health reasons, he prefers painting (mainly portraits) to the exhausting task of sculpting.

1914

His work is represented at the exhibition "Twentieth Century Art" at the Whitechapel Art Gallery in London. Around the beginning of the first world war, he loses touch with his patron Dr. Alexandre. Due to his tendency to attract chest infections, he is spared from serving in the war.

1914-16

Amedeo gets to know the English poet Béatrice Hastings and lives with her for two years. He finally turns his back on sculpting. Up to 1916, art dealer Paul Guillaume buys several of his works, but Modigliani remains poor. He prefers to paint his friends – for a little money or some alcohol. To pay his meals, he peddles his sketches in bars and cafés.

1916

He meets Leopold Zborowski. The Polish poet would like to turn Modigliani into an artistic celebrity.

1917

With Jeanne Hébuterne, with whom he is to remain until his death, the artist calms down. He commences his first series of nude studies (although he sketches neither Jeanne nor Béatrice Hastings as a nude). Modigliani's first individual exhibition at Berthe Weill gallery in Paris produces a public outcry and is closed down by the police on the day of its opening.

1918

His progressive tuberculosis forces the couple to retire for a year to the Côte d'Azur. Their daughter Giovanna is born in November.

1919

The family returns to Paris. He is again represented at numerous exhibitions. His health, however, deteriorates rapidly – in part due to his excessive alcohol consumption.

1920

Unconscious, Modigliani is taken to hospital and dies on January 24 at the age of 35. The following day, his companion Jeanne commits suicide in an advanced state of pregnancy.

Modigliani 1884-1920: Index of Works

Page 28
Seated Young Woman, 1918. Oil on canvas, 92 x 60 cm.
Musée Picasso, Paris.

Page 29
Girl from Montmartre, c.1918. Oil on canvas.
Private collection.

Page 31
Portrait of Pablo Picasso, 1915. Oil on canvas, 35 x 26.6 cm.
Private collection, Geneva.

Page 32
Portrait of Blaise Cendras, 1917.
Oil on cardboard, 60 x 50 cm. Private collection, Rome.

Page 33
Juan Gris, c.1915. Oil on canvas, 54 x 38.1 cm.
The Metropolitan Museum of Art, New York.

Page 34
Portrait of Diego Rivera, 1914.
Oil on cardboard, 100 x 79 cm. Museu de Arte, São Paulo.

Page 36
Jacques Lipchitz and his Wife, 1916-17.
Oil on canvas, 78.7 x 53.3 cm. Art Institute of Chicago.

Page 37
Jean Cocteau, 1916.
Oil on canvas, 100.3 x 81.3 cm.
Private collection, New York.

Page 38
Man with Pipe (The Notary of Nice), 1918.
Oil on canvas, 92 x 60 cm. Private collection, Paris.

Page 39
Portrait of Franck Burty Haviland, 1914.
Oil on canvas, 61 x 50 cm. Private collection.

Page 41
Gypsy Woman and Girl, 1919. Oil on canvas, 130 x 81 cm.
The National Gallery, Washington.

Page 42
Le Zouave, 1918. Oil on canvas, 63 x 48.3 cm.
Private collection, Paris.

Page 43
Yellow Sweater (Portrait of Mme. Hébuterne), c.1919.
Oil on canvas, 99 x 66 cm. The Solomon R. Guggenheim
Museum, New York.

Page 44
Portrait of Monsieur Baranowski, 1918. Oil on canvas.
Private collection, London.

Page 45
The Young Servant Girl, 1919. Oil on canvas, 99 x 61 cm.
Albright-Knox Gallery, Buffalo.

Page 46
Portrait of Jeanne Hébuterne, 1918. Oil on canvas, 91.4 x 73 cm.
Metropolitan Museum, New York.

Page 47
Seated Nude, c.1917. Pencil, 31.2 x 23.9 cm.
Private collection, Chicago.

Page 48
The Little Peasant, 1919. Oil on canvas, 100 x 65 cm.
The Tate Gallery, London.

Page 85

Crouching Caryatid, 1914. Limestone, 92 x 42 x 43 cm.
The Museum of Modern Art, Simon Guggenheim Fund,
New York.

Page 87

Portrait of Moïse Kiesling, 1915. Oil on canvas, 37 x 29 cm.
Pinacoteca di Brera, Milan,
Donation by Emilio and Maria Jesi.

Page 89

Bride and Groom, 1915. Oil on canvas, 55.2 x 46.3 cm.
The Museum of Modern Art, New York.

Page 91

Portrait of Béatrice Hastings, 1915. Oil on canvas, 55 x 46 cm.
Art Gallery of Ontario, Toronto.

Page 93

Portrait of Leopold Zborowski, 1916. Oil on canvas, 65 x 43 cm.
Private collection.

Page 95

Seated Nude, 1916. Oil on canvas, 92 x 60 cm.
The Courtauld Institute of Art Galleries, London.

Page 97

Portrait of Chaïm Soutine, 1916. Oil on canvas, 100 x 65 cm.
Private collection.

Page 99

Seated Nude with Necklace, 1917. Oil on canvas, 92 x 60 cm.
Private collection.

Page 101

Sleeping Nude with Arms Open (Red Nude), 1917.
Oil on canvas, 60 x 92 cm. Collection Gianni Mattioli.

Page 103

Nude with Necklace, 1917. Oil on canvas, 73 x 116 cm.
Solomon R. Guggenheim Museum, New York.

Page 105

Reclining Nude, 1917. Oil on canvas, 60 x 92 cm.
Staatsgalerie, Stuttgart.

Page 107

Nude, 1917. Oil on canvas, 72 x 117 cm. Private collection.

Page 109

Reclining Nude, 1917. Pencil on paper, 26 x 41 cm.
Private collection.

Page 111

Seated Nude, 1917. Oil on canvas, 73 x 116 cm.
Koninklijk Museum voor Schone Kunsten, Antwerp.

Page 113

Nude on a Blue Cushion, 1917. Oil on canvas, 65.4 x 100.9 cm.
National Gallery of Art, Washington D.C.

Page 115

Portrait of Jeanne Hébuterne with Large Hat, 1917.
Oil on canvas, 55 x 38 cm. Private collection.

Page 117

Reclining Nude with Loose Hair, 1917. Oil on canvas,
60 x 92.2 cm. Osaka City Museum of Modern Art, Osaka.

Page 119

Nude with Necklace, 1917. Oil on canvas, 64.4 x 99.4 cm.
Allen Memorial Museum, Oberlin, Ohio.

Page 121

Seated Woman in Blue Dress, 1917-19.
Oil on canvas, 92 x 60 cm. Moderna Museet, Stockholm.

modigliani